PICASSO

The Artist's Studio

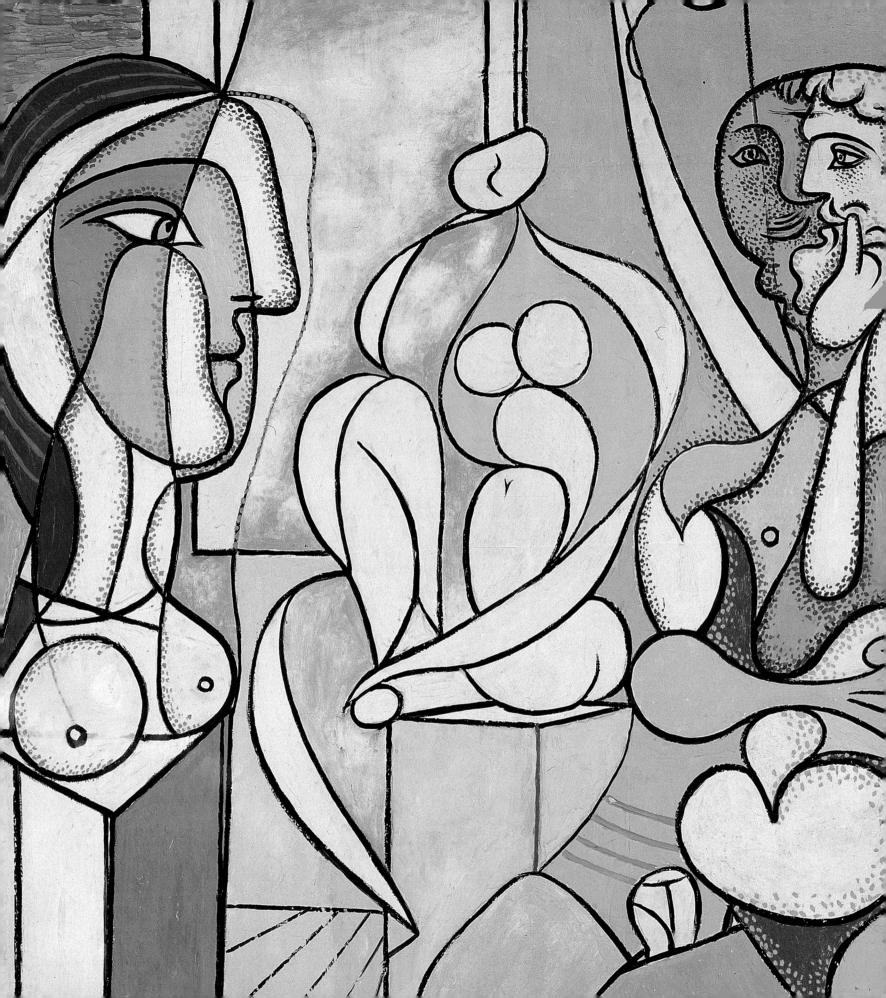

PICASSO
The Artist's Studio

Michael FitzGerald

with an essay by

William H. Robinson

Wadsworth Atheneum Museum of Art, Hartford

in association with

Yale University Press, New Haven and London

Organized by the Wadsworth Atheneum Museum of Art, Hartford, and the Cleveland Museum of Art

The exhibition is supported by an indemnity from the Federal Council on the Arts and the Humanities

The exhibition is sponsored in Hartford by Fleet.

Additional support provided by The Florence Gould Foundation, The Pryor Foundation, and the Howard & Bush Publication Fund

Support for educational programs and materials provided by the J. Walton Bissell Foundation, Inc. and Sotheby's

The Cleveland showing is sponsored by Key.

EXHIBITION DATES
Wadsworth Atheneum Museum of Art
9 June to 23 September 2001

The Cleveland Museum of Art
28 October 2001 to 6 January 2002

Index by Indexing Partners
Designed by Sally Salvesen
Set in Monotype Bembo and printed in Singapore

Library of Congress Cataloguing-in-Publication Data
FitzGerald, Michael C.
 Picasso: the artist's studio / Michael FitzGerald.
 p. cm.
Includes index.
 ISBN 0-300-08941-4 (alk. paper)
 1. Picasso, Pablo, 1881-1973—Exhibitions. 2. Artists' studios in art—Exhibitions. I. Picasso, Pablo, 1881-1973. II. Title.
N6853.P5 A4 2001
 709'.2—dc21

 2001002102

CONTENTS

LENDERS TO THE EXHIBITION

The Cleveland Museum of Art

Collection A. Rosengart

Indiana University Art Museum

Marina Picasso Collection

Musée national d'art moderne, Paris

Musée Picasso, Paris

Museo Nacional Centro de Arte Reina Sofia, Madrid

Museu Picasso, Barcelona

The Museum of Modern Art, New York

The National Museum of Modern Art, Kyoto

The Patsy R. and Raymond D. Nasher Collection, Dallas

Philadelphia Museum of Art

Picasso Collection of the City of Lucerne

The Speed Art Museum, Louisville

State Pushkin Museum of Fine Arts, St. Petersburg

Tate Gallery, London

Wadsworth Atheneum Museum of Art, Hartford

Private Collectors who wish to remain anonymous

SPONSOR STATEMENT

Fleet is proud to sponsor *Picasso: The Artist's Studio*, the first major U.S. exhibition devoted to Picasso's studio.

Unlike many artists who treated their studios as sanctuaries, Pablo Picasso used his studio not only as a place of work, but as a social and intellectual center. In his studio, Picasso negotiated with dealers, enthralled collectors, and argued with critics. As a result, the studio is a recurring theme throughout Picasso's art and his self-depictions.

The Wadsworth Atheneum, founded in 1842, is one of America's oldest public art museums. In 1934, the Wadsworth mounted the first major Picasso retrospective in America, which makes it all the more appropriate for the Wadsworth to be hosting the first major U.S. exhibition devoted to Picasso's studio. Fleet appreciates the Atheneum's role as one of Connecticut's leading cultural institutions and is pleased to be a partner of this exhibit.

This blockbuster inaugural event reflects Fleet's leadership role and our commitment to bring first quality arts and cultural activities to Connecticut. We hope you enjoy the exhibit.

James G. Connolly

Chairman and CEO
Fleet − Connecticut

Chandler J. Howard

President
Fleet − Connecticut

 Fleet

DIRECTORS' FOREWORD

The theme of the artist's studio captivated Picasso's imagination throughout the entire span of his career. *Picasso: The Artist's Studio* gathers major paintings and drawings of all styles and from all periods of the artist's work from public and private collections around the world to explore the many ways that Picasso imagined and represented the artist's studio. In Picasso's vision, the studio communicated a variety of meanings. Conceived as both an actual place and a symbol for artistic identity and the creative process itself, his images of the studio include self-portraits and portraits of friends, lovers and children, political commentaries and evocations of great artists of the past.

Both the Wadsworth Atheneum Museum of Art and the Cleveland Museum of Art have been enthusiastic collectors of Picasso's work. Under the leadership of former director, A. Everett Austin, Jr., the Wadsworth Atheneum played an early and critical role in recognizing Pablo Picasso as one of the most original artists of the twentieth century. After an initial exhibition in 1931 of drawings and lithographs by the artist, the Atheneum presented the first retrospective of Picasso's art in the United States. Opening in February 1934, this exhibition was a landmark event in the history of both the museum and the reception of Picasso in America. Happily, the present exhibition reunites two paintings from that historical display: *Nude with Drapery* (1922), the only painting then owned by the Atheneum, and the *Self-Portrait with Palette* (1906) now in The Philadelphia Museum of Art. In Cleveland, director William M. Milliken and trustee Leonard C. Hanna Jr. seized the opportunity in 1945 to acquire Picasso's early masterpiece *La Vie*. Subsequently, no less than four seminal works were added to Cleveland's holdings.

Thus, this exhibition dedicated to the theme of the artist's studio in Picasso's work affords an opportunity to celebrate both the great collections and distinguished histories of the Wadsworth Atheneum Museum of Art and the Cleveland Museum of Art. Inspired by the presence of two studio subjects *The Painter* (1934) and *The Artist* (1963) in Hartford, former museum director Peter C. Sutton initially conceived the idea for this exhibition and invited Professor Michael FitzGerald of Trinity College to serve as guest curator and principal author of the catalogue. Dr. FitzGerald has guided the conception of the exhibition and the gathering of loans with unfailing persistence and dedication. We are grateful for

his contribution to the success of the exhibition and catalogue. Under the late Robert P. Bergman, the Cleveland Museum of Art embraced the project at an early stage as co-organizer of the exhibition, aiding in the selection of works and contributing *La Vie*, one of the first major representations of a studio theme by the artist and a pivotal work for this exhibition. William H. Robinson, Associate Curator of Painting at Cleveland, has also contributed an essay on this work.

It is a difficult task to assemble loans of paintings by an artist such as Picasso whose work is perennially popular throughout the world. We are most indebted to all our lenders both public and private who have so generously shared their valuable treasures with us. We are especially grateful to Gérard Régnier, Director of the Musée Picasso, Paris; Glenn Lowry, Director of the Museum of Modern Art, New York; Werner Spies, Director of the Centre national d'art et de culture Georges Pompidou; M. Teresa Ocaña, Director of the Museu Picasso, Barcelona; and José Guirao, Director of the Museo Nacional Centro de Arte Reina Sofia, Madrid. The Picasso Family has been extremely generous and supportive of this project and we wish to thank Claude Ruiz-Picasso, Bernard Ruiz-Picasso, Paloma Ruiz-Picasso and Marina Ruiz-Picasso.

We are pleased that Yale University Press, London through the offices of John Nicoll has agreed to publish the catalogue and that Sally Salvesen has provided her considerable skills both as editor and designer to make this a beautiful publication.

We gratefully acknowledge the generosity of Fleet Bank, the lead sponsor of this exhibition at the Wadsworth Atheneum Museum of Art, and especially Richard Higginbotham, Managing Director of Fleet's Commercial Finance Division. In addition, many individuals at Fleet-Connecticut supported the project and we thank in particular James Connolly, Chairman and CEO, and Chandler Howard, President. Meg Albert, Senior Manager, Community Relations and Sponsorships, and Deborah French, Sponsorship Manager, also gave generously of their time and effort. For additional support of this project we are most pleased to thank The Florence Gould Foundation and its President John R. Young, and The Pryor Foundation and its Foundation Manager Millard H. Pryor, Jr. For support of educational programs and materials, we thank the J. Walton Bissell Foundation, Inc. and its President J. Danford Anthony Jr., and Sotheby's and its Director-Museum Services David M. Roche and Vice Chairman-North America James G. Niven. Publication of the exhibition catalogue has been supported by the Howard & Bush Publication Fund. This show has also received an indemnity from the Federal Council on the Arts and the Humanities.

Significant contributions to this exhibition and catalogue were made by a number of other individuals. We wish to thank the following: Gabriella De Ferrari, Michael Findlay, Franck Giraud, Quentin Laurens, Andrew Kalman, Maya Lengi-Konig, Jan Krugier, Matthew Marks, Charles Moffett, David Nash, David Norman, Shunsuke Kijima, Dominique Dupuis Labbe, Charlotte and Ralph Phil, Martha Reynolds, Louise Roman Bernstein, William Rubin, Gary Tinterow, Paul Hayes Tucker, Kirk Varnedoe, Susan Werder, Alice M. Whelihan, and Annette Williams.

On the Atheneum's staff, we wish to thank all those whose dedicated efforts

ensured the success of this project. The chief liaison among all the participants who made the exhibition happen for the Wadsworth Atheneum was Cynthia Roman, Associate Curator of European Art. In the planning and organization, the expertise and hard work of Exhibition Coordinator Nicole Wholean and Associate Registrar Mary Schroeder were invaluable. Elizabeth Kornhauser, Deputy Director, and Eric Zafran, Curator of European Painting and Sculpture, assisted with experienced advice and guidance. In addition, we wish to thank all members of the staff who assisted in the planning, preparation, installation, and special events, especially Cecil Adams, Jeremy Barrows, David Baxter, Gertrud Bourgoyne, Ulrich Birkmaier, Dana DeLoach, Gretchen Dietrich, Amy Ellis, Julie Feidner, Eugene Gaddis, Amy Larkin Gelbach, Zenon Ganziniec, Mark Giuliano, Caleb Hammond, Janet Heim, Allison Hewey, Susan Hood, Honora Horan, Gail Johnson, David Kaminski, Fran Kida, Stephen Kornhauser, Margaret Lukaszyk, Claire Matthews, Ann McCrea, Lynn Mervosh, Linda Roth, Erica Scherzer, Matthew Seigel, William Staples, John Teahan, Jack Tracz, Don Wentworth, Steve Winot, and Dave Zelie.

For the Cleveland Museum of Art we wish to acknowledge Key, sponsor of the Cleveland showing. In particular we thank Robert W. Gillespie, Daniel F. Austin, and KeyCorp Chief Executive Officer, Henry Meyer III, for their continued support of the Cleveland Museum of Art. On the Cleveland staff, Exhibitions Director Katherine Solender and Exhibitions Coordinator Heather Ulrich facilitated planning and organization between the two institutions. William H. Robinson served as coordinating curator for Cleveland. We also wish to thank Chief Curator Diane De Grazia, Chief Registrar Mary Suzor, Associate Registrar Beth Gresham, and Grants Manager Rob Krulak. Other members of the staff who provided invaluable assistance and expertise include Jeffrey Baxter, Jeffrey Strean, JoAnn Dickey, Holly Witchey, Joellen DeOreo, Stanton Thomas, Karina Gobar, Siobhan Conaty, Sylvain Bellenger, Tom Hinson, Michael R. Cunningham, Roberto Precla, Jill Alene Jiminez, Ann Abid, Christine Edmondson, Louis Adrean, Marcia Steele, and Kenneth Bé.

We hope our visitors will enjoy exploring the art of Picasso through the theme of the artist's studio and will gain insight into the life and work of the most important and influential artist of the twentieth century.

Kate M. Sellers

Director
Wadsworth Atheneum Museum of Art

Katharine Lee Reid

Director
The Cleveland Museum of Art

ACKNOWLEDGEMENTS

All exhibitions require the dedication of scores of individuals to realize their potential, but none devoted to Picasso's work can succeed without the support of the artist's heirs. We have been especially fortunate to benefit from the advice and loans contributed by Bernard Ruiz-Picasso, Claude Ruiz-Picasso, Marina Picasso, and Paloma Ruiz-Picasso. During the several years spent planning and executing this project, Claude, in particular, offered invaluable discussions of his father's art and crucial recommendations regarding works for the exhibition. We owe the family a tremendous debt of gratitude.

Three scholars contributed greatly to the conception of the exhibition. As the premier curator of exhibitions of Picasso's work for more than twenty years, William Rubin has set a challenging example for anyone approaching the task. His willingness to discuss the topic with me at an initial stage generated extremely provocative discussions that informed the ultimate course of the exhibition. John Richardson graciously took time from the Herculean task of writing the definitive biography of Picasso to share the knowledge of the artist's studio pictures that he first developed more than forty years ago during visits to La Californie and to call my attention to particularly significant early works. A participant from the beginning of the project, Charles Stuckey continually brought new insights to the subject and offered much appreciated practical advice.

Plans for the exhibition began in the summer of 1997, when Peter Sutton, then Director of the Wadsworth Atheneum, invited me to curate a show centered on the two studio paintings in the museum's collection and soon secured the Cleveland Museum of Art as co-organizer. The process of expanding this kernel into an exhibition of more than fifty paintings and drawings involved arduous efforts by many individuals at both institutions, during a period when each museum experienced a change of director.

Our deepest gratitude goes to the lenders – institutions, private individuals, and galleries – whose sacrifice in parting with works in their collections has made possible the realization of this exhibition. Although all lenders are acknowledged elsewhere in this catalogue, I would like to offer special thanks to the following. We are particularly indebted to Gérard Régnier, the Director of the Musée Picasso in Paris, for allowing us to borrow extensively from that rich collection. And Hélène Seckel, Chief Curator, offered invaluable advice throughout the

preparation of the show. Kirk Varnedoe, Chief Curator, Department of Painting and Sculpture, at the Museum of Modern Art in New York, went to great lengths to enable us to borrow several crucial works from MoMA's collection. We owe a particular debt of gratitude to Angela Rosengart of the Galerie Rosengart, both for the loans she provided and her advice on related matters.

Several auction house and gallery directors have facilitated our loan requests. Our particular thanks to Susan Dunne, of Pace Gallery; Charles Moffett, Co-Chairman of Impressionist and Modern Art at Sotheby's; and Michael Findlay, formerly International Director of Twentieth Century Art at Christie's and now at Acquavella Galleries.

Other individuals have helped us trace the works we were considering, generously made their time available to us, enriched us with their special expertise, and on occasion negotiated certain loans for us. We would especially like to thank Steven Nash, Associate Director and Chief Curator at the Fine Arts Museums of San Francisco.

Judith Gilligan, Administrator of the Fine Arts Department at Trinity College, has been essential to the realization of this publication by overseeing the demanding task of obtaining illustrations for the catalogue.

Almost all of the Wadsworth Atheneum's departments have participated in the preparation of this publication and exhibition. As the Deputy Director and Chief Curator, Elizabeth Kornhauser offered continual support during difficult stages of the project and greatly aided our relations with other institutional and individual lenders. Cynthia Roman, Associate Curator of European Art, has done an exemplary job of serving as the in-house supervisor of the exhibition. Her reliability, kindness, and professionalism have greatly facilitated the sometimes awkward role of an outside curator. Likewise, Nicole Wholean, Exhibition Coordinator, has been a steady and tireless negotiator of the intricate requirements of loan letters, insurance statements, and catalogue citations.

At Cleveland, I would like to thank William H. Robinson, who served as the museum's curatorial representative, for his contributions to the project and his essay on *La Vie* for the catalogue. Michael R. Cunningham, Curator of Japanese and Korean Art, generously aided us in negotiating a crucial loan.

Finally, I offer respects to my students at Trinity College, particularly those enrolled in two seminars I taught on the subject of this exhibition, for their insights and enthusiasm.

Michael FitzGerald

Associate Professor
Trinity College

Michael FitzGerald

THE STUDIO PAINTINGS

INTRODUCTION

On March 27, 1963, Picasso scrawled across the back flyleaf of a sketchbook, "la peinture est plus forte que moi / elle me fait faire ce qu'elle veut (Fig. 1)."[1] Almost every preceding sheet of the thirty-page album is devoted to an image of an artist painting in a studio. The painters range from fresh youths to wizened elders, the studios from windowed and electrically lit lofts to curtained alcoves, the models from voluptuous women to a staring monkey, and the manners of execution from spare, Neoclassical proportion to broadly stroked, childlike sketches. The succession of drawings suggests constant motion through an endless variety of transformations without resolution, both exhilarating and overwhelming, a response that Picasso put into words at the end of the book. And this is merely one of many albums Picasso devoted to the subject. During his final decade, the subject of the artist's studio swamped all others in both number of works and variety of media, encompassing pencil and crayon drawings, etchings, and a stream of monumental paintings. This late effluence was only the most intense and sustained of Picasso's life-long engagement with the subject and his attempts to plumb the many issues it evoked, as it flowed through the full diversity of his work and became one of the central themes of his art.

Although the theme began in Picasso's juvenilia and continued to within a year of his death in 1973, it was a sporadic concern. During some decades it appeared suddenly in a single picture or a cluster, and at other times it dominated his work for a decade or more, especially from the mid twenties through the mid thirties, and from the mid fifties through the early seventies. Given this chronological inconsistency, the subject would seem less significant to his art than those – such as portraiture or the female nude – that received steady attention. Yet, the studio is a different sort of subject. Artists frequently paint portraits as much to accommodate individuals' desires for immortality as to pursue their own aesthetic enterprise. The nude has been the focus of humanistic expression in western culture since classical times. Although the artist's studio shares an equally ancient history,

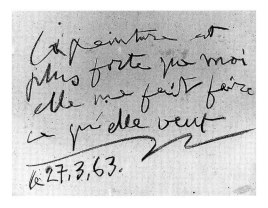

1. Inside back cover of a sketchbook, March 27, 1963, wax crayon on paper. Musée Picasso, Paris

Detail of Fig. 21. *Painter and Model*, 1928, oil on canvas. The Museum of Modern Art, New York, The Sidney and Harriet Janis Collection

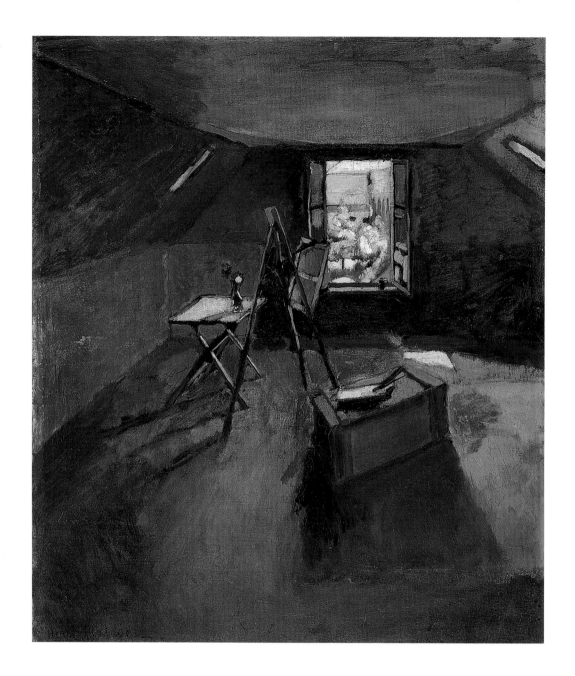

2. Henri Matisse, *Studio under the Eaves*, 1902, oil on canvas. Fitzwilliam Museum, University of Cambridge

it is fundamentally a parochial subject – a rendering of an artist at work in a specifically outfitted place – one that presumably would appeal primarily to artists or those particularly interested in professional practices. From this mundane origin have come some of the greatest paintings in western art, Vermeer's *Art of Painting* (1666) and Courbet's *Studio* (1855), among others, as artists have turned from recording the process of making art to creating allegories of its meanings.[2]

In the twentieth century, only Matisse rivaled Picasso's devotion to the subject of the studio. As students, both spent years drawing and painting in teaching studios, where they were drilled in the tradition of studio depictions. They shared this preparation with many of their contemporaries, who largely discarded the subject as they defined their mature approaches. Picasso and Matisse persisted,

3. Henri Matisse, *The Red Studio*, 1911, oil on canvas. The Museum of Modern Art, New York, Mrs. Simon Guggenheim Fund

making the studio a touchstone for the many aesthetic changes that marked their long careers. By sheer number of works, Picasso exceeded Matisse (who died eighteen years before Picasso), although Matisse employed it more consistently and in an essentially different way. For all the variety of Matisse's depictions, they are remarkably consistent in portraying the artist's workplace as an aesthetic sanctuary. From the *Studio under the Eaves* (1902) to *The Red Studio* (1911), *Nude in the Studio* (1928), and beyond (Figs. 2, 3), Matisse's images reflect the tremendous stylistic shifts in his art and often crystallize particular innovations, yet they rarely, if ever, seem to introduce anything beyond art – the political and economic events of the century and even Matisse's domestic life pass without notice.[3]

For Picasso, the artist's studio was the center of the world. His conception was as far from Matisse's as these two deeply intertwined artists could be, even though the divide would narrow in the late 1950s and sixties, when Picasso probed the relationship in the years following Matisse's death. Only in these last decades did Picasso share Matisse's idea of the studio as an escape from everyday life, and even then Picasso arrived at the notion in response to his international celebrity.

From his first independent steps as an artist, Picasso imagined the studio as a crossroads of events. Indeed, this departure is a defining element of his artistic maturity. While Matisse revived the purity of an academic ideal with his own radical ideas, Picasso shattered the isolation by drawing every aspect of his life and times into his studio images. Instead of a workplace or an aesthetic retreat, he

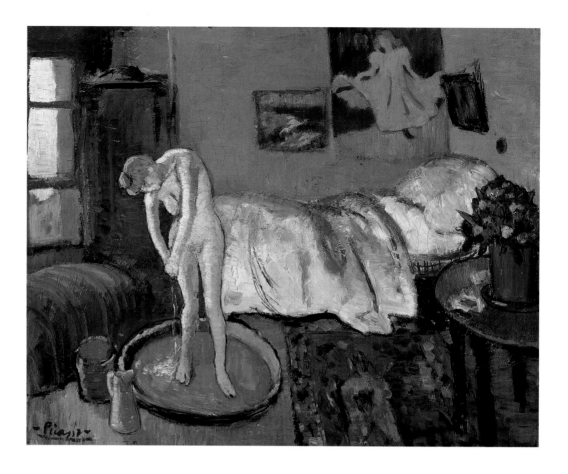

4. *The Tub (The Blue Room)*, 1901, oil on canvas. The Phillips Collection, Washington, DC

portrayed the studio as a social nexus. There he enthralled collectors, disputed with critics, negotiated with dealers, seduced lovers, and pondered art through the lens of the contemporary experiences that shaped his life, ranging from two World Wars and the Spanish Civil War to the succession of cultural movements that swept across the twentieth century.

Picasso's images span the gamut from relatively straightforward documents of a particular place to wholly fabricated situations. They extend far beyond the conventional format of a studio picture and assimilate almost every category of traditional subject matter. This transgression of boundaries is fundamental to most aspects of Picasso's art, but it particularly enriches his treatment of the artist's studio and expands the theme's potential to explore a diverse range of creative processes. It is not surprising that Picasso's self-portraits regularly portray him at work, or that some of his portraits and images of the nude are clearly set in a studio. References to artistic practice, however, permeate his art, cropping up in nearly every sort of subject and period. They populate still-lifes, shape interiors, and even animate landscapes, besides dominating a string of monumental paintings directly addressing the artist at work. Through this diversity, Picasso revealed the studio as the site of his most profound explorations of artistic meaning.

This expanded conception of the traditional studio subject is the basis for this catalogue and the exhibition it accompanies. The following essay focuses exclusively on Picasso's studio paintings and discusses contemporary culture only when

it appears strictly relevant to a particular work. I hope that this approach will highlight what I believe is the considerable integrity of these scattered pictures and their continuity across his career.

I

Picasso's first encounter with an artist's studio immersed him in academic tradition. His father, José Ruiz Blasco, was an artist and instructor at the art academy of Málaga (in the southern Spanish town where Picasso was born in 1881), and he encouraged his son to prowl his studio and to draw at an early age. Although premature by official standards, this choice to begin with pencils matched the procedures of a standard academic education. When he was old enough to enroll in an art school, Picasso initially attended the institute in La Coruña, in north west Spain, to which his father had transferred. He passed through the ritual of drawing from plaster casts of classical art, sketching the nude model, and then painting the figure – much as Matisse, Albert Marquet and Georges Rouault developed their skills in Gustave Moreau's atelier during the last decade of the nineteenth century. Picasso's *Academic Nude* (1895–97; Cat. 2) fits the conventional format of "academies," showing a nude man seated on a rough stool. His stance – one foot resting on a stone block and one hand holding a staff – identifies him as a professional model. If the tight frame and loosely brushed space of the composition do not portray a precise location, there is no doubt that he poses for the student, who is recording a stock character he might later transform by dress and a changed setting to inhabit some grand machine.[4]

The path from *Academic Nude* to *La Vie* (1903; Cat. 5) crosses the century line and charts Picasso's profound rejection of many aspects of his traditional training, as he nonetheless sought to project a modern version of the moralizing themes at the heart of academic doctrine. During his second trip to Paris, Picasso painted *The Tub (The Blue Room)* (1901; Fig. 4), a picture that addresses a precedent fundamentally different from the academy. The setting is not a teaching studio, but the very simple apartment in which he lived at 130 ter Boulevard de Clichy. He shared the place with Pedro Mañach, who had begun promoting his work the previous year. John Richardson has noted that, "The cosiness and neatness of the room and the inclusion of a vase of flowers – all very unlike Picasso – bespeaks the presence of a woman. And sure enough, there is a naked girl – Blanche..."[5] Yet, the painting is not simply a document of Picasso's domestic life. Unless a photograph or meticulous text is discovered, we will never even know whether it presents an accurate record.

The furnishings do, however, demonstrate Picasso's aesthetic ambitions, as well as the fact that he ate and slept where he painted. Images of young artists' garrets had been common for centuries, but Picasso presented one that evokes the art of the Impressionists and Post-Impressionists, artists who in the last decades of the nineteenth century had defined an alternative to the establishment. On the far wall, hangs a poster of May Milton by Toulouse-Lautrec (1895), framed by Picasso's own seascapes; the bather in a round tub is almost certainly based on Degas' images of women washing themselves in domestic interiors.[6] In parsing

5. Portrait of Matteu de Soto, 1901, oil on canvas. Oskar Reinhart Collection, Am Romerholz, Winterthur

this assemblage of references to recent artists, van Gogh's paintings are probably the most significant. They proved to be the greatest influence on the sixty-four paintings and drawings Picasso exhibited at Ambroise Vollard's gallery in June 1901, his debut exhibition in Paris and his first effort to establish a reputation in the artistic capital of Europe.[7] Van Gogh's vividly colored images of his austere room in Arles provide the most compelling precedent of an artist reflecting the arduous conditions of a life committed to the avant-garde. Rooted in a particular place and his very limited means, *The Tub* is Picasso's projection of his personal circumstances into the mainstream of modern art, a statement of artistic aspiration just as his art was moving into what would be called his "Blue Period."

Picasso's portraits and self-portraits describe his new community. Vollard was already famous for championing Cézanne and Gauguin; Picasso portrayed him among the paintings in his gallery in gratitude for having offered him the opportunity to join their ranks. The great importance Picasso placed on the exhibition is evinced by his willingness to paint two other principals in the enterprise: the critic Gustave Coquiot, who favorably reviewed it, and Mañach, who helped convince Vollard to give the fledgling a chance. All of these images

bear on Picasso's career as an artist, but they do not directly reflect the activities of the studio.[8]

The portrait of Matteu de Soto in the act of sculpting (1901; Fig. 5) shows one of Picasso's fellow Spaniards – most aspiring artists or writers – who formed his intimate circle during his first years in France. The self-portraits Picasso made that year follow a similar format and stem from his intensive preparation for Vollard's show. A caricatural sketch presents Picasso as a corduroy-clad bumpkin standing with easel, palette, and paint box in front of the Moulin Rouge.[9] Another incidental work, a photograph, suggests Picasso's desire to achieve the critical acclaim and wealth that would free him from these circumstances. This experiment in superimposition records a wall of Picasso's studio hung with his paintings, which he overlaid with a second exposure of himself decked out in a top hat and dark suit. The resulting grandiose self-image matches the portrait of Coquiot, whose formal dress confirms material success.[10]

At the upper left of the double-exposed photograph is the most famous of Picasso's early self-portraits, *Yo, Picasso* (1901; Fig. 6), which began with a drawing of the artist seated before his easel and looking up with brush poised to resume

6. *Yo, Picasso*, 1901, oil on canvas. Private Collection

7. Study for *Yo, Picasso*, 1901, pastel and charcoal on paper. Private Collection

work (Fig. 7). In the painting, Picasso retained little more than the upper left quadrant of the composition, deleting the easel and all other evidence of his profession. What remains is a close-up image of Picasso in a flowing white blouse and ample red cravat, a man whose stare conveys complete assurance. As the first painting listed in Vollard's catalogue, it no doubt received a place of prominence in the exhibition. In that setting, no explanation of Picasso's role was required or desired, since such details might dilute its pure expression of self-confidence. In developing the composition, Picasso had leaped the boundaries of the studio, projecting his artistic persona into the public space of the gallery and the art world that passed through it.

In the first years of the century, Picasso assumed many guises through his art, some more reflective of his real poverty than his desire for wealth, but all share an ambition to escape the literal by constructing a human drama. *La Vie* (1903; Cat. 5) is an early culmination of this trend and one of Picasso's most ambitious images of the studio. Although the final painting reveals no specific setting, preliminary studies for the composition show that it began as a fairly conventional depiction of an atelier (Cats. 6, 7). On the right, an elderly artist points to two nude models (a man and a woman) who stand on the left. At the center, a painting depicting the couple clearly rests on a large easel. Since *La Vie* is the subject of an essay by William Robinson in this catalogue (pp. 63–87), it need not be discussed at length here, yet the painting's transformation of a studio subject into a vague but deeply evocative allegory touching on sexuality and personal responsibility in the moralizing manner of an academic program is too important to leave unmentioned. It suggests a belief that the subject of the artist at work could carry meanings of relevance far beyond the confines of a studio, a conception that Picasso would explore throughout his career and find particularly significant as he planned the *Guernica* mural in 1937.

II

The first studio image of Picasso's artistic maturity is the *Self-Portrait with Palette* (1906; Cat. 8), a painting that marks the commencement of his engagement with a primitivism antithetical to the academic tradition, and his achievement of an aesthetic independence that would underpin his remarkable innovations during the following decade. Rather like *La Vie*, the self-portrait developed from explicitness to generality, but without any of the sentimentality that links the preceding painting with the nineteenth century more than the twentieth. Once again, preliminary studies show that Picasso considered a very different conception of the composition (Cat. 9). He drew a far slighter artist who is shown looking down as he touches brush to palette. The effect is intimate, as if the artist is caught unaware at a contemplative moment in the process of preparing his materials. The painting, however, shifts from introspection to public address. The artist looks up, although not directly at the viewer, and his massive torso and broadly chiseled head convey intense physical energy. This characterization is further enhanced by the wide-necked, collarless shirt, rolled-up sleeve and – most of all – the absence of a brush in his right fist. If Cézanne's *Self-Portrait with Palette* (1885–87)[11] probably lies behind the image, Picasso captures a rawness unknown in Cézanne's

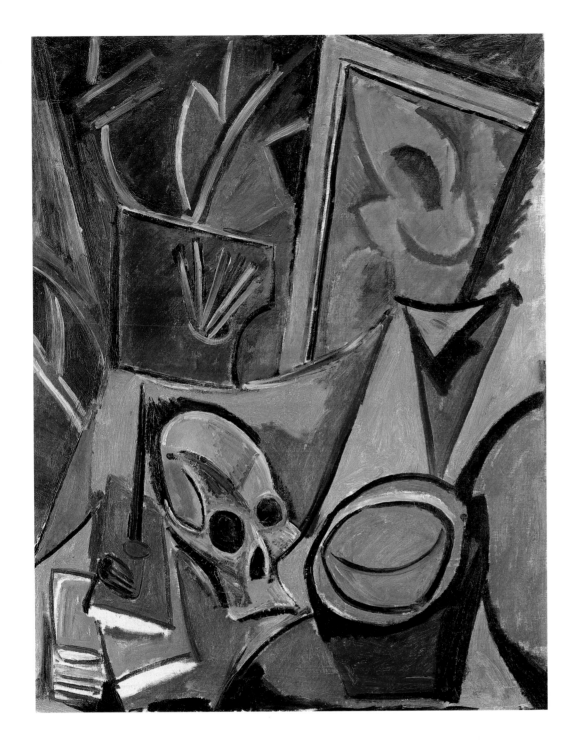

8. *Still-Life with Skull*, 1908, oil on canvas.
The State Hermitage Museum, St. Petersburg

mature work. He would largely maintain this conception of the artist through the
ground-breaking years of Cubism, from the strident *Self-Portrait* of 1907 through
the suite of photographs he took of himself in his studio during 1915–16, show-
ing the bare chest and legs of someone apparently devoted to culture of the phys-
ical sort.[12]

Given this approach, it is perhaps not surprising that Picasso made relatively
few studio images during the Cubist years. His next, *Still-Life with a Skull* (1908;
Fig. 8), emphasizes the harsh reality of life in his community. The skull surrounded

9. *Palette, Brushes, and Book by Victor Hugo,* 1911, oil on canvas. Collection Mr. and Mrs. James Alsdorf, Chicago

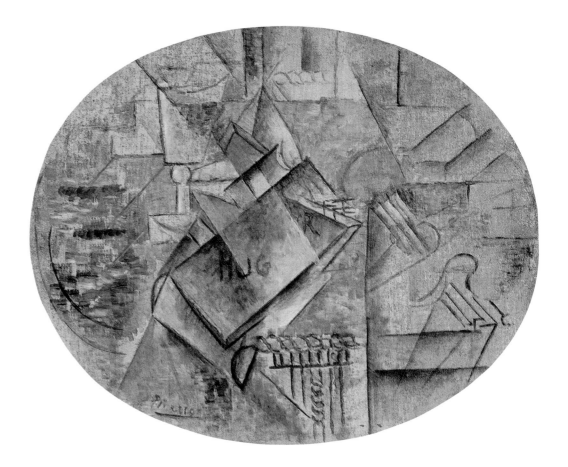

by acid reds probably commemorates the suicide of a German artist named Wieghels, who was addicted to opium and hung himself in the Bateau Lavoir.[13] But the background of studio effects, including a section resembling Picasso's contemporary *Three Women*,[14] situates this emblem of mortality in Picasso's own arena and restates with violent clarity the mingling of creativity and loss he had implied in *La Vie*.

Another still-life, *Palette, Brushes, and Book by Victor Hugo* (1911; Fig. 9) suggests that during the period of Cubist breakthroughs Picasso considered the theme of the studio retardataire, more tied to the past than to the present. In this Analytic Cubist composition of artists' materials grouped on a round table in the manner of Chardin, the most prominent object is a fat volume bearing Hugo's name in fractured, but legible, block letters. Presumably, Picasso invoked pictorial tradition to point out the contrast between his innovative style and an exhausted precedent, typified in literary terms by the popular sentimentality of Hugo's novels.

Nonetheless, the studio setting permeates Picasso's Cubist art. Perhaps more than any other phase of his career, these "laboratory" years produced an art that is steeped in the secluded space of an artist's workplace.[15] If Picasso did not often identify it and frequently seemed to place his still-lifes and figures in the interior of a café rather than his private quarters, he may well have found it liberating to shift the context from the confines of the rooms where he spent long hours in virtual isolation and with little hope of public appreciation of what he had achieved. Since our view of Picasso is largely shaped by his later fame, it is diffi-

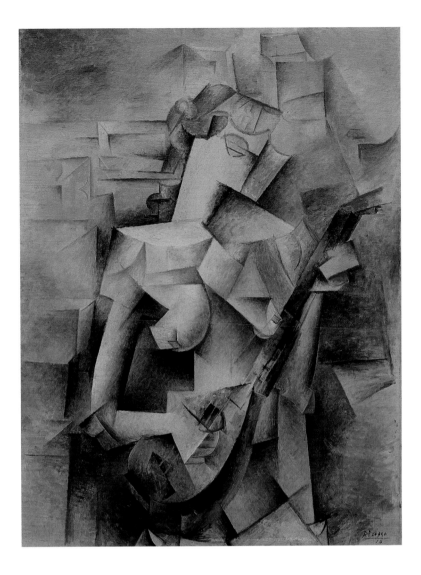

10. *Girl with a Mandolin (Fanny Tellier)*, late spring, 1910, oil on canvas. The Museum of Modern Art, New York. Nelson A. Rockefeller Bequest

cult to realize how small his audience was during the early years of Cubism. His decision not to submit works to the large juried exhibitions that launched the Fauves, among other contemporaries, effectively limited his exposure to one location, the little-known gallery of Daniel-Henry Kahnweiler. By 1910, Kahnweiler's intellectual commitment and steady purchases gave Picasso the security to pursue his art uninhibited by public attention; they signed a three-year contract in December 1912. Yet, Kahnweiler rarely organized shows of his artists' work, and he sold only a small number of the many canvases he bought, making it inevitable that neither artist nor dealer could expect widespread recognition in the near future.

Certain paintings do contain significant references to their place of production. Even though they were not painted from a posing model, several of the female nudes are clearly situated in a studio. The woman in *Girl with a Mandolin (Fanny Tellier)* (1910; Fig. 10), for example, is seen against background stacks of stretched canvases and frames. While Picasso may have found the right angles of these objects convenient foils for his reductive rendering of the figure, his choice of set-

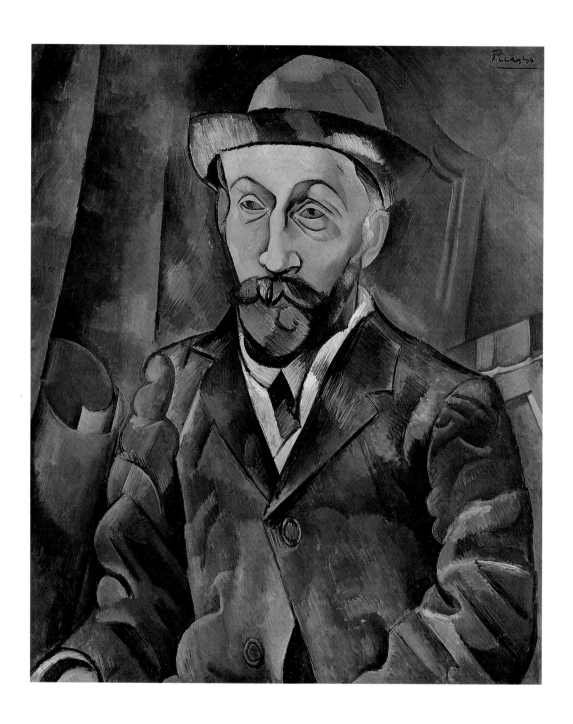

ting also makes it possible to see the composition as a radically reinvented "academie."[16] Again, Picasso may be invoking tradition to highlight his innovation, but with an awareness of his roots.

The most interesting set of Cubist paintings involving the studio are the portraits of dealers Picasso painted in 1909–10 – Clovis Sagot (Fig. 11), Wilhelm Uhde, Vollard, and Kahnweiler.[17] Since the vast majority of Picasso's portraits are devoted to women, his choice to make these images of men is exceptional, and even more unusual is his decision to portray these individuals rather than his close friends among poets and painters, such as Guillaume Apollinaire or Georges

Braque. In large part, the explanation probably lies in Picasso's ongoing search for a gallery to represent his work on a regular basis and provide a steady income. Although we know that some of the men sat for Picasso in his studio, Sagot, at least, also allowed Picasso to take a series of photographs.[18] None shows the pose of the painting, but all record the clothing Sagot wears there and the fact that he is seated before stacks of Picasso's recent work. Picasso was more selective in the paintings, and his references are more generic than in *Still-Life with Skull*, but the rolled sheets of paper and stretched canvases in the backgrounds of the portraits of Sagot and Uhde establish each man's presence in his studio. These objects were, after all, the subject of the courtship that took place between Picasso and the men, before he and Kahnweiler settled on an agreement that would last until the First World War intervened and be renewed decades later after the end of the Second.[19]

A still-life of 1912, *The Architect's Table* (Cat. 11) confirms that Picasso imagined a unity between events in the studio and those outside. Painted in at least two stages over the course of a year (spring 1911–12), the picture sums up the range of Picasso's concerns at the high point of Analytic Cubism. Although the composition is primarily a still life of mandolin, glasses and a bottle of marc, it includes the inscription "Ma Jolie" – Picasso's endearment for Eva Gouel – thereby encoding a reference to their passionate affair in a painting seemingly without personal content. The architect's ruler across the picture's center expands the references to include the visual arts, and a small object at the lower right mirrors the sly evocation of Gouel. This object, the most consistently rendered in the painting, is a calling card bearing the name Gertrude Stein, which Picasso apparently added after she left one of hers at his studio while he was absent. Its presence in the final painting became a solicitation to the woman who had been his most important patron but had recently drifted away. It proved successful; she made this her first purchase of one of his paintings since 1910. Picasso's slight addition seamlessly joined the privacy of his studio and personal life with his public audience and financial survival.[20]

Picasso's greatest Cubist painting on the theme of the studio, *Harlequin* (1915; Fig. 12), suggests a more profound bond between the creative life of the artist and events in the world. Dressed in commedia dell'arte costume, the figure holds a loosely brushed rectangle in his left hand – a palette – and stands before the wooden structure of an easel. This casting of harlequin as a painter is not surprising in light of Picasso's regular resort to the character as an alter ego in self-portraits. Except for the change of outfits, the composition is remarkably similar to the 1906 self-portrait, which also embodies considerable fabrication. The absence of any specific reference to Picasso, however, makes *Harlequin* a more fully symbolic image. When placed in the context of his contemporary life, the painting has been widely discussed as an allegory of loss, particularly commemorating the fatal illness of Gouel (who died in December 1915) and the deprivations of the First World War, which abruptly disbanded his circle of friends and caused the market for his work to collapse. The bleak mood would mirror the last time Picasso had portrayed himself in the multi-colored lozenges of harlequin (*At the Lapin Agile*, 1905),[21] itself a remembrance of the suicide of Carles Casagemas.[22] In

12. *Harlequin*, late 1915, oil on canvas. The Museum of Modern Art, New York. Acquired through the Lillie P. Bliss Bequest

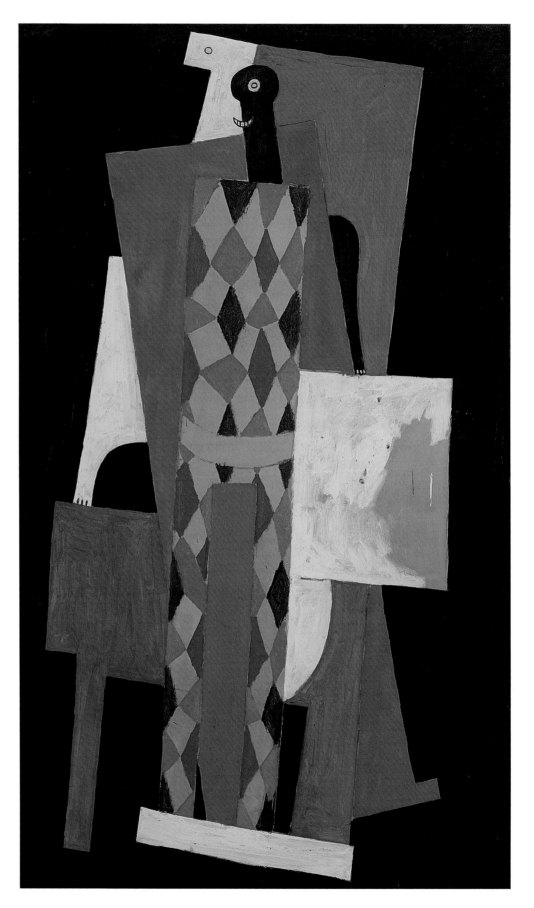

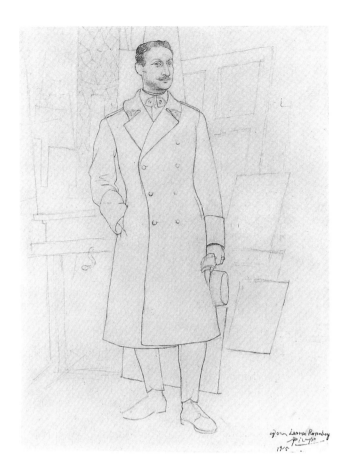

Harlequin, the skeletal head of the painter joins the mortuary-black background in defining a monumental image of a performer in adversity.[23]

Possibly at the same time as he was preparing *Harlequin*, Picasso drew four tiny but intricately structured studies of an artist's studio as well as one larger version (Cats. 12, 13). And only a month or two after he finished the painting, he recorded his studio in a formal portrait (Fig. 13). This finely detailed, full-length drawing shows the collector Léonce Rosenberg standing before an easel on which rests *Harlequin* – an arrangement that echoes the painting's composition down to the man's pose of right hand on hip and left extended down the side to hold an object (in this case, his hat). The conjunction of man and canvas is no coincidence since the portrait signals Rosenberg's purchase of the picture and his arrival as Picasso's most substantial buyer during the remainder of the war.

III

Although Picasso's involvement with the theme of the artist's studio began with his childhood training, it is far more a phenomenon of his work after the Cubist years. Beginning in 1914, he transformed his art to acknowledge explicitly the broad history of European art he had absorbed in his youth, and he started to forge a union between Cubism and tradition. In this rapprochement, the studio became one of his essential means of negotiation. Both the theme's long history and its focus on artistic process made the studio a prime site for drawing together

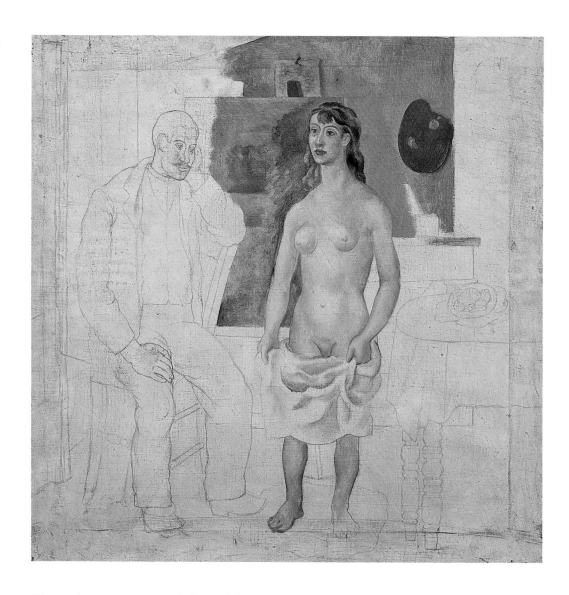

14. *The Artist and his Model*, summer 1914, oil and pencil on canvas. Musée Picasso, Paris

Picasso's current art and that of the past. Throughout the remainder of his career, Picasso would frequently invoke the studio as a passage from the present to the past, as he increasingly measured his achievements against those of previous artists.

An exceptional work, *The Artist and his Model* (Fig. 14) is in many ways the initial statement of this more ecumenical approach. Developed during the spring and summer of 1914, the painting apparently remained hidden among Picasso's possessions until its discovery during the inventory of his estate. It was a startling find because its classicizing style differs so substantially from the Synthetic Cubism that dominated Picasso's contemporary work. Had it become known at the time, this departure would almost certainly have appeared scandalous, even a repudiation of the avant-garde innovations of the previous decade. The fine, graphite line of the drawing, the irregular proportions of the figures, and the probably intentional state of unfinish all strongly recall the work of Ingres, a nineteenth-century master Picasso had long revered but not so openly emulated. The dress and pose of the seated man suggest Cézanne.[24] The scenario of the picture, however, recalls the center of Courbet's most famous painting, *The Studio* (1855), in the arrange-

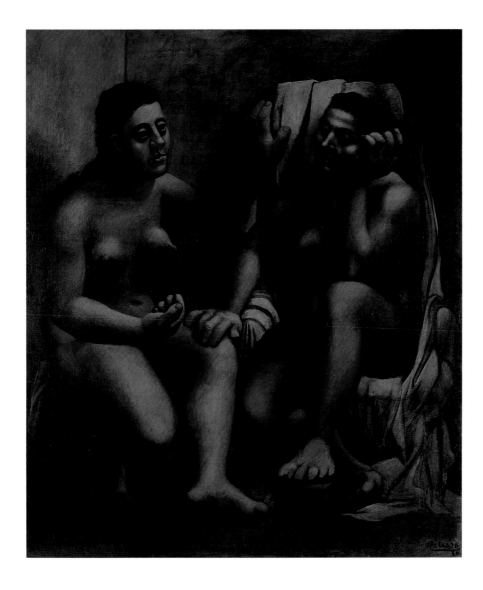

15. *Two Seated Female Nudes*, 1920, oil on canvas. Kunstsammlung Nordrhein-Westfalen, Düsseldorf

ment of the man (presumably an artist), the semi-nude model and, most particularly, in the fact that the painting in progress is a landscape rather than one based on the model. In the midst of Cubism, the painting is an extreme throwback as well as a leap forward; the composition seems to reflect both Picasso's fascination with past masters and an uncertainty about how to proceed that hold the fictive artist in contemplation, palette hung on the wall, and probably led the real painter to shield it from public scrutiny.[25]

Despite this reticence, classicizing styles would fundamentally inflect Picasso's art during the following decade, and the theme of the artist's studio would grow in prominence along with his appropriation of historical styles. The departure into Neoclassicism was not consistent, but by the early 1920s it had become the predominant mode of his art. Picasso's own studio became the subject of a painting, *Rue La Boétie – Figure in the Studio* (*c.* 1919; Cat. 14) which mixes Cubist and classicizing elements, as well as more strictly representational drawings of the room strewn with his works and materials (Cats. 15, 16). One painting, *Studies* (1920), presents a seemingly haphazard combination of sketches in a wide range

of styles, as if they were tacked to the studio wall (even though the conception probably stems from Renoir's technique of sketching unrelated subjects on a single canvas).[26]

Throughout the first half of the twenties, paintings of the nude model multiply. Except for the women's elephantine proportions in pictures such as *Two Seated Female Nudes* (1920; Fig. 15) and *Nude with Drapery* (1922; Cat. 17), these could almost be "academies," so strongly do they emulate the conventions of pose, drapery, and even the use of rough supportive blocks that appear in Picasso's student works.[27]

Among the established repertory of academic motifs, Picasso also resurrected the still-life of studio implements, making it a prime subject. In 1924–25, he created a large series of still-lifes that are noteworthy for their luxurious materials, vivid colors, and blend of Cubist structure with realistically rendered objects. Not only does the style reflect traditional precedents, but several of these still-lifes include painted versions of Roman portrait busts (*Bust and Palette*, 1925; Cat. 18) – the first substantial examples of classical art to appear in his work since the last years of the nineteenth century. Mixed with the palettes, brushes, and rulers common to an artist's studio, these ancient heads strongly recall traditional representations of the arts, particularly those by Chardin.[28]

The often sumptuous objects not only evoke the past but also match Picasso's post-war circumstances. In 1918, he had taken two steps toward conventional success: he married the Russian ballerina Olga Khokhlova, and he accepted Paul Rosenberg's offer to promote his art. As a prominent dealer in nineteenth-century art, Rosenberg (the brother of Léonce) regularly handled the work of Chardin, along with that of Courbet, the Impressionists, and Post-Impressionists, so Picasso had easy access to their paintings in the gallery, especially since it was next door to the building he and his wife occupied. Picasso's acceptance of Rosenberg as his dealer and his immersion in this worldly atmosphere are the social evidence of his new conception of the artist, one who rejects the bohemian life that had become stereotypical among the avant-garde, just as he bucked the trend toward puritanical definitions of modern art that grew in prominence during the war. Instead, he sought to refresh his work by expanding its sources. In aligning his approach more closely with tradition, the subject of the studio rose to prominence.[29]

La Statuaire is Picasso's most complex and seductive exploration of the apparent contradictions and potential resolutions between avant-garde and historical art (Fig. 16). Stemming from the Roman busts of contemporary still-lifes, this painting offers a polyvalent set of readings. The woman might be one of the models common to his studio pictures, except for the fact that she is clothed and her tan smock likely identifies her as a sculptor. This is Picasso's first depiction of a woman artist, a characterization that he would use regularly in the thirties and later.

Despite an initial appearance of almost overly refined elegance, the painting is composed of extreme contrasts. The stark white and coarse features of the bust oppose the delicate flesh of the figure, and the soft tones of the picture – tan, aqua, and gray – create a mellow effect in keeping with the sculptor's girlish

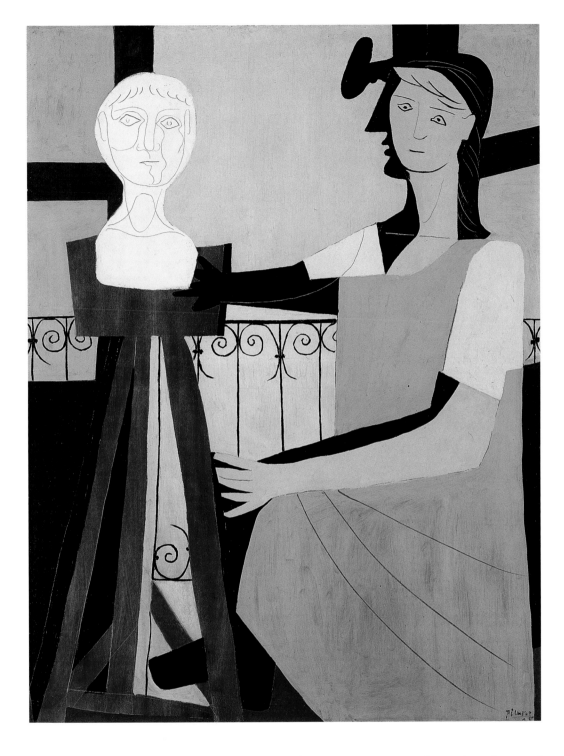

appearance. Yet the execution is far from harmonious. Large, irregular planes of color are juxtaposed with forms that are rounded in perspective and realistically detailed; smoothly applied layers of paint are sliced through with the blunt end of a brush. Indeed, the woman's graceful features are partially drawn in this crude technique. The result is a subversion of the initial impression, as the painting's foundation in both ancient and avant-garde forms is revealed and sealed in a union that preserves differences as well as synthesizes a new visual language.

17. *Paulo Drawing*, 1923, oil on canvas. Musée Picasso, Paris

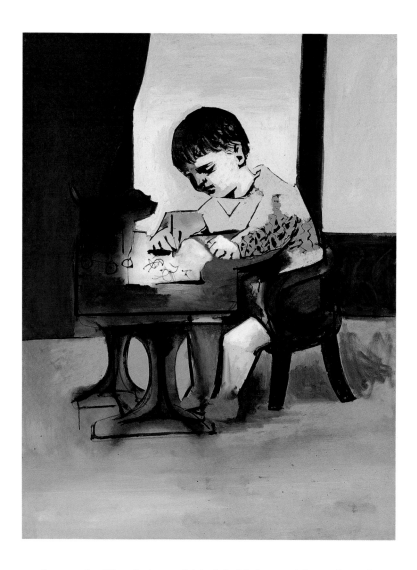

As a pair, *The Artist and his Model* (1914; Fig. 14) and *La Statuaire* bridge issues that had absorbed Picasso over the intervening decade. The represented medium has shifted to the age-old form of sculpture, and the genders of the participants are switched, but the scene is otherwise quite similar. An artist still sits contemplatively before the work. Now there is no intermediary between the artist and the art, as the sculptor reaches out to touch the bust and its support. Whether or not this sculpture is her creation or a study piece, the circuit of creativity is joined. Doubts about eclecticism, which must have plagued Picasso in 1914, are resolved in a masterly demonstration that in his work modernism and tradition cohere.

IV

During the late 1920s, Picasso became intensely involved with the artist's studio and produced a steady stream of masterpieces on the theme. He continued to use sculpture and still-life suggestively; yet, increasingly, he turned to the studio itself and images of an artist at work, approaches that he had largely avoided so far in his career but would use extensively from this time onward. This more explicit treatment moved beyond the resolution of apparently conflicting styles he had

achieved in the mid-twenties to address issues surrounding the imaginative process that always underlay Picasso's stylistic diversity and that rose to prominence with the establishment of Surrealism.

If *La Statuaire* can be interpreted as a highpoint of resolution, two other paintings introduce a new opposition, one that Picasso would explore extensively. Rather than addressing contrasting styles within visual art, he chose to reach beyond it to untrained, more spontaneous forms of expression, particularly the marks of children and styles self-consciously based upon them. Picasso's son, Paulo, may well have sparked the issue when he grew old enough to scrawl lines across papers in his father's studio, much as Picasso had done. Instead of disciplining his son, Picasso adapted the method. In 1923, he painted the two-year old drawing at a low table (Fig. 17). Although his formal dress implies the controlled behavior of a "young man," the scattered network of lines flowing from his concentrated effort appears entirely liberated from the toy resting on the tabletop (presumably the boy's model). The spirals do, however, bear a considerable resemblance to the nearly abstract sketches of guitars and figures to which Picasso would devote an entire sketchbook in 1924.[30] The following year, he again took up the subject of a child-artist in *The Drawing Lesson* (1925; Fig. 18), a painting

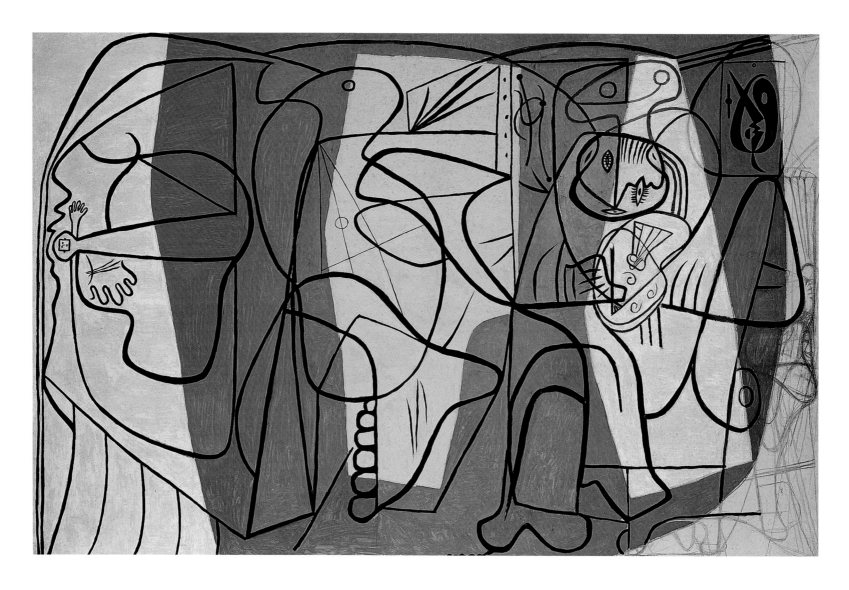

19. *The Artist and his Model*, 1926, oil on canvas. Musée Picasso, Paris

which shows another boy rendering objects before him (here, several fruits) in highly simplified, awkward strokes. As if to emphasize the child-like manner, Picasso included a classical bust of a young man immediately beside the boy; a sculpture the boy seems to ignore as he buries his face in his work.[31] In these pictures, Picasso created a new variation on the subject of the studio, one that opened the theme to the untutored and raw creative sources he would pursue during the following decade.

The next year, Picasso painted *The Artist and his Model* (1926; Fig. 19), a monumental image that would initiate a series of large-format canvases over the next four years. Instead of the amateurish efforts of a child, these return to the theme of the professional artist; yet they plumb the spirit of playfulness and spontaneity found in *Paulo Drawing* and *The Drawing Lesson* to portray artistic practice as a combination of forces beyond the boundaries of any of the traditions Picasso had so far addressed. This transformation moves from the benign pleasures of children's games through the Surrealists' obsession with irrationality. The paintings constitute some of Picasso's most profound meditations on creativity.

20. *The Artist and his Model*, 1927, oil on canvas. Museum of Contemporary Art, Teheran

The Artist and his Model adopts a common method of illustrating the process of perspective in order to subvert the rationality of a structure central to western art since the Renaissance. As shown in a famous print by Dürer, an artist sits directly opposite a model, who reclines with her feet nearest to the draftsman. Model and artist are separated by a gridded frame, which supplies a fixed reference to transfer the model, cell by cell, to a sheet of paper or canvas that has been divided in the same manner. Because the model's elongated pose places her feet almost under the artist's nose and her head far away from him, the arrangement produces an image of deeply plunging perspective in which the feet dominate, one that seems to turn proportion on its head. Picasso exaggerated this effect and spread its confusion throughout the composition with a morass of twisting lines that suggests a rectilinear grid gone mad. The absence of modeling, near-monochrome color-scheme, and the large blocks of gray, white or beige that are overlaid without apparent relationship to the scene enhance the effect of pictorial means unhinged from representation, as if the intense concentration had burst the limits of traditional pictorial practice and opened the way to more liberated forms.

By sheer size alone, Picasso signaled a new conception. The chaotic effect of *The Artist and his Model* is enhanced by its huge dimensions (only slightly smaller than Picasso's largest painting to date, *Les Demoiselles d'Avignon*).[32] And the version he painted the following year (Fig. 20) also approaches the size, as well as the roughly square format, of his most revered masterpiece. These similarities are probably not coincidental, since the new paintings return to the well of horrific

emotions that had driven what Picasso later called his first "exorcism picture."[33] Despite its imposing size, *The Artist and his Model* (1927) is almost unknown to scholars because it has rarely been exhibited or even reproduced in color and has been secluded in the collection of the Teheran Museum of Contemporary Art for more than two decades. Seen obscurely through patterned overlays, the painter is reduced to a narrow framework of thick lines, while the voluminous model fills two-thirds of the canvas. The extreme distortions of her body are not generated by tricks of perspective but by the eroticism of her pose. Picasso turned the conventional gesture of head thrown back with one hand behind to expose the throat and breasts into a scatter of nostrils, eyes, and nipples even more contorted than the monsters in the *Demoiselles*. Similar to his contemporaneous designs for grotesquely distorted nudes as public monuments along the Croisette at Cannes,[34] this figure presents an extreme of physical abandon and, here, contrasts to the stick-figure austerity of the artist who seems almost to blend into the woodwork of the painting chamber. Although a product of the artist's imagination, this fantastic woman overwhelms the painter and dominates the spiraling, ambiguous space. As model or muse, she represents violent creative forces beyond the artist's control.

Since at least 1924, when André Breton arranged for his patron, the couturier Jacques Doucet, to purchase *Les Demoiselles d'Avignon* directly from Picasso, the artist had been friendly with the leaders of Surrealism and deeply interested in their probing of unconscious, irrational thought. During the late twenties and early thirties, Surrealism very likely underlay the significant change in Picasso's studio images in particular, as they shifted from creating aesthetic continuity to exploring rupture, a conception of creativity in character with the Surrealists' "convulsive beauty."[35] Several of these paintings were first published in *Documents*, a magazine whose editors remained independent of Breton's control but shared the fundamental goals of the Surrealists. And in 1933, Breton published an essay in the first issue of *Minotaure* (Picasso provided a collage of the beast for the cover) that serves as a guide to the artist's involvement with the studio during the previous eight years. Entitled, "Picasso dans son élément," the text is accompanied by sixty photographs by Brassaï, many showing Picasso's most personal environment – his studio. Complementing Breton's interpretation of Picasso's work place as a creation in itself, a private world of his imagination uninhibited by outside convention, the photographs document the remarkable assemblage of objects that filled the rooms (as had always been Picasso's custom), ranging from Oceanic figures and African masks to examples of his work from all periods and media and – scattered everywhere – the tools of his profession: brushes, tubes of paint, rags and bottles of turpentine.[36]

Later, Picasso would revert to his early practice of painting images of his studio that approach documentation, but in these years he largely ignored its actual appearance, choosing instead to define the site in deeply imaginative terms. *The Studio* (1927–28; Cat. 19) is Picasso's most elemental treatment and his most extreme statement of the room as a creative space removed from the everyday things that so often stimulated his art. As his closest approach to abstraction, it verges on a form of creative liberation that fascinated his contemporaries, such as

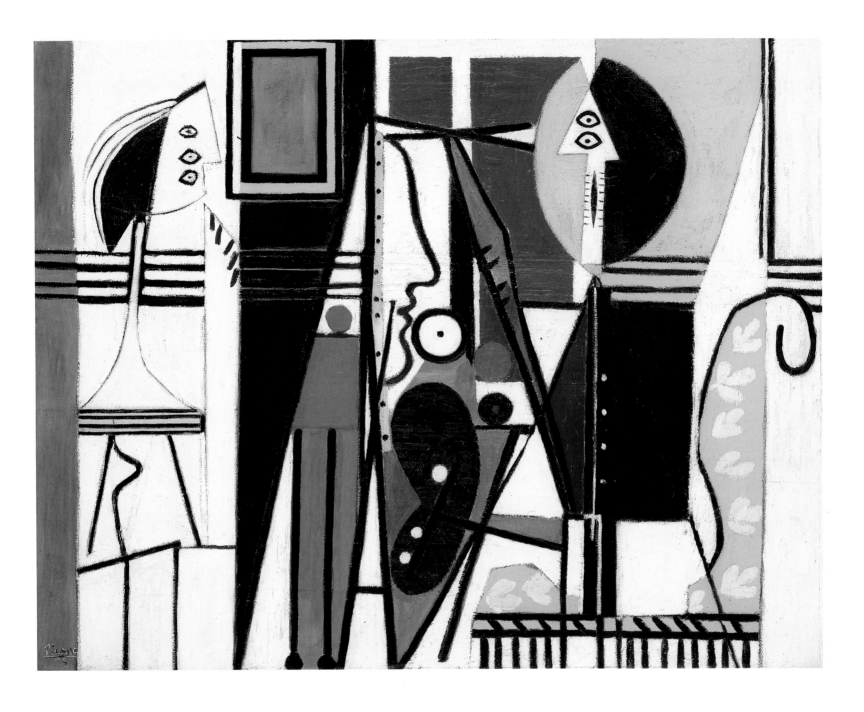

Mondrian, but which Picasso never fully accepted as an alternative to an art based on reality, in all its diversity. The model is reduced to a bust on a table (reminiscent of the mid-twenties still-lifes), and the linear framework of the artist is multiplied to structure the whole pictorial space through a series of rectangles and blocks of color. The result is an ethereal frame similar to Picasso's contemporaneous wire sculptures – constructions that inspired Breton (when he saw them in the rue La Boétie studio) to equate the airy interiors of their open volumes with the intangible spirit of creativity. This interpretation applies equally to the environment of *The Studio* and may well have come from Picasso himself, since the sculptures were maquettes for a monument to his close friend Guillaume

21. *Painter and Model*, 1928, oil on canvas. The Museum of Modern Art, New York, The Sidney and Harriet Janis Collection

Apollinaire (who had died in 1918) and drew on Apollinaire's own conception of a monument, "out of nothing – like poetry and glory."[37]

Almost immediately, Picasso reversed this sentient simplicity to create one of his most visually and thematically complex paintings on the theme, *Painter and Model* (1928; Fig. 21).[38] This picture is unique among Picasso's studio images and very rare in his complete oeuvre, because it is accompanied by two unfinished paintings that probably served as studies. Given the transformation from *The Studio* to *Painter and Model*, however, their presence is not so surprising. The smallest, *The Painter in his Studio* (c. 1928; Cat. 20) is a rendering of the full composition; it retains the internal divisions of *The Studio* and on the left side a linear structure reminiscent of it, but is otherwise quite dissimilar. The positions of artist and model are reversed (the artist is on the right), and the painter is endowed with a shield-like head, as well as the identifying brushes and palette that Picasso almost entirely excluded from the previous image. The second sketch is more than twice the size of the first and rehearses the figure of the artist alone at the full dimensions of the final canvas (Cat. 21). It largely reproduces the figure in *The Painter in his Studio* but articulates his head as two overlapping profiles, a Janus-like configuration that would appear in *Painter and Model*, minus some details and with the addition of a vertical mouth bordered by short bristles.

The preliminary canvases do not hint at Picasso's new conception of the model or the painting on the easel, both of which would create a complex counterpoint with the image of the artist. For the model, on the left side of *Painter and Model*, he returned to *The Studio* and appropriated the artist's vertical stack of three eyes, an augmentation that seems to make her more than a mere subject. The composition is densely filled with stuffs, such as the fringe and leafy pattern on the painter's upholstered chair, which anchor its fantastic imagery in mundane things.

Standing between the artist and model, the radically transformed painting-in-progress offers a key to the conception. In contrast to the large yellow rectangle framing the painter in *The Studio* like a doorway, this canvas is heavily worked. The painter is just completing the thick outline of a classically rounded profile. Compared to the highly stylized angularity of the painter and model, it appears to be the only realistic figure. Moreover, we now know that the profile is not generic; it derives from Picasso's own, which he had photographed in the late twenties and used in several paintings.[39]

The result is a confounding image that reverses the conventional order of creation. Instead of using the scene of an artist seated in his work place to frame the invention on the canvas, this picture initially creates an impression of the canvas as an anchor in a surreal environment. Of course, we acknowledge the entire image as Picasso's creation; his work of the previous fifteen years had amply demonstrated the artifice of all pictorial modes. The profile's reality dissolves as yet another device, a classicizing figure projected from the mind of the "primitive" artist, although one that recalls the painter himself, Picasso. In this perpetual tumble, artist and artwork change creative places, and the question arises whether Picasso may himself be an invention of creative forces he channels but does not fully control. More than any of his paintings, *Painter and Model* both displays Picasso's polymorphous imagination and casts doubt on the assumption that

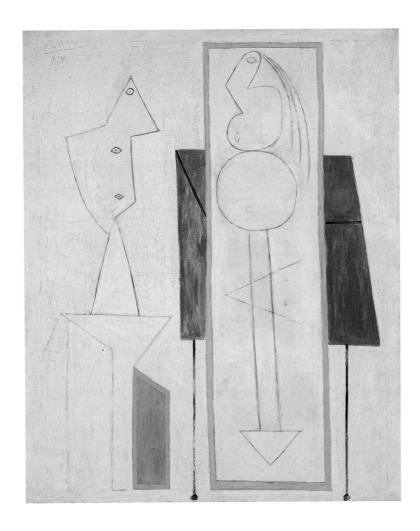

22. *The Studio*, 1928, oil and crayon on canvas. Peggy Guggenheim Collection, Venice

Picasso's art, no matter the artistic guise, is a sole reflection of his genius.

The Studio (1928; Fig 22) in the Peggy Guggenheim Collection offers a radically reduced image swept clean of the previous paintings' complex forms and hues to leave a face-off between a sculptural bust (similar to the one in *The Studio*, 1927–28) and a framed image of a figure propped against a table, both imbedded in a field of white from which they emerge as black outlines surrounded by accents of intense color. Recent technical analysis reveals that Picasso arrived at this austere solution after heavy repainting.[40]

Although simplified to the point of near illegibility, the full-length figure appears to derive from the painter in the 1927–28 *Studio*. In the Guggenheim picture, the figure is fully contained within the framed rectangle and defined as a painted (or possibly reflected) image by leaning the gold-edged enclosure against a red-topped table. Endowed with a penis and testicles, this ideogram is male; moreover, his curling forelock probably identifies him as Picasso.[41] If so, both the artist and true author are embodied in a finished artwork that stands in conversation with another; yet the painter is locked within the framed canvas. Despite their visual disparity, the Guggenheim *Studio* continues the examination of the artist's ambiguous role first seen in *Painter and Model*.

The final painting in this series, *The Studio* (1928–29; Cat. 22), makes the male profile an explicit symbol of uncertainty. The composition is closest to the strict linear divisions of the earlier *Studio* (1927–28; Cat. 19) but is condensed to a narrower format. Again, a stick-figure artist stands on the left before a canvas, and a still-life of fruit bowl and bust rest on a table. This time, however, the bust is a grotesque, screaming head of a woman, and the right side of the composition is filled with a silhouette that matches the profile in *Painter and Model* – a dark, monumental presence that overlaps the edge of the canvas. While the initial contrast is between the twisted bust and the Grecian head, it soon emerges that the woman's head is tightly framed, even caged, between the almost invisible artist it faces and the looming shadow behind.

This contorted woman probably injects another level of biographical reference. Similar figures appear in several contemporary paintings and sculptures as well as drawings; they are generally thought to allude to Picasso's wife, Olga, who is said to have raged at him in his studio as their marriage fell apart.[42] In this case, however, Picasso kept her ferocity distant from him, confined in an artwork. Although *The Studio* first appears to present a half-lit, empty space, it is filled with shadowy presences, most particularly that of Picasso, who dominates the image without actually being present.

In this series of five great compositions, Picasso moved through creative conflicts that seemed to overwhelm his individuality only to arrive at a personal, domestic struggle that challenged his ability to work. No other group of his studio paintings addresses so wide a range of issues or implies so fully the complexity of Picasso's role as artist.

After these very challenging works, *The Sculptor* (December 7, 1931; Cat. 24) sets a tone of calm, perhaps joyous, resolution. In both mood and composition, it revisits *La Statuaire*, and, like the earlier picture, its elegantly drawn figures mask startling stylistic leaps. With genders reversed, a male artist, on the right, sits in contemplation of a female bust, on the left. Both the artist in *La Statuaire* and the bust in *The Sculptor* bear the features of Picasso's mistress Marie-Thérèse Walter, who had entered his life in the mid-twenties, and the close-cropped hair of the Roman bust in the earlier picture has been carried over to the latter. Each artist is double-sighted; each examines the sculpture and also looks outward as if lost in thought. In both cases, this pacific mood is undercut by the diversity of renderings Picasso used to construct the pictures. He again blended elements of classicism and abstraction without visual contradiction, but he pressed the balance further. From head to toe, the sculptor dematerializes. His white head is modeled by shadow and stippled strokes to evoke volume, yet his torso dissolves in a swirl of bright colors and confetti dots that pass into flat ribbons of lavender, green and yellow, whose undulating outlines barely describe legs and feet. The figure, and the entire composition, are held together by the curvilinear pattern of the picture and the brilliant hues scattered across the surface, except for the artist's darkened, frontal glance and the end of his bench (which is spattered with black, gray, and white in a manner anticipating Jackson Pollock's technique). In 1925, Picasso was only just beginning to consider the possibility of once again making sculpture in the round; by 1931 he was deeply engaged in reshaping classical prototypes into

a series of highly sexualized, monumental heads portraying Walter. While *The Sculptor* marks this achievement, its linear structure and kaleidoscopic colors celebrate, above all, the power of painting.

A still-life of 1932, *Bust, Bowl and Palette*, continues this dialogue (Cat. 25). Another bust of Walter rests on a table next to a bowl of fruit. Completing a triad across the canvas, a palette hangs on the wall and seems just to touch the fruit. In this rendering, however, the strongest relationship is between the bust and the palette, since the thick, bulbous outlines and roughly blocked interiors of each object describe similar shapes despite their different sizes.[43]

During the early thirties Picasso enjoyed a rare period when he was equally productive as a painter and a sculptor, and his exploration of the two media spilled over into other forms, particularly printmaking. Made chiefly from March 1933 through December 1934, the one hundred prints that have come to be known as the "Vollard Suite" contain more than three dozen images of sculptors in their studios, but only one that addresses painting (no. 18). Since the exhibition, which this catalogue accompanies, is primarily devoted to Picasso's paintings, the prints of the Vollard Suite will be discussed only in relation to these. The sculptor's studio suite (dated March through May, 1933) has been studied extensively by other authors and certainly offers a wide variety of perspectives on the relationship of sculptor, model, and sculpture, all within the Neoclassical modes that Picasso had explored intensively during the previous decade.[44]

When he finally put down the engraver's stylus to pick up a brush, Picasso made an image of a painter at work that includes no reference to his recent absorption with sculpture, yet retains attributes of the preceding prints. Unlike the highly reductive *Painter and Model* (1928), the *Studio* (1934; Cat. 26) is immediately accessible. As in several of the Vollard prints, the physical proximity of artist and model, touching arm to leg, suggests that her swoon may be sexual in nature; the dais on which she reclines and her broadly bordered wrap, which leaves her so exposed, recalls the vaguely classicizing furnishings and clothing in the Suite. If the model is defined by her sensual abundance, however, the artist seems to be absorbed into his materials, his body blended into the background and his multi-hued face barely distinguishable from the palette he holds just below.

The most significant element is once again the painting on the easel, which overturns expectations by depicting a flowering vine instead of the model. In the early thirties, Picasso extended his fascination with elemental creativity to imagine a more pacific form of the raw drives he had explored in the late twenties. Similarities between the nubile bodies of young women and blossoming plants broached an idea of a fundamental unity of nature, a belief that the Surrealists, in particular, prized as a force freeing humanity from the constraints of organized society. Picasso's portraits of Walter are filled with such analogies, but the female model offered the greatest possibility for feeding this liberating notion into explorations of the creative process.[45] In the *Studio*, Picasso provided a clue to the transformation by having the model hold a blossom in her left hand, but the real source of the comparison lies in the sinuousness of her reclining form. Only by immersing himself in painting, literally effacing himself, does the artist arrive at this perception of a profound linkage.

The Painter (Cat. 27) is Picasso's most complex examination of this arcadian hope, a conception that fluidly envelops a multi-layered logic. In a tight space, the model poses next to the artist, yet the two seem strictly separate. Stripped of her robe, the entirely nude model again seems to sleep, her head falling back limply. Her undulating, tendril-like limbs fill three-quarters of the composition and out-perform the rather wan stems in a vase on a windowsill. Blended with the lavender of slumber, her greenish coloring links her with the spring hues seen through a window, whose pane is inscribed to identify that the painting was made at Picasso's country house, Boisgeloup, on May 13, 1934. The relationship implied between the model and still-life in the *Studio* is here incorporated into a broader natural order, quite in contrast to the artist and his work. Despite their proximity, painter and model could not be more different. The heavily outlined, solid blue rectangle of the canvas marks a division that is continued by the equally strong outlines and yellow color of the artist. In contrast to the model's vegetal sensuality, the painter radiates clarity and rigor. Although nearly cropped from the composition, his blocks of primary color overwhelm the tertiary tones of the woman, just as he – as artist – controls the work.

No other painting of the studio by Picasso so directly implies an essential difference between the rationality of the artist and the instinctual nature of the subject. Yet, even here, the apparent dichotomy is resolved by the full composition, as the painter's cuff-linked wrist and undulating profile join the flowing body of the reclining nude to unify the design and suggest that a successful work of art must combine both forms of imagination. In this sense, *The Painter* serves as a resolution of the complex, often conflicting sources of inspiration Picasso had explored during the previous two decades, ranging from the multiple forms of classicism to Surrealism's obsession with the unconscious. Characteristically, Picasso moved from the mainstream to the obscure tributaries of these supposedly opposing philosophies, finding unexpected common ground without seeking an enduring culmination.

V

During the late thirties and early forties, Picasso's involvement with the theme of the studio expanded beyond the creative debates that had absorbed him to embrace the exceptional political events of the time. A few of his earlier pictures, such as *Still-Life with Skull* (1908; Fig. 8) and *Harlequin* (1915; Fig. 12), had contained references to occurrences outside his activities, but all had rested on their immediate impact on his life, even during World War I. The outbreak of the Spanish Civil War in 1936, however, shattered this detachment. His exploration of aesthetic and psychological violence during the previous decade had prepared Picasso to respond to the destruction that swept across Europe with the ascendance of fascist movements. The battles strongly influenced his art and enlarged his conception of the studio theme, making it, at least initially, his chosen subject for the *Guernica* mural.

The change can be measured by comparing *Young Woman Drawing* (1935; Fig. 23) with *The Artist Before his Canvas* (1938; Fig. 24). *Young Woman Drawing* revisits

the oppositions in *The Painter* only to overturn them. In this conception (and a related one, *Interior with a Girl Drawing*, February 12, 1935),[46] the artist is a woman as beautiful as any model, and she is accompanied by another youthful woman who leans on a table, either napping or watching the artist sketch in an album. Her subject is apparently a vase of flowers, which stands next to the seated woman and reflects darkly in a mirror resting on the floor. Not only is the relationship of floral still-life and female figure recalled; but the fact that the artist is nude as she draws unites the sensual and cerebral, which Picasso had previously shown as isolated presences.

In *The Artist Before his Canvas*, the painter works alone. The erect pose of the artist – shown in silhouette with painting arm rising stiffly from the torso while the other holds a palette – resurrects the rod-like structure of the painter in *Painter and Model* (1928), but fleshes out the figure to resemble Picasso. Among his paintings, this is Picasso's only clearly recognizable self-portrait as an artist since the *Self-Portrait with a Palette* of 1906. *Artist Before his Canvas* seems to reach back to it for the heavily outlined, ovoid eyes of the painter, his robust proportions and T-shirt (now stripped), even though his furrowed brow suggests the thirty-two years that had passed. Equally monumental, the painter now holds a brush and raises it

to begin a fresh canvas. Nonetheless, both of his eyes (shifted to the visible side of the strict profile) look out at the viewer with only the more distant one partially facing the canvas. More than any other time in his life, the war years were a period when Picasso's work in the studio was deeply shadowed by events outside.

On April 18, 1937, Picasso drew a dozen sketches for the mural that he had agreed to make for the Spanish Pavilion at the Paris World's Fair, scheduled to open in June. Although the bombing of Guernica eight days later would cause him to alter radically his conception, these sketches are apparently his first attempts to rough out a design. All depict an artist's studio without any overt reference to politics. However unusual this initial conception may be, Picasso must have imagined that it had the potential to convey the moral outrage that was required of a huge, public work in support of the Republican fight against the military coup lead by Francisco Franco. Near the center of the composition, an artist sits, palette in hand, and reaches forward to touch a brush to a canvas standing on an easel at the far left. Behind the painter, a nude woman reclines on a couch. Since the painter is also a nude woman, the overlapping bodies of artist and model are visually intertwined (Cats. 28–31).[47]

So far, the design is patterned on *Young Woman Drawing*, but Picasso's initial sketches for the mural contained new elements, which passed into the final work and contribute to its denunciation of violence. In each of the drawings almost the entire right half is taken up with a large horizontal window that would, presumably, afford a panoramic view from the studio. Yet in every study, the painter turns her back on this opening and focuses full attention on model and canvas. The features of the model are far from the languid sensuality of earlier images. In a detailed study (no. 6; Cat. 30), Picasso showed the woman's contorted body, her neck stretched to the point of snapping, limbs twisted in knots, fingers disjointed, nipples erect, and eyes and mouth thrown open with tongue protruding. These are features Picasso used for the sufferers in the final mural, and they show that the initial design was not an image of art as a tranquil sanctuary from war. While physically isolated and turned away from the exterior, the artist is nonetheless paired with a nude whose battered body could represent the plight of Spain – a tortured *Maja*, in the tradition of Goya's masterpiece.

The destruction of Guernica would fire Picasso's imagination and force the scene outdoors, yet essential features of the earlier design remained – not only the wrecked figure but also the tripartite design, central triangle, and electric floodlights, which illuminated the original studio interior and whose presence in the final mural has led critics to wonder whether it might be set indoors.

Moreover, Picasso did not put aside the studio as an emblem of artistic engagement. In November and December 1938, he created a series of five paintings that integrate the threatening bull of *Guernica* with the theme of the artist's studio. Like the paintings of 1925, these are still-lifes that include a palette, brushes and a bust. While the earlier paintings suavely resolve aesthetic questions, however, those of 1938 marshal art as a symbolic weapon against brutality and chart a fluctuating, sometimes hopeless, course of conflict.[48]

The first four of these still-lifes were painted in November and contain four primary groups of objects arranged in the same sequence (left to right): a burn-

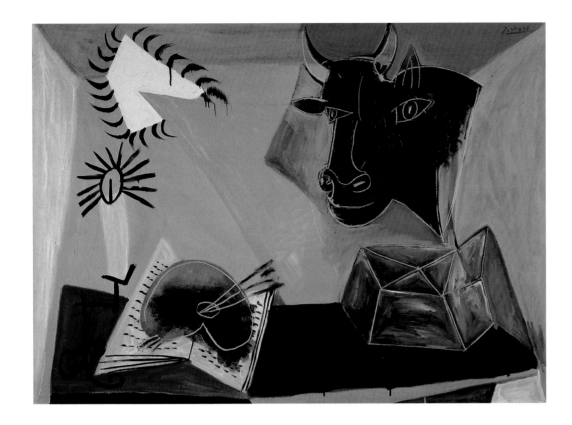

25. *Still Life with Candle, Palette and Black Bull's Head*, November 19, 1938, oil on canvas. Menard Art Museum, Aichi, Japan

ing candle on a simple stand, a palette and brushes, resting on an open book, and the head of a bull or minotaur on top of a block. The first (November 4; Cat. 32) is the most intense. Highlighted by a red triangle, the blazing candle illuminates the book, palette and brushes and pierces the darkness of the bust, a multi-profiled image of a minotaur. Tonal contrast combines with traditional symbols to create an opposition between the luminous field of painting and literature and the somber space of the beast. Over the years, Picasso's characterization of the minotaur passed through many aspects, showing the creature as both a threatening force and a pathetic presence. Yet, the sharply pointed, shadowy form of this bullish man approaches the creature of *Guernica* too closely to stand as anything other than a symbol of violence.

Only the initial version confines the visual combat within the arts themselves, making it a clash between the tools of painters and writers, with their potential for enlightened expression, and an ominous final work, the sculpture. Drawing on additional features of the mural, the second painting in the series (November 19; Fig. 25) moderates this central confrontation and shifts its frame of reference beyond the studio, with its array of utensils and art works. Here, a realistic head of a bull floats in the place of the minotaur's bust; it resembles the detached, white one of *Guernica*. A new light source, similar to the electric bulb in the mural, shines a ray toward the bull's black head and supplies the primary contrast within the composition. The opposition between art and beast, however, is defused. In this more evenly lit space, the candle barely glows, the palette and brushes lack

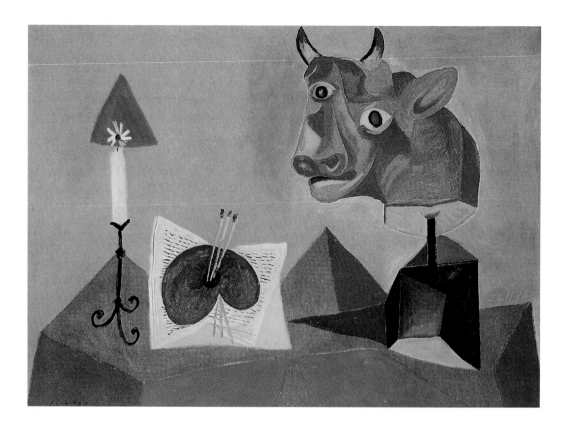

26. *Still Life with Red Bull's Head*, November 26, 1938, oil on canvas. Private Collection

the bright hues and detailed rendering of their predecessor, and the text fades into the background.

One week later, Picasso created a third variation, a subtle but significant modification of the second (Fig. 26). The bull's head remains, but is colored the bloody red of flayed flesh and displayed on a rod as if planted on a spike. With the disappearance of the ceiling light, the candle blazes more prominently, and the pages, palette and brushes brighten as well. In spite of the gruesome head and anemic tools, this conception's minty tonality, unmodulated background, and steady light create a rather pacific mood, perhaps a suggestion that the beast has been tamed. If so, Picasso did not stop at this resolution. The next day he painted a fourth canvas in the series, one in which he reshaped the flayed head into a minotaur's, increased the size and visual weight of the book and palette, and added a new element: an empty frame hanging from a nail in the back wall (Cat. 33). Presumably the enclosure of a painting, this relatively small and casually suspended object is blank compared to the shining light that occupied that approximate location in the still-life with a black bull's head. Moreover, the minotaur is far less threatening than its predecessors. While orange, its flesh is not streaked with garish pinks, and its face is both more human and more calm than the image in the inaugural painting. For the first time, the threatening opposition between art and bestiality that lies at the center of this series has metamorphosed into co-existence, or even equivalence.

The final picture strips the theme bare. Painted in thin washes of grisaille two weeks after *Still Life with Candle, Palette, and Red Head of Minotaur* (Cat. 33), it

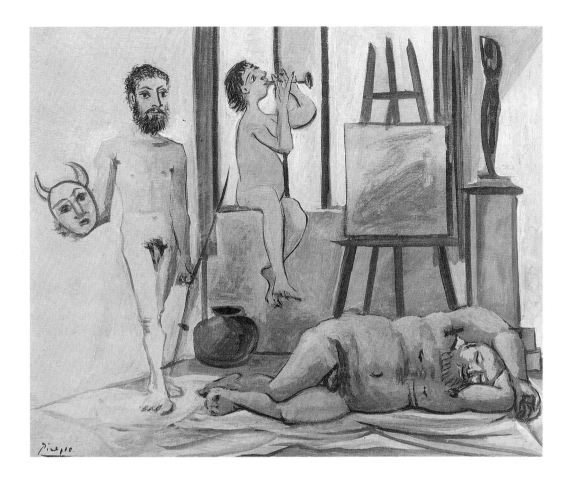

27. *The Three Ages of Man*, November 1942, oil on wood. Collection unknown

shows only the barest outlines of an interior with a bull's head, palette, and brushes resting on a cloth-covered table (Cat. 34). Having banished the candle and other secondary objects, Picasso sharpened the basic opposition and rendered it in the most elemental form he knew. In this image, in which the pigment barely stains the canvas, the artist's tools are overwhelmed by the large, screaming head.

In the midst of the Nazi occupation of Paris, Picasso again used the minotaur's hybrid head to ponder the multiple roles of art. Called *The Three Ages of Man* (November 1942; Fig. 27), the painting inverts the classical theme in the course of constructing an allegory of the studio. Unlike traditional treatments of the three ages, the most famous being Titian's (*c.* 1515, National Gallery of Scotland, Edinburgh), Picasso arranged his triad to emphasize the later stages of life. The foreground is devoted to an elderly, fat man who sprawls naked on the floor, followed by the standing figure of young manhood, and a child sitting on a windowsill in the background. Instead of the common landscape setting to evoke a cycle of nature, Picasso located his scene in an artist's spare workroom. The corpulent man is a striking contrast with the youthful women who generally recline before Picasso's artists, although the boy might have stepped from one of his recent works. As a rendering of three phases of life, Picasso drew primary attention to the middle figure. Unlike the boy who gazes out of the window as he pipes and the older man who dozes, the young man looks directly at the viewer.

He stands in the midground alongside a painting and a sculpture; presumably, he is an artist, even though he is nude and does not hold a brush or palette.

What he does hold, however, is crucial. In his left hand is a staff, which could be a painter's mahlstick or might be a short lance. In his right is the mask of a minotaur. It resembles the more human rendering in the still life with a red minotaur and closely recalls a similar scenario Picasso had drawn in April 1936.[49] In that sketch, a young woman raises a baby toward a bearded man, who leans away from the couple and loosely grasps the mask instead of extending his arm to return the child's embrace. Drawn six months after Marie-Thérèse Walter gave birth to their daughter, Maia, the image probably registers Picasso's unwillingness to put aside his independence and join his mistress (whose features are transposed to the drawn mother) in domestic life. In *The Three Ages of Man*, the ambivalence is professional. The man holds the mask more actively – raised in his right hand – as if he might be in the process of covering or uncovering. As he stands, daintily posed with one foot behind the other, his slight physique and almost neutered body (Picasso deleted the penis with a free stroke) could hardly be further from the virility associated with Minos' creature. Yet the point of this contrast is uncertain. Is Picasso again suggesting that there is a fundamental difference between art and the brutality symbolized by the minotaur, or does this case imply that, as in the 1936 sketch, an artist's creativity is analogous with the minotaur's power? Like the balletic posture of the man, the painting offers no resolution; it seems to equivocate between engagement and detachment.

In the fall of 1942, when the Nazis were on the verge of conquering all of Europe, Picasso may well have doubted that art was still meaningful and even contemplated putting it aside for the mask of violence. At the age of sixty-one, he was closest to the feeble old man in *Three Ages*. Its youth, however, did reappear in early studies for Picasso's foremost work of the Occupation period, the sculpture *Man with a Lamb* (1943). There he has aged into the hard-bitten elder who stands at the center of this image of resolute sacrifice. [50]

VI

In the years following the Second World War, Picasso's fame extended far beyond the art world and made him one of the leading celebrities of the time. Partly in response to the attention that this status brought, he increasingly sought sanctuaries where he could live and work in private. As he passed from his seventies into his eighties, he also became more detached from events in contemporary art. Particularly after Matisse's death in 1954, Picasso looked primarily to historical masters for inspiration and a means to measure his own achievement. Mirroring this relative seclusion, he largely ceased exploring ways to link the studio theme with the current world and accepted its longstanding identity as an aesthetic preserve, filled with a heritage of great artists he slowly joined.[51]

The birth of Picasso's children with Françoise Gilot (who had become his companion in 1946) prompted a brief revival of the domestic scenes of the studio he had made during Paulo's childhood in the 1920s. The images of Paloma (born 1949) and particularly Claude (born 1947), however, depart significantly

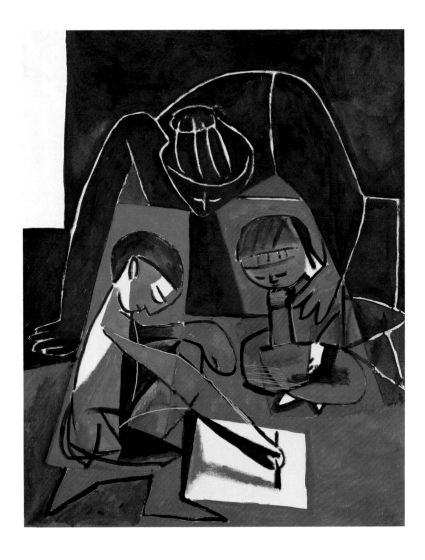

from the earlier pictures. The portraits of Paulo turned on the contrast between the boy's formal dress and posture versus the spontaneity of the sketches he is making. In those of Paloma and Claude, informality prevails. The children squat on the floor and freely mark sheets of paper scattered among them (*Claude Drawing, Françoise and Paloma*, May 17, 1954; Fig. 28). Some of Edward Quinn's photographs show father joining in the fun, but Picasso's own paintings either portray the children alone or with their mother, who embraces them as they play. Since Gilot was returning to her own artwork at that time, her guiding presence is factual. His portraits of Gilot as an artist, however, are exceptional. Although his paintings of his previous lover, Dora Maar, never acknowledged her substantial reputation as a photographer, Picasso unequivocally recorded Gilot's devotion to art in *Woman Drawing* (1951; Cat. 36).[52]

His severe characterization of this beautiful young woman (then aged twenty-nine) probably reflects the growing estrangement that had already begun to divide them; yet the composition and style of the painting also mirrors their mutual admiration for Spanish art of the seventeenth century. The portrait is closely related to a studio image he had painted the year before, *Portrait of a Painter, after*

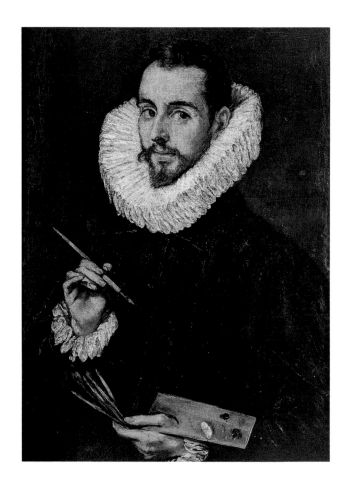

29. El Greco, *Portrait of Jorge Manuel Theotokopulus*, c.1600–05, oil on canvas. Museo de Bellas Artes, Seville

El Greco (1951; Cat. 35). Both represent half-length, largely frontal figures (although Gilot is seated), which almost entirely fill the canvas. The tonalities are extremely somber, consisting primarily of brown and black with inlays of white, and in both edges and interior modeling are rendered in thick black lines. As the subtitle indicates, *Portrait of a Painter* is based on a picture by El Greco, a portrait of his son, Jorge Manuel Theotokopulus, executed about 1600–05 (Fig. 29).[53]

Portrait of a Painter, after El Greco is Picasso's first explicit variation since his student years on a work by one of the great masters of Spanish art, and his first painting in the studio series to recreate a historical work. By the end of the decade, he would produce dozens more. Like the later pieces, this one was an opportunity for Picasso to acknowledge his respect for his predecessors, while contesting their example by transforming their compositions through his own styles. His radical flattening of the figure and costume (especially the lace collar), superimposed profiles, and only slightly inflected lines do create an original image in a Cubist mode, despite the composition's close correspondence to the source.

During the second half of the fifties, Picasso's oeuvre would be dominated by images of the studio – both his own and other artists' – as the theme grew to be one of the most frequent and most important of his late career. The catalyst was a change of place. In the summer of 1955, Picasso purchased La Californie, a villa overlooking Cannes. This substantial house with surrounding grounds offered the

physical seclusion his previous accommodations had not and confirmed his intention to spend most of his time along the Mediterranean coast, as he had done since the end of the war. In doing so, Picasso both returned to his roots and emulated his contemporaries, particularly Matisse, who had chosen the south over Paris once their careers were firmly established.

His paintings of the villa may well have helped Picasso become accustomed to the new surroundings, but they do not constitute a tour of the property. There are no views of the house's exterior or the gardens; only the grand salon, which Picasso appropriated for his studio, appears in this series that stretched intermittently from October 1955 through the next couple of years. These pictures recall his paintings of the mid-twenties and early thirties, specifically *La Statuaire* and *The Sculptor*, in their juxtaposition of exterior and interior (Fig. 16; Cat. 24). Inside, the room is already scattered with materials; in the foreground a palette and brushes lie on a chair and a bust on a modeling stand faces the viewer. In the background, between this evidence of painting and sculpture, the villa's large, rounded windows open the scene to profuse vegetation. Palm trees fill the center of the composition with their thick trunks and flowing fronds, and in several paintings the trees' looping pattern seems even to spread through the interior.

After these early images integrating inside and out, art and nature, Picasso changed his predominant format from vertical to horizontal and focused on the studio in relative isolation (Cat.39, 40). These paintings, executed in March and April 1956, show a wider expanse of the room and reduce the palm trees to views glimpsed from afar. Picasso called them "paysages intérieurs,"[54] and the contrast between the distant brilliance of the Mediterranean light and the dark, capacious space of the studio enforces a sense of separateness in which art is produced. They are exceptional in Picasso's work for the absence of any human presence, even excluding the nude model who reclines on a couch in *Nude in the Studio* (1953). Yet like Braque's contemporaneous paintings of his studio, the rooms do not read as empty but filled with a mysterious imaginative energy.[55] Instead of the tools of art Picasso had shown before, these pictures feature a blank canvas, set on an easel in the center of the composition where the windows had previously been. Surrounded by architectural arabesques, random furniture, and finished paintings turned for display, these bright rectangles are like white holes drawing everything in the shadowy space toward them. Their radical emptiness stands as a challenge to the painter's accomplishments – both the finished paintings scattered around the room and the ones he would soon undertake. They suggest that the studio is still a threatening place, even if it is now detached from the surrounding world.

In a related series, Picasso depicted his lover and future wife, Jacqueline Roque, seated next to a canvas (sometimes painted, sometimes not) or a window (Cats. 41, 42). Unlike the many women Picasso had depicted in studios, she is present as a companion of the artist, one who may at times also fulfill the role of model.[56]

Having explored his new studio and domestic life there, he soon fled the premises to invade the atelier of a great predecessor. In August 1957, Picasso vacated his spacious studio at La Californie to work in the attic. The apparent deprivation afforded him far greater privacy than he could easily obtain in the main rooms of the villa and placed him in a different space, mundane and free of association with

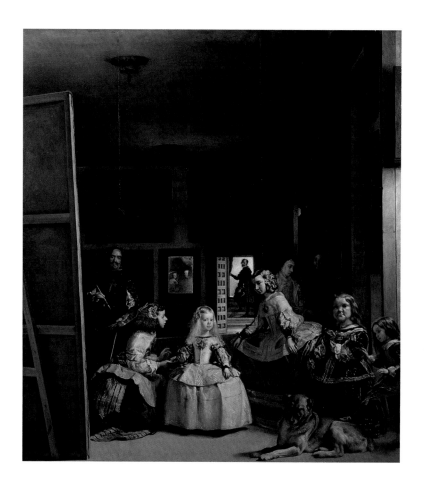

art, that became the stage to project himself into what is probably the greatest painting of an artist's studio, Velázquez's *Las Meninas* (1656; Fig. 30).

As Susan Grace Galassi has revealed in telling detail, Picasso had admired the painting since his youth and had spoken of making his own version as early as 1950.[57] When he did begin, the engagement lasted four months and produced forty-five paintings based directly on Velázquez's masterpiece.[58] The project may have already been in his mind when he painted the La Californie series. His depictions of the salon resemble the high-ceilinged, dim chamber Velázquez represented (his studio in the Prado); moreover both compositions pivot on a formal contrast between the dark interior and a bright rectangle (the rear door in Velázquez's, the fresh canvas in Picasso's).

The similar spaces, however, frame a fundamental contrast, because *Las Meninas* presents an essentially different conception of artistic practice. It is a portrait of the painter as a part of the Spanish court, a picture of social activity stilled by the artist – completely different from the images Picasso had recently made, as well as the life he lived. Picasso may well have believed that he dominated his age more fully than Velázquez did his, and he celebrated his independence from any patron, even a king. His first engagement with the masterpiece (August 17; Fig. 31) focuses on an aggrandizement of the artist. Although he greatly altered or even deleted subordinate sections (such as the lower right corner), Picasso made one

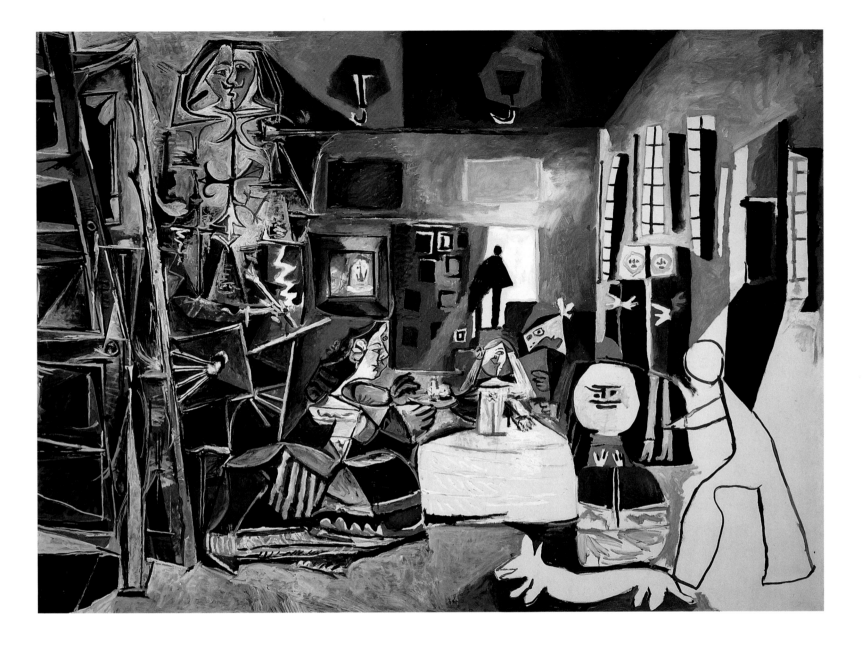

31. *Las Meninas, after Velázquez*, August 17, 1957, oil on canvas. Museu Picasso, Barcelona

fundamental transformation. The figure of Velázquez towers over the adjacent princess and her retinue, rising to the top edge of the canvas that is reproportioned from a vertical to a horizontal format, even though his fractured torso fades into the background like the self-portrait in the original.

Given this glorification, it is remarkable that only three of the remaining forty-four paintings include the painter, and only a few more depict the majority of the space shown in Velázquez's *Las Meninas*. Picasso followed his initial reprise with twenty much smaller canvases primarily devoted to the Princess Margarita Maria. On September 18, he stepped back from his fragmentary approach to revisit the entire composition, as he did again on October 2 and 3, before completing another twenty small-scale series devoted to the maids of honor (Cat. 43). This extreme reversal of approach is maintained in the overall views (September 17

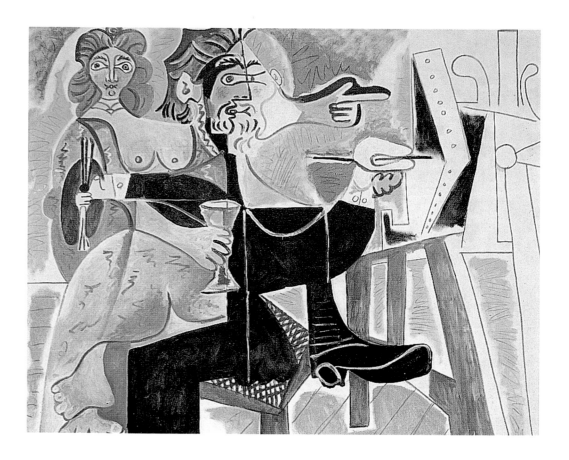

32. *Rembrandt and Saskia*, March 13, 1963, oil on canvas. Collection unknown

and 19), in which the painter's space beside the canvas is void. Even the three, mid-stream images that include the painter shrink him to normal size and so fully integrate his body into the linear and tonal structures of the paintings that he no longer stands out.

This internal balance corresponds to Velazquez's composition, but it also suggests a possible reading of the sequence. After literally showing Velázquez as a giant (a stature he clearly deserves in that company), Picasso turned his attention to remaking the ostensible center of the original – the princess and her court. (He never focused on the image of the King and Queen, which is reflected in a mirror on the back wall.) Then, he returned to the full composition and created the three paintings that reproduce Velázquez's arrangement only to overwhelm it with a variety of Picasso's own Cubist styles. Picasso seems to have shifted from identifying with his acclaimed predecessor to competing with him, itself another form of respect.

When he climbed down from the attic after finishing the final variation on December 30, 1957, he had completed his most sustained meditation on a work by another artist. By entering the studio of a long-dead painter, Picasso showed that his inspiration increasingly sprung from a dialogue with past art. His lifelong contest with history had moved to a new phase, one in which his predecessors' achievements were at least as essential for his art as was contemporary life.

VII

During the eleven years preceding his death on April 8, 1973, Picasso became even more deeply involved with the theme of the studio. As he loosened his technique and increased his speed of execution, he completed so many paintings on the theme that these final works seem almost to swamp the many he created during the previous seven decades.[58] Given the numbers, it is possible to identify revisions of nearly every approach he had taken; yet three provide the greatest access to his thoughts about the nature of art in these last years. Two represent the extremes of age and experience – an intensified mediation on the work of past masters and an invocation of childhood innocence. The third is intrinsic to his experience of painting itself – a radical directness of means flowing from his decades of engagement with the issues of the studio.

In March and April 1963, Picasso painted more than a dozen pictures of an artist at work. Although they vary widely in style and composition, all show the artist in profile, seated before an easel on the right. In some cases, a model appears beyond the easel in a spacious studio, but in others the composition shows only the painter and his canvas. *The Artist* (March 10 and 12, 1963; Cat. 47) is one of these close ups and the last of three similar compositions Picasso painted during a three-day period. In each case, the artist's curly locks recall the Greek gods of the Vollard Suite, yet by the end the references have multiplied to include modern art. While the flat backdrop of the first two pictures implies an interior setting, the profusion of flowers in the third suggests that the artist is painting outdoors, in the tradition of Impressionism, and his thrusting attack at the canvas conveys the physical force associated with van Gogh. A revival of late nineteenth-century art was not exceptional. Three years earlier, Picasso had painted variations on Manet's *Luncheon on the Grass*, and in the spring of 1963 he made several pictures of artists seated in a landscape while painting from a model.[60]

If this range of references indicates that Picasso's conception of the artist at work was primarily defined by the history of art, rather than his contemporary world, he soon came to rest on a particularly compelling image from the past. The day after finishing *The Artist* (Cat. 47), he painted *Rembrandt and Saskia* (Fig. 32), based on the Dutch master's portrait of himself and his wife (*c.* 1635; Dresden). Picasso had admired Rembrandt's art (particularly his prints) since at least the thirties. During his last decade he showed a particular appreciation for two, apparently contradictory, aspects of his predecessor's work – the unflattering realism of Rembrandt's late style, particularly self-portraits and depictions of the female nude, and the ornamental costumes of his early phase.

Rembrandt's *Self-Portrait with Saskia* suited Picasso perfectly because it combines the artist's self-obsession with the fantasy of role playing. Picasso's late work is filled with musketeers and other flamboyant characters decked out in doublets, plumed hats, and high boots, figures that are often discussed as cryptic self-portraits. In *Self-Portrait with Saskia*, Picasso found Rembrandt doing much the same thing, although without disguising either his features or those of his wife. Despite the title, however, Picasso copied very little of his source, except the general situation of a woman sitting on a man's lap. Rembrandt clearly painted his own face

but gave no evidence of his profession, showing a saber slung over his shoulder and substituting a tall glass for the brush he would normally hold. Picasso's artist is the same incarnation he had used on the three previous days and bears no substantial likeness to Rembrandt, nor does the woman closely resemble Saskia.

Rembrandt's resort to fancy dress and bawdy antics suggests a desire to escape the strictures of professional life in seventeenth-century Holland, a liberation his financial insolvency never fully allowed. In these areas, Picasso had no need for fantasy. By the 1960s, he had amassed far more wealth than he could ever consume and enjoyed almost complete freedom of action, living how and where he chose. In his version, Picasso made no effort to disguise the man's trade, yet the artist's dual profile both faces the canvas and looks back toward Saskia. She confronts the viewer, as her left hand points to the work in progress and her right holds a celebratory goblet. Her gown departs from Rembrandt's demure example to showcase her body by exposing her breasts and the outline of her buttocks resting on his lap. Although Picasso did not picture the explicit coupling of his later print series on Raphael and La Fornarina (1968),[61] he implied that the jolliness of Rembrandt's image combined the pleasures of sex and art. Slipping into Rembrandt's skin as he had Velázquez's five years earlier, Picasso continued to measure himself against the achievements and compromises of great artists of the past.

Throughout his life, Picasso had been intensely attentive to developments in contemporary art, and even in the relative withdrawal of his last years he did not ignore new trends. The 1960s was the decade in which recent American art, especially Abstract Expressionism, was acclaimed in Europe and featured in exhibitions across the continent. It is not yet clear whether Picasso saw actual paintings by Pollock and his contemporaries but there is a growing belief that the work of de Kooning, in particular, may well have contributed to Picasso's loosening of his brushwork and the impression of dynamic thrust that resulted. These new characteristics are present in *At Work* (1971; Cat. 56).[62] The frontal, full-length image of a painter, standing before us with a palette but no brush, conveys a concentrated force more evocative of his 1906 *Self-Portrait with Palette* (Cat. 8) than one might expect from an eighty-nine-year-old. The figure's large eyes and sharply sculpted head identify the figure as a self-portrait, yet the turbulent brushwork of the background is the picture's most expressive feature and suggests that Picasso was confronting new challenges at the same time he revisited his own career and the historical record.

After nearly seven decades of exploring the studio, Picasso arrived at a radically reduced code, one which liberated him from the symbols that had dominated his art. In many of his paintings of the mid-sixties (Cat.47–54), he used only the most schematic notations to identify painter, model, canvas, or easel. Frequently, they are so spare as to be nearly unintelligible to anyone who has not followed the course of his work. But the goal was not obscurity, a hermetic dialogue with connoisseurs. Freed of the need to delineate the relationships of specific characters, Picasso gave himself to the medium itself, to the primal activity of wielding paint that underlay the studio theme. In these paintings, academic tradition is almost entirely abandoned in favor of a raw directness. With only the slightest framework

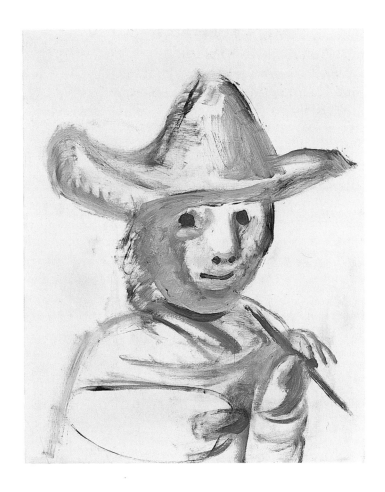

to establish the situation, the brushstrokes – broad, fluid, and apparently spontaneous – state the elemental theme.

During the last few years of his life, Picasso explored a final variation; it would be his benediction. Like the preceding ones, this was a reprise of earlier ideas, but now shifted from the specific to the general. Following the birth of each of his sons, Picasso had celebrated with portrayals of Paulo or Claude drawing, evoking the spontaneous creativity of children. In the fall of 1969, he returned to this conception with an explicit comparison between infancy and old age. In *Painter and Infant* (Cat. 55), a cupid-like baby, no longer a portrait, sits with a bearded man, who reclines holding the palette and brushes in his left hand. In his right, he raises another brush but seems to share its shaft with the baby, who spreads his arms energetically. In the act of painting, youth and age apparently join, renewing the elder's vigor. Despite the optimism projected by the image, Picasso's interpretation is ultimately less sanguine. A close look reveals that the brush is broken between the two protagonists, raising the possibility that youth has snatched it.

The Young Painter (1972; Fig. 33) combines the two spirits in a single, haunting image. A figure raises a brush and palette as he confronts us. His amorphous, fleshy face gives him the appearance of a baby, yet his poised gesture, direct glance, and clothing convey maturity. His broad-brimmed hat resembles those of the musketeers and dashing artists Picasso had painted during the previous decade. Given

this combination, it is difficult to decide whether the painter is another cherub or a slack-faced adult at the end of life. The thin washes of paint and large areas of untouched canvas enhance a ghostly effect. Instead of youth merely invigorating age, *The Young Painter* presents a more profound union, one which seems to acknowledge in the dark depths of his direct stare both the hopefulness of the young and the hard realism of the old.

Picasso inscribed the statement, "painting is stronger than me," in March 1963, the month he made the Atheneum's *Painter* (Cat. 49) and *Rembrandt and Saskia* (Fig. 32). Toward the end of his life, he does seem to have accepted that creativity was an independent genius flowing through him as it had preceding artists, driving each down his individual path. If he believed this at the beginning of his career, he probably fought the notion of being subject to a greater force. For decades he explored the diverse, often contradictory byways of imagination as changes in contemporary culture and his personal life uncovered challenging possibilities. At the end, consistency provided reassurance, a firm place among the masters he revered, a haven from a world that held few attractions for him, and a potential to reinvigorate endlessly his own artistic self.

1. The sketchbook is number M.P. 1886 in the collection of the Musée Picasso, Paris.

2. Despite its ubiquity in studies of Picasso's work, the theme of the studio is the subject of only a few studies, all of them brief essays, see particularly Michel Leiris, "The Artist and his Model," in Roland Penrose and John Golding, eds., *Picasso in Retrospect*, New York 1973, 243–63; Marie-Laure Bernadac, "Picasso 1953–72," in *Late Picasso: Paintings, sculpture, drawings, prints 1953–1972*, Tate Gallery, London 1988, 74–78; and Dore Ashton, "Picasso in his studio," in Peggy Guggenheim Collection, *Pablo Picasso: L'Atelier*, Venice 1997, 119–49. Karen L. Kleinfelder's *The Artist, His Model, Her Image, His Gaze*, Chicago 1993, focuses on the prints and drawings Picasso made in his last years, especially the "347" Suite of 1968. For the general history of the theme of the studio in western art, see Michael Peppiatt and Alice Bellony-Rewald, *Imagination's Chamber: Artists and Their Studios*, Boston 1982; and Fred Licht, "The Artist in the Studio," in Peggy Guggenheim Collection, *Pablo Picasso: L'Atelier*, 57–85.

3. For the most illuminating account of Matisse's studio paintings (though 1918), see Jack Flam, *Matisse: The Man and His Art, 1869–1918*, Ithaca and London 1986. For the most recent study of the relationship of Picasso and Matisse, see Yve-Alain Bois, *Matisse and Picasso*, Paris and Fort Worth 1999.

4. For Picasso's early career, see John Richardson with Marilyn McCully, *A Life of Picasso*, volume I: 1881–1906, New York 1991; and Marilyn McCully, ed., *Picasso: The Early Years 1892–1906*, Washington D.C. 1997.

5. Richardson with McCully, *A Life of Picasso*, vol. 1, 225–26.

6. See Erika D. Passantino, ed., *The Eye of Duncan Phillips*, Washington D.C. 1999, 242.

7. For a detailed account of the exhibition, see Pierre Daix, *Picasso: Life and Art*, New York 1987, 17–25 and 437–39.

8. The portrait of Coquiot is in the collection of the Musée National d'Art Moderne in Paris; the portrait of Mañach is in the collection of the National Gallery of Art, Washington, D.C.; the portrait of Vollard is in collection of the Emil G. Bührle Foundation in Zurich. For an account of Picasso's relationships with his dealers and the art market from 1900 to 1940, see Michael C. FitzGerald, *Making Modernism: Picasso and the Creation of the Market for Twentieth-Century Art*, New York 1995.

9. Zervos, XXI, 250.

10. For Picasso's photographs, see Anne Baldassari, *Picasso Photographe 1901–1916*, Paris 1994.

11. Fondation E. G. Bührle Collection, Zurich.

12. The 1907 self-portrait is in the collection of the National Gallery in Prague. For the most up-to-date account of this and other self-portraits, see Kirk Varnedoe, "Picasso's Self-Portraits," in William Rubin, ed., *Picasso and Portraiture: Representation and Transformation*, New York 1996, 110–79.

13. See Theodore Reff, "Themes of Love and Death in Picasso's Early Work," in Golding and Penrose, *Picasso's Early Work*, 44–45.

14. Collection of the Hermitage Museum, St Petersburg.

15. This period is most fully analyzed in Pierre Daix, *Picasso: The Cubist Years 1907–1916*, Boston, 1979.

16. My thanks to Charles Stuckey for having suggested the relationship of this and later paintings of the nude to academic convention.

17. The portrait of Sagot is in the collection of the Kunsthalle in Hamburg; Uhde is in the Pulitzer Collecton in St. Louis; Kahnweiler is in the Art Institute of Chicago.

18. For the photographs of Sagot, see Baldassari, *Picasso Photographe 1901–1916*, 100–01.

19. For further discussion of these portraits, see FitzGerald, *Making Modernism*, 32–37.

20. See Pepe Karmel's essay on the painting in Kirk Varnedoe and Pepe Karmel, *Picasso: Masterpieces from The Museum of Modern Art*, New York 1997, 60.

21. In the collection of the Metropolitan Museum of Art in New York.

22. Casagemas committed suicide in February 1901. For a analysis of images related to the suicide, see Reff, "Themes of Love and Death in Picasso's Early Work," 13–28.

23. See FitzGerald, *Making Modernism*, 58–62.

24. See Kenneth E. Silver, *Esprit de Corps: The Art of the Parisian Avant-Garde and the First World War, 1914–1925*, Princeton 1989, 63–68.

25. See Michael FitzGerald, "The Modernists' Dilemma: Neoclassicism and the Portrayals of Olga Khokhlova," in Rubin, ed., *Picasso and Portraiture*, 296–302.

26. For further discussion of *Studies*, see FitzGerald, *Making Modernism*, 100–06. The painting is in the collection of the Musée Picasso in Paris.

27. In works such as *Seated Nude* (1906; National Gallery, Prague), Picasso evoked the academic nude as a source for his variations on classical models.

28. For the fullest account of Picasso's still life painting, see Jean Sutherland Boggs, ed., *Picasso and Things*, Cleveland 1992.

29. See FitzGerald, *Making Modernism*, 80–132.

30. The sketchbook is number 83 in Marc Glimcher's listing of the sketchbooks; see Arnold Glimcher and Marc Glimcher, *The Sketchbooks of Picasso*, New York 1986, 323.

31. For an account of Picasso's images of children and the relation of his art to concepts of untrained spontaneity, see Werner Spies, *Picasso's World of Children*, New York, 1994.

32. Collection of the Museum of Modern Art in New York.

33. Picasso made this statement to André Malraux, see Malraux, *La Tête d'obsidienne*, Paris 1974, 18–19; for discussion see William Rubin, "The Genesis of *Les Demoiselles d'Avignon*" in The Museum of Modern Art, *Studies in Modern Art 3*, New York 1994, 13–16.

34. See Michael FitzGerald, "Pablo Picasso's Monument to Guillaume Apollinaire: Surrealism and Monumental Sculpture in France, 1918–1959," dissertation, Columbia University 1987, 130–92.

35. André Breton, *Nadja*, Paris 1928, final sentence.

36. See FitzGerald, *Making Modernism*, 176–84. For the periodicals *Documents* and *Minotaure*, see Dawn Ades, *Dada and Surrealism Reviewed*, London, 1978, 228–49 and 278–329.

37. *Ibid*.

38. The most revealing study of the painting remains William Rubin's entry in Rubin, *Picasso in the Collection of The Museum of Modern Art*, New York 1972, 130.

39. For the discovery of this photograph, see Anne Baldassari, *Picasso and Photography: The Dark Mirror*, Paris and Houston 1997, 189–90.

40. For a thorough study of the painting, see Angelica Z. Rudenstine, *The Peggy Guggenheim Collection, Venice*, New York 1985, 617–22. For the technical analysis, see Paolo Spezzani, "Technical Report," in Peggy Guggenheim Collection, *Pablo Picasso: L'Atelier*, 157–59.

41. During most of the 1920s and 1930s, Picasso produced this feature by combing his hair over his forehead to cover a receding hairline. It is visible in the photographs taken by Man Ray and Cecil Beaton during these decades.

42. See FitzGerald, "The Modernists' Dilemma," in Rubin, ed., *Picasso and Portraiture*, 323–31.

43. For further discussion of the painting, see Elizabeth Cowling and John Golding, *Picasso: Sculptor/Painter*, London 1994, 272.

44. For the most recent study, see Lisa Florman, *Myth and Metamorphosis: Picasso's Classical Prints of the 1930s*, Cambridge 2000.

45. For the most revealing account of Picasso's depictions of Walter, see Robert Rosenblum, "Picasso's Blond Muse: The Reign of Marie-Thérèse Walter," in Rubin, ed., *Picasso and Portraiture*, 336–83.

46. In the collection of The Museum of Modern Art in New York.

47. These sketches are M.P. 1178–91 in the collection of the Musée Picasso in Paris. They were discovered after Picasso's death and were first discussed in Herschel B. Chipp, *Picasso's Guernica: History, Transformation, Meanings*, Berkeley 1988, 58–69. See also Judi Freeman, *Picasso and the Weeping Women*, Los Angeles 1994, 32–33.

48. These paintings are discussed in Boggs, *Picasso and Things*, 254–56.

49. This drawing is M.P. 1158 in the collection of the Musée Picasso in Paris.

50. On July 3, 1943, Picasso painted a view of his studio window (Israel Museum, Jerusalem) in which the interior is reduced to an awkward assembly of radiator and water pipes that frame the window. For discussion of this painting and the *Man with a Lamb*, see Steven Nash, "Picasso, War, and Art," in Nash, *Picasso and the War Years 1937–45*, San Francisco and New York 1999, 13–37.

51. Pierre Daix knew Picasso well at this time, and his account is the most accurate. See *Picasso Life and Art*.

52. For an account of Picasso's portraits of Gilot, see Michael FitzGerald, "A Triangle of Ambitions: Art, Politics, and Family during the Postwar Years with Françoise Gilot," in Rubin, ed., *Picasso and Portraiture*, 296–403. One of Quinn's photographs is reproduced on page 442 of this essay.

53. See Susan Grace Galassi, *Picasso's Variations on the Masters: Confrontations with the Past*, New York 1996, 118–26.

54. Picasso made this statement to Pierre Daix, see *Picasso Life and Art*, 327.

55. For the series of paintings Braque devoted to his studio in the late forties and early fifties, see John Golding, ed., *Braque: The Late Works*, New Haven and London 1997.

56. For Picasso's portraits of Roque, see William Rubin, "The Jacqueline Portraits in the Pattern of Picasso's Art," in Rubin, ed., *Picasso and Portraiture*, 446–84.

57. Galassi, *Picasso's Variations on the Masters*, 148–84.

58. The entire series is in the collection of the Museu Picasso in Barcelona.

59. For the most perceptive account of these final works, see Gert Schiff, *Picasso: The Last Years, 1963–1973*, New York 1983.

60. For Picasso's interest in van Gogh in his last years, see Varnedoe, "Picasso's Self-Portraits," in Rubin, ed., *Picasso and Portraiture*, 163–65. For the series after Manet's painting, see Galassi, *Picasso's Variations on the Masters*, 185–203. Among the landscapes are Zervos XXIII, 223 and 288.

61. See Kleinfelder, *The Artist, His Model, Her Image, His Gaze*, 217–22.

62. See Pepe Karmel's entry in Varnedoe and Karmel, *Picasso: Masterpieces from The Museum of Modern Art*, 140.

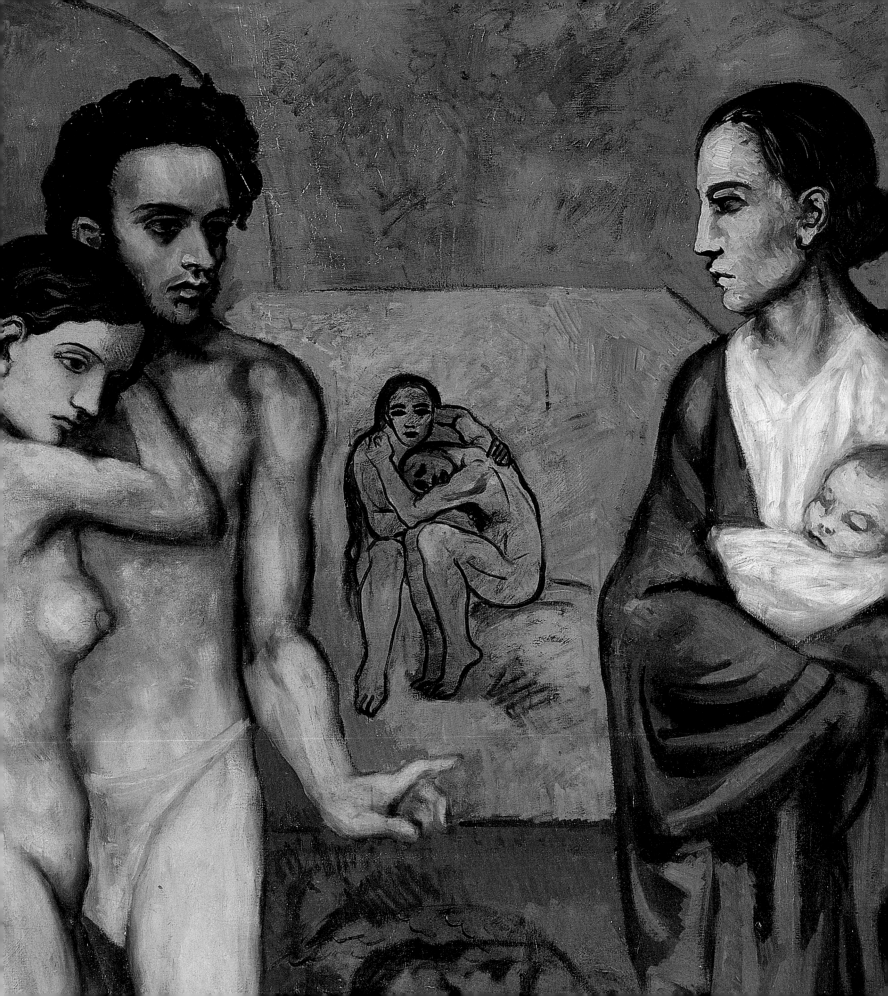

William H. Robinson

THE ARTIST'S STUDIO IN "LA VIE"

THEATER OF LIFE AND ARENA OF PHILOSOPHICAL SPECULATION

> *My studio is a sort of laboratory. . . . On occasion my paintings have beauty — at least people see it in them. So much the better. But what matters is how they are created — every line that is added, the transition from one stage to another. That's what painting is about, part poetry, part philosophy.*
>
> Pablo Picasso[1]

Pablo Picasso was notoriously reluctant to discuss his art. During his early years he adopted Alfred Jarry's anarchist gesture of responding to annoying questions by firing a pistol in the air — once while riding in a taxi with a German poet.[2] This does not mean Picasso's paintings are devoid of intellectual content, only that he believed the visual image should carry the burden of meaning. He also abhorred pretentious theorizing, especially if it threatened to impose a single, fixed interpretation on a work of art. So rather than issuing didactic statements or manifestoes, he embedded ideas directly in images that challenge conventional definitions of art. As a parallel concern, he explored philosophical questions of personal and artistic identity through recurring depictions of the artist's studio.

Picasso was forced to confront these issues at an early age. His family hoped he would become a celebrated salon painter, perhaps surpassing his father's modestly successful career. A wealthy uncle expressed the family's faith in their *wunderkind* by financing Pablo's studies at the Royal Academy of San Fernando in Madrid. But their young protégé left that institution toward the end of his first year, effectively concluding his formal art training in 1898 at the age of seventeen. For the next several years Picasso struggled to define the direction of his life and art. Increasingly alienated from his family's material aspirations, he joined a circle of radical artists, poets, and anarchists who frequented the cafés of Barcelona. These colleagues introduced him to the writings of Friedrich Nietzche and other intel-

34. Detail from Cat. 5, *La Vie*, 1903, oil on canvas. The Cleveland Museum of Art. Gift of the Hanna Fund 1945.24

lectuals who contested the most fundamental assumptions about the nature and purpose of creative activity.

In the spring of 1903 Picasso, at age twenty-two, began work on *La Vie* (Cat. 5; detail Fig. 34), a large painting that would summarize his ideas about his life as an artist. He chose the artist's studio as the setting for this drama and began modestly with the idea of depicting himself standing between a naked woman, presumably his model or lover, and a canvas on an easel (Fig. 35). After partly completing the painting, however, he reworked the composition extensively and altered the identity of various figures in an effort to invest the subject with more expansive meanings. Comparative analysis of other works indicates that Picasso developed many essential ideas and visual motifs for *La Vie* through related drawings and paintings. Indeed, this complex allegory can only be understood by considering it within the broader context of Picasso's art of the Blue Period (1901–04), and by viewing the painting as the product of an extended process of alteration and transformation stimulated by the artist's evolving ideas about its content. Ultimately, from this process of relentless intellectual inquiry emerged a

masterpiece of *fin-de-siècle* Symbolist art and Picasso's first major statement about the life of the alienated, bohemian artist.

Art historians have traditionally interpreted *La Vie* as either an allegory of sacred and profane love, or a variation on the "cycle of life" theme popular with Symbolists at the turn-of-the-century.[3] While those interpretations are based on the finished image, a more comprehensive understanding of the painting's meaning can be derived by following Picasso's evolving ideas, as revealed through his drawings and alterations to the composition.[4] He indicated his early intentions in four preparatory studies, each depicting himself standing between a naked woman and a painting on an easel (Fig. 35).[5] This arrangement, similar to Gustave Courbet's *The Painter's Studio: A Real Allegory* (Musée d'Orsay, Paris), signals the artist's role as mediator between the woman and the painting on the easel, or between the physical world and the metaphysical realm of art.

Not only did Picasso depict himself in the central role of the artist in his drawings for *La Vie*, but x-radiographs (Fig. 36) reveal that he continued to portray himself as the artist in the early stages of the painting. This recurring self-portrait

37. Infrared reflectogram of *La Vie* (detail of birdman scene at lower center)

38. Infrared reflectogram of *La Vie* (detail of reclining woman's face in the birdman scene)

strongly suggests that it was *not* Picasso's original intention to create an allegory about life in general, but instead, one referring to his own life as an artist. The strategic placement of a canvas on an easel in the center of the composition (x-radiographs reveal that the easel was present in the early stages of the painting) grounds the scene within the specific professional milieu of an artist's studio. Although Picasso would ultimately eliminate the easel from the painting's final state (Cat. 5), it remains obvious that the two framed images in the center are works of art, as denoted by the diminutive scale of the figures and the heavy lines separating their space from the rest of the composition. When Picasso eventually replaced his features with those of Carles Casagemas (1881–1901), a fellow painter who had committed suicide two years earlier, he merely shifted the identity of the only distinctly recognizable individual in the composition to that of another artist.[6]

Many attempts have been made to unravel the meaning of this complex allegory, often described as one of Picasso's most "difficult" images. Even today, its precise meaning remains shrouded in an obscure language of personal signs and metaphorical relationships. John Richardson observed:

> *La Vie*, the great set piece that Picasso began planning in the spring of 1903, has given rise to more mystification than any other early work by the artist. . . . *La Vie* is also the first metaphysical manifestation of the studio theme that time and again will dominate the work: the theme of "Theatrum Mundi" – an arena where art becomes inextricably entwined with life.[7]

New insights into the painting's meaning have emerged from recent scientific

analyses conducted by curators and conservators at the Cleveland Museum of Art. Studies with infrared reflectography, for instance, have proven more useful than x-radiography for examining Picasso's alterations to *La Vie*, especially those associated with the dark, crouching woman isolated at lower center. Infrared reflectograms reveal that this figure lies over an earlier scene (Fig. 37) of a strange creature, with the body of a man attached to the head and wings of a bird, who flies above a naked woman reclining on the ground.[8] While the woman's features remain indistinct in x-radiographs, detailed studies with infrared reflectography (Fig. 38) indicate that she has a broad face accented by long black hair, softly lidded eyes, and a closed mouth with full, sensuous lips. Rather than recoiling with fright, as one might expect, she gazes intensely at the birdman, as if to welcome his approach.

A nearly identical woman appears in Picasso's *Allegorical Sketch* (Fig. 39), previously dated May 1902 by scholars.[10] This woman reaches out to receive a man with an erection who bears the unmistakable features of Picasso (compare with the self-portrait in the previously cited drawing for *La Vie*, Fig. 35). Above the amorous couple, a large winged deity crowned with leaves spreads his arms in a gesture symbolic of sheltering or sanctioning their sexual union.

A variation on this scene appears in yet another Picasso drawing (Fig. 40),

39. *Allegorical Sketch*, graphite on paper. Museu Picasso, Barcelona

40. *Allegorical Sketch*, May 1902, graphite on paper. Museu Picasso, Barcelona

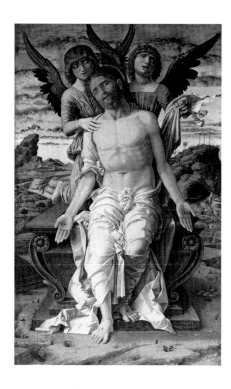

41. Andrea Mantegna, *Pietà*, 1489, tempera on panel. Statens Museum for Kunst, Copenhagen

42. Giotto, *Stigmata of Saint Francis, c.* 1300, tempera on panel. Musée du Louvre, Paris

except that now the winged deity has become a woman, the self-portrait has been moved to the upper left, and the male lover no longer stands upright, but falls toward the woman lying on the ground. These drawings suggest that Picasso created the birdman in *La Vie* by conflating the deity with the male lover, who approaches the woman in the second drawing from nearly the same position as the flying birdman in the painting.[11]

Infrared reflectograms also indicate that the birdman assumes yet another attribute of the winged deities in the previously cited drawings: he extends both arms and displays the palms of his hands, forming a gesture with precedents in both classical and Christian art. Of particular significance in this context are representations of Christ displaying this gesture, either when presenting the wounds of his crucifixion (Fig. 41), or flying like the birdman in *La Vie* (Fig. 42).

Picasso invested this gesture with new meaning in his drawing of a woman with sagging breasts, long black hair, and head bowed in an attitude of sorrow (Fig. 43).[12] The woman is flanked by a guitar, the head of a bearded man, and a poem in Spanish, probably written by Picasso himself. This poem, a sorrowful ode to rejected love ("I dreamt you did not love me . . . since then, I don't sleep"), suggests that the woman's pose represents an appeal for pity or mercy on behalf of those who suffer betrayal and rejection.

Picasso recast the gesture of exposed palms in an oil sketch of a standing nude woman (Fig. 44), who extends her arms in the same manner as the deities in the drawings associated with the birdman scene in *La Vie* (compare Figs. 6–7). The precise meaning of her stylized pose has eluded scholars, but it seems to indicate

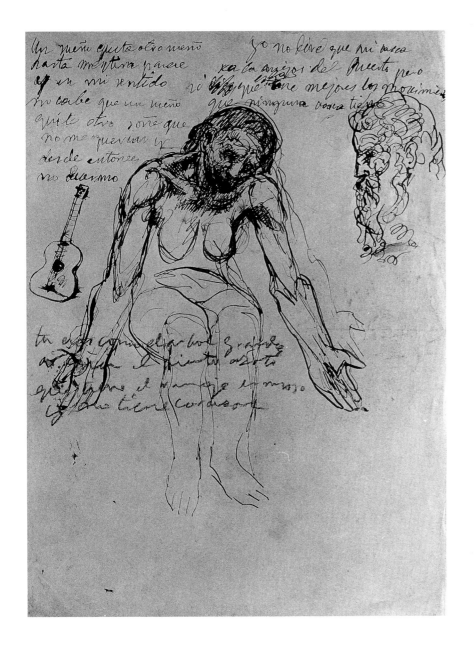

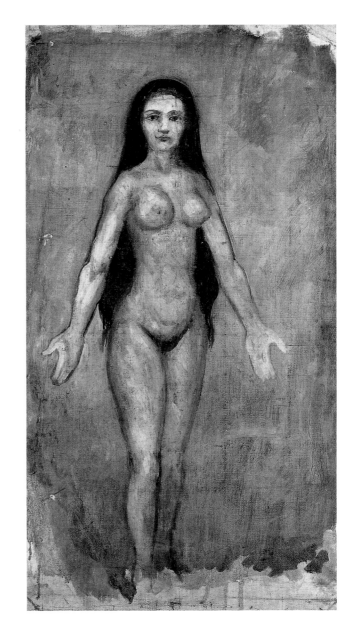

some allegorical or symbolic connotation, perhaps related to allegories of *The Wheel of Life* and *The Wheel of Fortune*.[13] The latter was a standard subject in fortune-telling cards popular with artists and poets in Picasso's circle at the turn-of-the-century. One French deck, the Delarue Tarot of *c.* 1895, depicts *Fortune* as a woman (Fig. 45), draped and blindfolded, standing on a wheel, and displaying the palm of one hand in a manner associated with palmistry.[14]

The poet Max Jacob (1876–1944), an avid practitioner of fortune-telling, probably introduced Picasso to palmistry and the Tarot.[15] Picasso and Jacob met in the summer of 1901 and quickly became close friends, providing Picasso with intimate access to Jacob's extensive knowledge of French literature and astrology. Toward the end of 1902, when Picasso and Jacob shared an apartment in Paris, Jacob made two charts of Picasso's left palm (Fig. 46) indicating the "lines of life,

43. *Figure, Head, and Guitar*, 1902–03, ink and blue crayon on paper. Museu Picasso, Barcelona

44. *Nude Woman*, 1903, oil on linen. Museu Picasso, Barcelona

45. *Fortune*, from the Delarue Tarot, *c.* 1895, color lithograph. Cary Collection of Playing Cards, Yale University Library, New Haven

46. Max Jacob, *Palmistry Study of Picasso's Left Hand*, 1902, graphite and ink on paper. Museu Picasso, Barcelona

chance, love," etc., and revealing different aspects of the artist's character and destiny. These charts indicate that Picasso possessed an ardent temperament and that love would play a significant role in his life. Jacob also predicted that Picasso would enjoy a brilliant artistic career during his early years, but would suffer much cruelty later in life. Jacob noted one highly unusual feature of his friend's palm: " . . . all the lines appear to emanate from the line of *chance* in this hand. It's like the first spark of fireworks. This type of radiant star appears only rarely and among *predestined* individuals."[16] One wonders in this context whether Picasso's recurring open-palm imagery may refer to palmistry as an indicator of predestination.

Picasso's fascination with questions of fate or destiny was stimulated and reinforced by his early encounters with Symbolist art. First exposed to Symbolism in Barcelona, Picasso's understanding of the movement deepened after meeting

many of its leading artists and theorists on visits to Paris in 1900 and 1901. Of particular significance was the influence of Paul Gauguin (1848–1903). Although Picasso never met Gauguin, they shared the same dealer, Ambroise Vollard. It was probably through this relationship that Picasso discovered Gauguin's monumental canvas *Where Do We Come From, What Are We, Where Are We Going?* (Museum of Fine Arts, Boston), one of the most important Symbolist paintings to explore the question of human destiny.

Picasso's preoccupation with such issues may also have been prompted by a series of tragedies in his personal life, including the death in 1895 of his younger sister, Conchita, from diphtheria. Picasso later told Françoise Gilot and Jacqueline Roque that he tried to save his sister's life by making a secret pact with God; but despite promising to abandon art in exchange for Conchita's life, the young artist was unable to alter her fate.[17] This was not the only personal tragedy Picasso experienced during his early years. In 1899 the painter Hortensi Güell i Güell, a member of Picasso's circle in Barcelona, described as a "neurotic, self-destructive aesthete," committed suicide by throwing himself from a cliff.[18] Two years later, Picasso's closest friend, the Catalan poet-painter Carles Casagemas, shot himself in the head after being spurned by a lover. Manuel Manolo, a Catalan sculptor and member of Picasso's circle, commented that this was not an entirely unexpected event, as Casagemas had previously tried to take his life by stabbing himself.[19]

"It was thinking about Casagemas," Picasso later told Pierre Daix, "that got me started painting in blue."[20] Casagemas's suicide obviously provided Picasso with a catalyst for speculating on questions of life, death, and the artist's fate in the modern world. Evidence that Picasso saw a deeper meaning behind his friend's suicide surfaced in *The Death of Casagemas* (Musée Picasso, Paris), a posthumous portrait of 1901, which depicts his former companion laying on his back, his sickly-green face illuminated by the sulfur yellow light of a burning candle. John Richardson observes that the painting's intense color and impastoed surface were inspired by a concurrent retrospective of paintings by Vincent van Gogh.[21] Beyond these stylistic affinities, Picasso's emphasis on the gaping bullet hole in Casagemas' temple serves to reinforce the analogy with Van Gogh, another ill-fated artist, who was likewise the victim of social rejection and who ended his life by suicide.

The suicides of Van Gogh, Güell i Güell, and Casagemas must have troubled the superstitious Picasso because they formed a pattern of events suggesting that artists – at least those who live in opposition to mainstream society – are fated to suffering and tragedy. This pattern held true for Picasso's greatest hero of the Blue Period, Paul Gauguin. Among *fin-de-siècle* modernists, Gauguin was the most conspicuous representative of the alienated, bohemian artist who suffers as a result of defying the social and aesthetic assumptions of the dominant culture. The art historian Donald Kuspit observes:

Gauguin confronted, and was perhaps the first to do so consciously, the problem of modern art, that is, the problem of making art in a democratic society: how to articulate and arouse feeling in a bourgeois world which stubbornly values obvious fact – in a world in which feeling seems beside the point

because it is not always obvious, indeed often far from easy to perceive and
analyze and distrusted because it is often disruptive and unpredictable.[22]

Picasso also came into direct contact with Gauguin's paintings through Paco
Durrio (1868–1940), a Spanish ceramist living in Paris and one of Gauguin's for-
mer companions. During his early years in the French capital, Picasso enjoyed lis-
tening to Durrio tell stories of Gauguin's life in the South Pacific. Picasso's
deepening fascination with Gauguin may be measured by the fact that in 1901,
when given a copy of *Noa Noa*, Gauguin's Tahitian journal, he filled it with his
own illustrations.[23] Through this journal Picasso discovered that Gauguin was
profoundly disappointed to discover that Europeans had already corrupted Tahiti
and turned the native culture into a caricature of the "customs, vices, fashions,
and absurdities of civilization."[24] Having fled Europe in an unfulfilled search for

utopia, Gauguin set the pattern for the artist who is condemned – or condemns himself – to a life of solitude and poverty. Several years earlier, Gauguin had expressed his own feelings of social alienation through self-identification with the persecuted Christ in his paintings *Christ in Gethesemane (Self-Portrait)* of 1889 (Norton Gallery, West Palm Beach, Florida) and *Self-Portrait with Yellow Christ* of 1890 (Musée d'Orsay, Paris). Despite his efforts to escape the corrosive power of European materialism, Gauguin found no respite in the South Pacific, where recurring bouts of depression occasionally left him unable to paint and contributed to a failed suicide attempt in 1897.

Picasso's painting *The Burial of Casagemas (Evocation)* of 1901 (Fig. 47) follows Gauguin's precedent of associating an alienated artist with religious martyrdom. Picasso organized the composition in three zones. In the lower level, robed mourners surround Casagemas' shrouded corpse and his body lies adjacent to a tomb in a manner that alludes to the iconography of the Entombment and the Lamentation. In the second level, prostitutes lament his death, while a barefoot mother and baby, a reference to the gypsy-vagabond theme, metaphorically signal Casagemas' "outsider" status relative to bourgeois society. In the upper register, Casagemas ascends on a white horse and receives a final embrace from a naked woman. Most significantly, Casagemas stretches out his arms in the shape of a cross, alluding again to self-identification with the crucified Christ.

Associating the alienated, bohemian artist with Christ as a figure scorned by an oppressive, materialistic society was a recurring theme of *fin-de-siècle* Symbolist art. Picasso's drawing of a crucified man surrounded by embracing couples (Fig. 48), especially when compared with his allegorical drawing of the painter Sebastià Junyer (Fig. 49), suggests that Picasso embraced this notion of identifying the

48. *Crucifixion and Embracing Couples*, 1903, graphite and blue crayon on paper. Musée Picasso, Paris

49. *The Painter Sebastià Junyer and His Vision of Mallorca*, 1902, ink and colored pencil on paper. Private collection, Belgium

50. *Dead Man and Woman with Raised Arms*,
1902, pastel and charcoal on paper. Heirs of
the Artist

artist-creator with Christ-like suffering. The latter drawing depicts Junyer with a
lyre and a palette, sitting by the edge of the sea, robed and barefoot like an antique
deity. Nude and copulating figures emerge from the bushes and rocks amid sym-
bolic vulva and phallic shapes, apparently referring to the artist's procreative func-
tion. Picasso depicted himself in the same manner – resting before the sea, holding
a palette, and wearing the robe of an antique deity – in a related drawing of 1902
(Zervos I: 129). In this context, Picasso's drawing of the crucified man surrounded
by copulating couples (Fig. 48) can be interpreted as a metaphor for the psycho-
logical if not physical suffering of the artist who defies social conventions.

Picasso's preoccupation with the fate of the alienated artist may explain his
admiration for the French poet Alfred de Vigny (1797–1863). Max Jacob almost
certainly introduced Picasso to Vigny's poems and novels, in which poets are
repeatedly portrayed as individuals predestined to social rejection, suffering, mad-
ness, and suicide. Picasso wrote a revealing reference to Vigny's poem *Moses* along
the margin of his drawing *Woman Appealing to Heaven*, a study for *Dead Man and
Woman with Raised Arms* (Fig. 50).[25] Vigny's poem describes Moses as an individ-
ual gifted with unusual powers of insight, but who feels oppressed by having the
responsibility of special knowledge thrust upon him. Condemned to live forever
apart from society, Moses pleads with God to be released from this burden: "What
have I done to be your elect," Moses asks.[26] But God rebukes Moses by observ-
ing that they share the same fate: to live powerful and alone, to work without
respite, to be scorned and repudiated by society.

51. *The Christ of Montmartre (The Suicide)*, 1904, pen and watercolor on paper. Foundation Prince M., Zurich

In light of the personal tragedies he had experienced, Picasso was naturally attracted to Vigny's stories about poets predestined to tragedy and suffering. The protagonist of Vigny's novel *Stello*, for instance, is a poet "favored by the stars," but who finds himself unable to work after repeated attacks by the "blue devils" of *ennui*. Stello then consults Dr. Noir, who tells stories of three "damned" poets. The first, Nicolas-Joseph-Laurent Gilbert, is driven to poverty and madness. The second, the eighteen-year-old Thomas Chatterton, commits suicide. The third, the young André Chénier, is sent to the infamous St.-Lazare prison during the French Revolution and condemned to the guillotine because of his opposition to authority.[27] Literary critic Irving Massey interprets these stories as allegories of the artist-poet's fate in the modern world:

Absolute monarchs fear the revolutionary implications of poetry; bourgeois governments declare the poet useless; egalitarian republics fear and resent the natural superiority of artists. The poet is the mouthpiece of immediate truth, the oracle whom no society based on fictions and conventions can tolerate.

52. *Vulture Piercing a Man's Skull*, 1902, ink on paper. Formerly collection Junyer-Vidal, Barcelona

53. *Casagemas Naked*, 1903–04, ink and blue pencil on paper. Private collection, Barecelona

But since every society is an edifice of lies and conventions, its architects and its maintenance men (philosophers and politicians) will necessarily exclude poets from the building.[28]

Later in life, Max Jacob revealed something of Picasso's attraction to Vigny when he told an interviewer: "Picasso may perhaps remember the day we gazed from the height of our balcony down to the ground and the poems of Alfred de Vigny that made us weep."[29] Jacob was recalling the bitterly cold winter of 1902, when he and Picasso had little money for food or heat, and took turns sleeping in the room's only bed. According to Antonia Vallentin, who interviewed Picasso on the subject: "One day, they were both leaning over the balcony of their fifth floor room overlooking the boulevard. The same thought struck them both . . . but almost immediately, Picasso said: 'We must not have ideas like that'."[30] Although it will never be known if Picasso intended to recall those dark moments in his drawings *The Christ of Montmartre (The Suicide)* (Fig. 51) and *Suicidal Man and Self-Portrait in Profile* (Zervos VI: 617), these images do suggest that the subject of suicide haunted Picasso for some time after Casagemas' death.

54. *Preparatory Sketch for "Poor Geniuses,"* 1899–1900, conté crayon on paper. Museu Picasso, Barcelona

Vigny's paradigm of the poet as a superior individual, condemned by modern democratic societies to a life of intellectual and spiritual desolation, was a popular theme in late nineteenth-century literature. Through Max Jacob, Picasso almost certainly knew that Charles Baudelaire and Stéphane Mallarmé regarded Edgar Allen Poe as the archetype of the gifted, creative individual predestined to suffering and alienation. Baudelaire described Poe's fate of social alienation and predestined tragedy in a well-known essay: "Does there not exist a diabolical Providence that plots misfortune from the cradle forward — that deliberately thrusts these spiritual and angelic beings into hostile surroundings, like martyrs into the arena? . . . Their destiny is inscribed in their very nature; it sparkles with a sinister gleam in their looks and in their gestures, running through their veins with every drop of blood."[31] Baudelaire concluded with an ominous remark: "Poe's death is almost a suicide — a suicide long in preparation."[32]

We can only wonder whether Picasso's strange drawing of a large black bird piercing a man's skull with its beak (Fig. 52) is in some way related to Poe's famous poem, *The Raven*, which both Baudelaire and Mallarmé translated into French.[33] Curiously, the bearded man makes the same gesture as Casagemas in another Picasso drawing (Fig. 53), in which two hands clasped over the genitals may allude to sexual dysfunction, whether resulting from physical or psychological causes.

Even prior to Casagemas' suicide, Picasso had reflected on the tragic destiny of artists in a series of works depicting an artist's studio, in which a dead or dying man is surrounded by distraught colleagues (Fig. 54). These drawings culminated in one of the few paintings Picasso graced with his own title, in this case by writing in the upper left of the finished oil painting, *Poor Geniuses!*[34] We will proba-

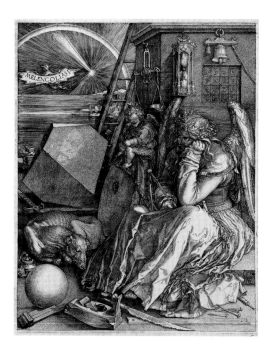

55. Albrecht Dürer, *Melancholia 1*, 1514, etching. The Cleveland Museum of Art. Gift of Leonard C. Hanna, Jr., in memory of Ralph King 1926.211

bly never know if this theme was inspired by Güell i Güell's suicide of 1899, but the placement of a painting on an easel near the center of the composition to identify the setting as an artist's studio certainly foreshadows the iconographic scheme of *La Vie*.

The notion that artists are susceptible to depression and suicide because they are burdened with special powers of creative insight and an acute awareness of the inevitability of death is the subject of one of the most famous studies in the history of art, Rudolf and Margot Wittkower's *Born Under Saturn*. The Wittkowers observe that for centuries artists have been associated with the "Saturnine temperament" (i.e., sensitive, brooding, and inclined toward suicide), as ". . . there is an almost unanimous belief among them [the public] that artists are, and always have been, egocentric, temperamental, neurotic, rebellious, unreliable, licentious, extravagant, obsessed by their work, and altogether difficult to live with."[35] The Wittkowers also assert that Western artists have been traditionally perceived as individuals who tend to isolate themselves and live as "a race apart from the rest of mankind," a condition associated with the "otherness" of artists.[36]

Picasso's youthful conception of the artist as an individual fated to live as an outcast from society, a modern "leper" condemned by psychological conditions to unrelenting mental anguish, has many precedents in the history of art. Raphael's portrayal of Michelangelo in *The School of Athens* and Albrecht Dürer's engraving *Melancholia I* of 1514 (Fig. 55) are among the most salient depictions of the artist as an brooding introvert, oppressed and tormented by the genius of special knowledge. Dürer represented *Melancholia* as a winged woman surrounded by objects associated with creative activity.[37] She sits beneath an hourglass and an astrological chart. A Saturnine comet, symbolic of special foresight into coming misfortunes and disasters, passes under a rainbow. On the wall directly behind her, a magic Jupiter Square with numeric and astrological signs represents protection "against Saturn and against Melancholy."[38] The ladder indicates a desire for transcendence, but she remains earthbound. Immobilized by knowledge of her inevitable failure in a life devoted to competition with God, as well as an acute awareness of her mortality, she withdraws into a profound depression. Erwin Panofsky astutely interpreted this image as "a spiritual self-portrait of Albrecht Dürer" and a symbolic representation of the artist who feels ". . . inspired by celestial influences and eternal ideas, but [who] suffers all the more deeply from his human frailty and intellectual finiteness."[39]

Paul Verlaine (1844–86), Casagemas' favorite poet and a figure much admired by Picasso and Jacob, also believed that artists are prone to melancholia and suffering. Verlaine lamented the fate of individuals gifted with special powers of creative insight in his *Poémes Saturiens*:

> But those born under the sign of SATURN,
> Wild and tawny planet, dear to necromancers,
> Share among themselves, derived from ancient scrolls,
> A good portion of misfortune, a good portion of bile,
> Imagination, disturbed and debilitated,
> Which defeats their attempt to Reason.
> In their veins blood, subtle like a poison,

Burning like lava, rare, flows and runs over,
Scorching their sad, crumbling Ideal.
Thus the Saturnians must suffer, and thus must
Die – from awareness that we are mortal, –
Their chart of life was drawn line by line,
By reason of a malign Influence.[40]

Recent medical studies have confirmed anecdotal observations that individuals of artistic temperament are more prone than the general population to mood disorders, depression (melancholia), and suicide. A psychiatric study of fifteen artists affiliated with the Abstract Expressionists of New York revealed that about one-half suffered from manic-depressive illness, and that their suicide rate was "at least 13 times the general rate."[41] Another study of sixty composers revealed a nearly tenfold increase over the general population in depression or melancholia. Yet another study compared individuals in the "creative arts" with other professions and concluded: "the artistic group showed two to three times the rate of psychosis, suicide attempts, mood disorders, and substance abuse. . . [and] the rate of forced psychiatric hospitalization in the artists, writers and composers was six to seven times that of the non-artistic group."[42] Another study of medical records of thirty-six major British and Irish poets born between 1705 and 1805 documented "a strikingly high rate of mood disorders, suicide, and institutionalization;" the same study observes that independent analysis of the lives of modern writers and artists shows equally high rates of depression and suicide.[43]

Lacking any scientific or medical analysis of the relationship between artistic temperament and depression, Picasso must have struggled to understand the suicides of his colleagues. His desire to comprehend these tragic events naturally intersected with his own search for self-identity as an artist. At times he pursued this inquiry through visual metaphors referring to the act of creation and his own life as an artist. As previously noted, he depicted himself in a sketch for *La Vie* (see Fig. 2) standing between a naked woman and a painting on an easel. In this sketch he points toward the easel, thereby signaling his role as mediator between life and art, or as an individual endowed with the power to transform the physical reality of the model on the left into the painted image on the right. The art historian Josep Palau i Fabre believes Picasso derived this gesture from the creation scene in Michelangelo's *Sistine Ceiling*, where God generates life through a near electric spark of energy that passes from the divine finger to the body of Adam.[44] Picasso performs the same function in his drawings for *La Vie*, except it is the artist, rather than God, who animates or generates life. This raises the obvious questions of whether the artist possesses some special power associated with divinity, and whether there exists some mysterious affinity between intellectual and biological creation.

Answers to these questions may perhaps be found by returning to the mysterious birdman scene in *La Vie* (Fig. 37) and the related drawing *Allegorical Sketch* (Fig. 39), in which a naked woman reclines on the ground and extends her arms to welcome the arrival of her consort and the sexual act to follow. At the top of Picasso's *Decorated Frame* of about 1900 (Fig. 56) a nearly identical woman reclines on the ground and raises her arms in the air. She is flanked by a fish and a bull,

56. *Decorated Frame*, 1900, oil on wood. Museu Picasso, Barcelona

and accompanied by other symbolic images referring to procreation. At left center, a woman with long hair empties a vase of water, from which flows a baby and a fish, suggesting metaphors for egg and sperm. On the right side of the frame Zeus holds a small Athena, referring to the story of how the goddess allegedly "sprang" directly from Zeus's head. This is an especially significant creation myth because it concerns a man generating life through the process of thought, while the woman on the opposite side of the frame is associated with conception through biological or physical means.[45] The two images on either side of this frame thus represent a polarity of female vs. male, biological vs. intellectual, profane vs. sacred procreation. The fish and the bull flanking the reclining woman in the upper center echo these gendered polarities, while flowers blossom from urns, another reference to the regeneration of life.[46]

The bull eating a flower in the frame's upper right may also refer to Zeus, who according to Greek mythology, transformed himself into various animals in order to consort with women. Picasso was certainly familiar with the artistic tradition

of depicting Zeus engaged in violent sexual encounters with women, often in animal disguise, emphasizing the god's role as progenitor of life. Apparently fascinated by creation myths, Picasso drew numerous images of naked women accompanied by symbolic references to their role in the life cycle. A drawing of 1902 (Fig. 57) depicts a ram at the far left gazing at a naked woman reclining in a field of flowers. The woman raises her arms and displays her palms in a gesture of sexual availability, while flowers sprout from her breasts signifying fertility. This early appearance in Picasso's art of a horned animal as a symbol of phallocentric sexual desire, with implicit anthropomorphic and autobiographical associations, established a precedent for his later minotaur themes.[47]

Yet another bull appears in the left background of Picasso's *Decoration for a Fireplace* (Fig. 58), a drawing of June 1903, roughly contemporaneous with *La Vie*. On the left side of this image a young couple embraces, while to the right an old couple seeks the warmth of a fire. The enormous bull in the background can be compared with the large winged deity sheltering the lovers in *Allegorical Sketch* (Fig. 39) in the sense that the bull is associated with the initiation and maintenance of the life cycle. The flying birdman in *La Vie* assumes a parallel symbolic meaning by alluding to the artist's role as progenitor of life. Considered in the context of Picasso's early art, then, the iconographic scheme of *La Vie* engages a host of philosophical issues: What is the artist's role in the life cycle? Is artistic creation analogous to sexual procreation? Why are artists treated as social outcasts, and what is the artist's fate in the modern world?

Picasso's preoccupation with such issues surfaced in another of his drawings for *La Vie* (Cat. 6; detail Fig. 59), this one depicting the artist's model with long, flowing hair and a swollen abdomen indicating pregnancy.[48] In other drawings of the

57. *Study*, 1902–03, graphite and colored crayons on paper. Location unknown

58. *Sketch for the Decoration of a Fireplace*, 1903, ink on paper. Museu Picasso, Barcelona

59. Detail from Cat. 6, *Preparatory Sketch for La Vie*, 1903, conté crayon on paper. Museu Picasso, Barcelona

period Picasso indicated his familiarity with the Symbolist convention of associating long hair on women with sexual availability or fertility. By contrast, Picasso's drawing of a naked woman reclining on the ground with her hands crossed over her vulva (Fig. 60) – the same gesture associated with Casagemas in a previously cited drawing (Fig. 53) – signals a symbolic association between *short* hair and infertility or frigidity. Considering Picasso's symbolic association of sexuality with hair length, it seems entirely logical that Casagemas would be accompanied in *La Vie* by a woman with short hair and no hint of pregnancy – the opposite attributes of the woman who accompanies Picasso in the previously cited drawing (Fig. 59). And while Picasso depicted himself completely nude in the *La Vie* drawings (see Fig. 35), he covered Casagemas' genitals in the painting with a white cloth, another probable reference to sexual dysfunction.[49]

If we accept the theory that *La Vie* is an allegory about the life of the alienated, bohemian artist, a logical explanation emerges for why Picasso resurrected his friend, two years after his death, and cast him in the crucial role of the artist.[50] In light of Casagemas' suffering and suicide, Picasso must have considered his ill-fated friend a better representative of the tragic life of the outcast artist. Picasso

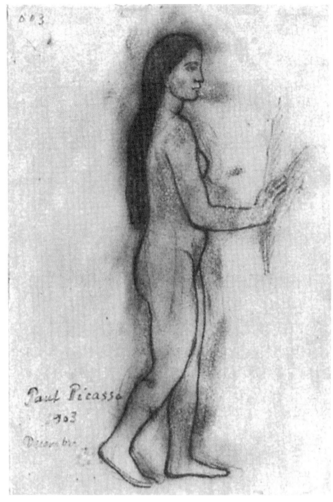

60. *Reclining Nude with Folded Hands*, 1902–03, conté crayon. Location unknown

61. *Standing Nude*, signed "Paul Picasso 1903 Décembre," charcoal on paper. Private collection

may have also wanted to extend his speculation on the relationship between intellectual and sexual creation by introducing Casagemas, a man incapable of generating new "life."[51] And once Casagemas assumed the role of the artist in the painting, the sexually potent birdman at lower center had to be replaced with a more appropriate visual symbol – a somnambulant woman huddled in a death pose.

Picasso's decision to rework *La Vie* may also be linked to the death of another artist. In May 1903 Gauguin died on a remote island in the South Pacific. However, the news did not reach Paris until August, and press notices did not appear until the fall.[52] Later that year, Picasso depicted a nude woman standing in profile and adorned with the long, dark hair of a Tahitian "Eve" (Fig. 61).[53] Noting the similarities in their given names, Picasso afforded Gauguin the ultimate homage by signing this drawing: "*Paul* Picasso / 1903 / Décembre." This inscription raises the intriguing question of whether the superstitious Picasso was unnerved to discover that his hero, Gauguin, had died in May 1903, the very month he had started work on *La Vie*, his most important statement about the life and death of the alienated, bohemian artist.[54] Did Gauguin's death reinforce

62. Photograph of Picasso standing in front of *The Fall of Icarus*, 1958. Palais de l'UNESCO, Paris

Picasso's fear that artists who defy social conventions are predestined to lives of suffering and tragedy? Knowing that fortune-telling "natal charts" are based on an individual's birth year, Picasso may have been equally disconcerted by the fact that he was born in 1881, the same year as Casagemas and Germaine, the woman who had "made his friend suffer" so much he committed suicide.[55] Did Picasso wonder whether these events were mere coincidence, or did he fear that like Casagemas, van Gogh, and the others, he too was "born under the sign of Saturn," i.e., an artist predestined to a tragic fate? After all, Jacob had predicted that later in life Picasso would suffer much cruelty – ironically, it turns out, at the hands of women.

In 1958, just fifteen years before his death, Picasso was commissioned to paint a mural for the UNESCO building in Paris.[56] An early drawing for the project depicts an artist surrounded by nudes in his studio, a theme ultimately replaced by *The Fall of Icarus* (Fig. 62). [57] Yet, traces of Picasso's original conception remain in the finished mural, as a full view reveals Icarus falling between four nudes, two reclining like bathers or models. According to classical mythology, Icarus was a mortal who tried to fly like the gods, but when he flew too close to the sun his wax wings melted and he plummeted to his death. This story has been traditionally interpreted as a metaphor for the artist's arrogant bid to rival God, a contest in which artists are predestined to tragic failure. (It is intriguing to observe here that Picasso told Geneviève Laporte of a recurring childhood dream in which he was an eagle in flight.)[58] In painting the death of Icarus, Picasso – now an old man, rich beyond imagination, the most famous painter in the world – must have thought about his former colleagues, as well as the irony of his own triumph over the presumed fate of the modern, alienated artist.

1. Picasso quoted in Geneviève Laporte, *Sunshine at Midnight*, trans. Douglas Cooper, New York 1975, 38.

2. There is some doubt about whether Picasso acquired Jarry's personal revolver, or simply adopted the same iconoclastic gesture using his own gun. John Richardson examines Picasso's relationship with Jarry in *A Life of Picasso*, New York 1991, I: 332, 362–4.

3. The "sacred and profane love" interpretation is suggested by the juxtaposition of the robed mother and child (sacred love) on the right with the naked couple (profane love) on the left.

4. I disagree with McCully and McVaugh's assertion that *La Vie* is unfinished. If so, why did Picasso sign the painting? Second, the Barcelona newspaper *El Liberal* published a laudatory article about the painting on the occasion of its sale to a French collector on June 4, 1903, and it seems unlikely that Picasso would have released this information if he had been displeased with the painting or considered it unfinished. Third, Picasso later commented on the title, but made no reference to the painting being unfinished. Fourth, there are other explanations for why Picasso did not entirely paint out the birdman scene below the recumbent naked woman in the lower center: for instance, perhaps this area represents a painting in the process of completion, and thus deliberately refers to the setting as an artist's studio and to process of artistic creation. Finally, Picasso often left visible *pentimenti* in paintings he considered finished. See McCully and McVaugh, 67.

5. This is the largest of the four known preparatory drawings for *La Vie*. The other drawings (Musée Picasso, Paris 473; Museu Picasso, Barcelona 110. 507 and 110. 508) include a third figure, a bearded man, presumably another bohemian artist (judging by his shabby appearance), who enters the studio on the right. Picasso executed two of the preparatory studies in brown ink, the other two in conté crayon.

6. Pierre Daix has identified the artist's lover or model as Germaine Pichot, the woman who had spurned Casagemas. Not everyone agrees, however, because the woman's features in *La Vie* are rather generic and idealized, especially when compared with the more distinctive appearance of Picasso and Casagemas. See Pierre Daix, *Picasso: A Life in Art*, New York 1993, 35.

7. Richardson I: 270, 275.

8. Previous studies with x-radiography reveal that an entirely different composition, horizontal in format, lies beneath the surface. The earlier composition was identified as *Last Moments*, a large canvas depicting a woman on her deathbed, painted by Picasso in Barcelona at the age of eighteen in an effort to align himself with Catalan *modernisme* and the international Symbolist movement. *Last Moments* and its relationship to *La Vie* are analyzed by McCully and McVaugh. Although difficult to see in reproductions, Picasso lightly sketched a bird in the lower center of one *La Vie* drawing (Museu Picasso, Barcelona 110. 508).

9. Richardson I: 243; Juan Cirlot, *Picasso: Birth of a Genius*, New York 1972, no. 960.

10. I would like to thank Dr. Stanton Thomas for observing that the faintly indicated woman with large breasts, who appears inside the winged man (Fig. 6), matches the contours of the winged women in another Picasso drawing (Fig. 7) with uncanny precision. Picasso may have unintentionally transferred her image from one drawing to the other by a process of laying one piece of paper above another, and leaving marks from the upper drawing (Fig. 7) on the lower one (Fig. 6) through the physical pressure of the drawing process.

11. According to Reff: "The black bird, whether a raven, a vulture, or a crow, is of course a familiar omen of misfortune or evil, . . . thus the lower painting in *La Vie* may have referred to the terrors of a guilty, sensual love, as the upper one refers to its desperate consequences." However, infrared reflectography clearly shows that the woman *welcomes* the birdman, thereby dispelling Reff's interpretation of the scene as a menacing or evil omen associated with death. Moreover, considering Picasso's anti-authoritarian if not anarchist sympathies, it seems difficult to believe that he would have created an allegory about the "terrors of guilty, sensual love." Even more improbable is Gedo's association of the birdman with "homicidal ideas." See Reff, 1973, 27–8; and Gedo, 1981, 126.

12. This drawing is a study for a painting in the underlayers of *The Old Guitarist* of 1903 (Art Institute of Chicago). The earlier painting is partly visible in x-radiographs of *The Old Guitarist*. See Ronald W. Johnson, "Picasso's 'Old Guitarist' and the Symbolist Sensibility," *Artforum* 13, December 1974, 56–62, and Mary Mathews Gedo, "A Youthful Genius Confronts His Destiny: Picasso's *Old Guitarist* in the Art Institute of Chicago," *Museum Studies* 12, 1986, 153–65.

13. Richardson sees intriguing relationships between *La Vie* and various cards of *The Tarot*. For example, the naked woman beside the artist resembles *The World* card, the artist's gesture in one *La Vie* drawing parallels that of *The Magician*, and the placement of the artist between two different types of women follows the scheme of *The Lovers*. Richardson I: 270–5.

14. *Catalogue of the Cary Collection of Playing Cards in the Yale University Library*, New Haven 1981, no. 214, described I: 166, illustrated III: 214.

15. Picasso's relationship with Jacob is discussed in Richardson (vols. 1–2) and Hélène Seckel, *Max Jacob et Picasso*, exh. cat., Paris 1994.

16. Italics mine. Author's translation of: "Toutes les lignes semblent naître à la base de la ligne de chance dans cette main. C'est comme la première étincelle d'un feu d'artifice. Cette sort d'étoile vivant ne se rencontre que rarement et chez les individuals prédestinés." Picasso kept this drawing in his personal possession prior to donating it to the Museu Picasso, Barcelona, in 1970. The text is transcribed in Seckel, 1991, 12–13.

17. Richardson I: 49; and Ariana Stassinopoulos Huffington, *Picasso: Creator & Destroyer*, New York 1988, 30.

18. Richardson I: 95–97.

19. According to Manolo, Casagemas' previous suicide attempt occurred in Barcelona. Manolo was an eyewitness to Casagemas' suicide at a Paris restaurant in February 1901. His account of the event, originally published in Catalan in 1927, is reprinted in translation in Reff, 46–47.

20. Daix, 27.

21. Richardson I: 211.

22. Donald Kuspit, *Signs of Psyche in Modern and Postmodern Art*, Cambridge, England 1993, 6.

23. Charles Morice gave Picasso this copy of *Noa Noa*, the location of which is currently unknown. See Richardson I: 263–4.

24. Paul Gauguin, *Noa Noa*, Eng. trans. New York 1919; first published 1901, 7–12, 74.

25. I have reproduced the second drawing, rather than the one with Picasso's inscription, because the former displays a complete view of the scene. Picasso's inscription on the drawing not reproduced here reads: "Calmann Lévy, editeur ancienne maison Noilles Lévy frères rue Auber 3 et 12 des Italiens et la librairie nouvelle et catalogue complete envoyé . . . Alfred de Vigny, oeuvres complètes, Poésies complètes, poèmes antique et modernes, les destinèes, poèmes philosophiques (oeuvre posthume) (poème Moïses)."

26. Author's translation of *Alfred de Vigny, Poésies complètes: Poèmes antique et modernes, les destinèes, poèmes philosophiques*, Paris 1989, 5–20.

27. Dr. Noir also witnesses the tragic scene of a condemned mother with her baby standing near a fountain in the prison courtyard of Saint-Lazare. There are striking parallels between de Vigny's description of Saint-Lazare and Picasso's paintings of 1901 depicting prostitutes interned at this prison, formerly the medieval leper house of Paris, which was converted into a state prison during the French Revolution. Picasso visited this prison and used it as the setting for his Blue-Period painting *Two Sisters*.

28. Irving Massey, introduction to Alfred de Vigny, *Stello*, Eng. trans. Montréal 1963, xii, xvii.

29. Author's translation of Pierre Andreu, *Vie et mort de Max Jacob*, Paris 1982, 40.

30. Antonina Vallentin, *Picasso*, Garden City, New York 1957, 46–7.

31. Baudelaire's essay of 1857 was published in reviews and an anthology of his collected works. The essay is here quoted in translation from *The Unknown Poe: An Anthology of Fugitive Writings by Edgar Allen Poe, with appreciations by Charles Baudelaire, Stephane Mallarmé, Paul Valéry, J. K. Huysmans, and André Breton*, ed. and trans. by Raymond Foye, San Francisco 1980, 79–82.

32. Ibid.

33. Mallarmé's translation of 1875 contained five illustrations by Edouard Manet, including an image of a raven perched on top of a bust of Athena.

34. I have reproduced one of the drawings, rather than the painting itself, because the latter is so dark in totality that it is difficult to read.

35. According to the Wittkowers, the Greeks were the first to associate artists with madness. They note, however, that when Plato wrote about the "sacred madness" of artistic inspiration, he distinguished between "creative" and "clinical" insanity. See Rudolf and Margot Wittkower, *Born Under Saturn: The Character and Conduct of Artists: a Documented History from Antiquity to the French Revolution*, New York 1963, xix, 101.

36. The Wittkowers were not alluding to the more specific connotation that appears so frequently in more recent art criticism, in which "the other" is associated with groups or individuals born — by circumstances of race, gender, sexual orientation, etc. — to live in permanent, oppositional status to the dominant culture. The more contemporary understanding of the term implies that one cannot choose to become an "other." The Wittkowers, by contrast, were describing a state of psychological alienation that might be termed the "bohemian other."

37. This interpretation of Dürer's engraving is derived from the brilliant analysis in Raymond Klibansky, Erwin Panofsky, and Fritz Saxl, *Saturn and Melancholy: Studies in the History of Natural Philosophy, Religion, and Art*, London 1964, 284–373. Picasso's humorous drawing *What Rusiñol was Thinking* (Perls Galleries, New York) also depicts an allegorical figure of "art" as a winged female deity.

It is interesting to note that in 1901 Max Jacob gave Picasso a Dürer print as a present, but the specific subject is not known.

38. Erwin Panofsky, *The Life and Art of Albrecht Dürer,* Princeton 1955, 171. Jean Clair revisits the subject in "Sous le signe de Saturne," *Cahiers du Musée National d'Art Moderne* 7/8, 1981, 177–207.

39. Panofsky, 1955, 171.

40. Author's translation of "Or ceux-là qui son nés sous le signe SATURNE, Fauve planète, chère aux nécromanciens, Ont entre tous, d'après les grimoires anciens, Bonne part de malheur et bonne part de bile, L'Imagination, inquiète et débile, Vient rendre nul en eux l'effort de la Raison. Dans leurs veines le sang, subtil comme un poison, Brûlant comme une lave, et rare, coule et roule, En grésillant leur triste Idéal qui s'écroule. Tels les Saturiens doivent souffrir et tels Mourir, – en admettant que nous soyons mortels, – Leur plan de vie étant dessiné ligne à ligne, Par la logique d'une Influence maligne." Lawrence and Elisabeth Hanson, *Verlaine: Fool of God,* New York 1957, 90.

41. Kay Redfield Jamison, *Depression and the Spiritual in Modern Art: Homage to Miró,* ed. by Joseph Schildkraut and Aurora Otero, Chichester, England 1996, 16–17. Schildkraut is a Doctor of Psychiatry at the Harvard Medical School, Otero is a Doctor of Psychiatry at the University of Barcelona Hospital and a former president of the Catalan Society of Psychiatry. Jamison has written other distinguished studies of manic-depressive illness and suicide, including *Touched with Fire: Manic-depressive Illness and the Artistic Temperament,* New York 1993 and *Night Falls Fast,* New York 1999.

42. Ibid.

43. Ibid., 9, 16, 20, 28. Although medical studies indicate that "artistic temperament" is related to higher rates of depression and suicide, no connection has been established with schizophrenia. The Wittkowers disagree and assert there is no demonstrable proof that artists are more prone to madness and suicide than the general population. Taking a broad view of history by studying artists from ancient to modern times, the Wittkowers argue that artistic character is individual and determined by historical conditions. The Wittkowers assert that during periods when intellectual detachment and rationality is valued, artists do *not* exhibit an exceptional tendency toward self-destructiveness and mental disorder. By contrast, the modern age of romanticism and psychoanalysis ". . . has produced a new type of artistic personality with distinct characteristics of its own." See Wittkower, 100–02, 148–49, 292–94.

44. Palau i Fabre, 341.

45. Various classical authors gave alternative accounts of Athena's birth. Some stories indicate that Zeus first swallowed his wife Metis while she was pregnant with Athena; another version attributes Hephaestus with adding the birth by splitting Zeus' head with an axe. See Mark O. Morford and Robert J. Lenardon, *Classical Mythology,* 4th ed. New York, 131–38.

46. Picasso apparently associated both the bull and the fish with the male principle, the latter because of its phallic connotations.

47. Picasso associated the minotaur with the bullfight, a ritualized drama of death, in which the beast succumbs to its predestined fate. The minotaur in Picasso's art seems to personify antithetical forces of procreation and destruction, life and death, good and evil.

48. A bearded man also appears on the right side of this drawing. His long hair and disheveled clothes indicate that he is probably another bohemian artist, rather than Picasso's father, as some scholars contend. Conservation analysis has been unable to resolve the question of whether this man was ever present in the painting itself. Picasso's decision to replace the man with a robed woman carrying an infant may reflect an attempt to overlay the artist's studio theme with a reference to the Symbolist "cycle of life," thereby expanding the subject into a more general allegory about the artist's relationship to the cycle of life, death, and regeneration. The two small scenes in the center of the finished painting – one depicting a naked couple huddled together, the other an isolated woman crouched in a fetal position – would complete the life cycle by referencing images of abandonment, suffering, and death.

49. When Picasso reworked the painting, he scraped out areas of paint and covered other areas with a heavy layer of lead white. These areas, such as around the head and back of the naked model, or beneath Casagemas' slip, contain lead white which blocks X-rays, making it is difficult to tell whether the model ever had long hair, or whether Picasso originally depicted himself with genitalia.

50. The crucial question of why Picasso resurrected Casagemas and placed him in the crucial role of the artist in *La Vie* has never been answered satisfactorily. I am not convinced by the psychoanalytic theory that Picasso was motivated by feelings of guilt over Casagemas' suicide. If so, why did Picasso begin the painting as an allegory about his own life as an artist? In other paintings and drawings of the period, Picasso indicts bourgeois society, women, and human greed for the misfortunes of the bohemian artist.

51. Whether Casagemas was physically impotent or not is a question that has been disputed in the Picasso literature. However, Picasso's drawing of Casagemas clasping his hands over his genitals (Fig. 21) certainly indicates an awareness of rumors that his friend suffered from sexual dysfunction.

52. Daniel de Monfried began circulating news of Gauguin's death among Parisian artists in August 1903, and death announcements appeared in *L'Art moderne* and *Revue universelle* in September–October 1903: see Françoise Cachin et al., *Gauguin,* Paris 1988, 376.

53. Gauguin wrote that a few, rare vestiges of the old culture still survived among the "conquered race" of Tahiti, most notably, the uncorrupted "Eve" who still possessed the "grace and elasticity of healthy young animals," and whose naked body and blood imparted the fragrant scent (*noa noa*) of "mingled perfume, half animal, half vegetable." Gauguin, *Noa Noa,* 12, 74.

54. Picasso dated one sketch for *La Vie* (Fig. 23) "2 Mayo 1903."

55. Picasso later made this remark to Françoise Gilot in an oblique reference to Casagemas' suicide. See Gilot, *Life with Picasso,* New York 1964, 82.

56. The early drawing for the project referred in the text is Musée Picasso, Paris, nr. 1518. A complete view of the finished mural shows Icarus flanked on the left by a naked woman and on the right by two reclining figures and a naked man clasping both hands over his torso. See Gaëton Picon, *La "Chute d'Icare" au Palais de l'Unesco,* Geneva 1971.

57. Daix, 337.

58. Laporte, 79.

THE CATALOGUE

1. Study of a Left Arm

1894
Charcoal and pencil on paper
17 ⅜ × 13 ⅜ in. (45 × 34 cm.)
Museu Picasso, Barcelona

Picasso made this drawing at the age of thirteen or fourteen, while a student at the Instituto da Guarda, an art school in La Coruña. Three years earlier, his family had moved to this town on the Atlantic coast of Spain, because his father, José Ruiz Blasco, had accepted a position as professor at the school. The boy officially enrolled in 1892 and pursued a curriculum that followed the conventions of European academies. Students were first immersed in drawing from casts of Greek and Roman sculpture in order to establish classical systems of proportion and idealized form, before moving on to the study of living models and the medium of painting.

Dated 1894, this drawing is one of a considerable number preserved from the second year of his schooling at La Coruña. It demonstrates a great mastery of academic technique, both in the rendering of the muscular arm preserved in this fragment and in the pattern of light and shadow playing over the forms. The number five inscribed at the lower right probably identifies the sheet's position in a sequence of class exercises.

As the signature at the upper left records, the student was still using the surname of his paternal family, Ruiz. Over the next few years, he would slip away from this artistic identification with his father and adopt his mother's more unusual surname, first signing "Ruiz Picasso," and finally "Picasso."

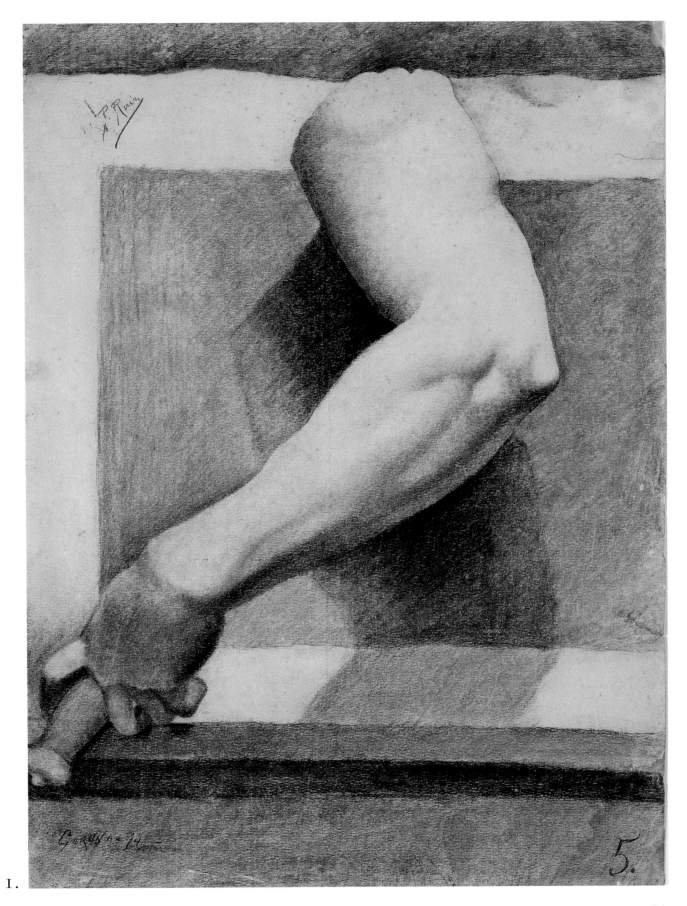

I.

2. Academic Nude

1895–97
Oil on canvas
32 ¼ × 24 in. (82 × 61 cm.)
Museu Picasso, Barcelona

In the spring of 1895, the Ruiz family moved to Barcelona, where Picasso's father took a position teaching at the School of Fine Arts. During the summers of 1895–97, the family returned to Picasso's native town of Málaga, where they stayed in the home of don José's brother, Dr. Salvador Ruiz Blasco, who had become wealthy serving as the chief medical officer at the port.

Dr. Salvador took a strong interest in Picasso's training and provided both studio space and models for him to study during his months in Málaga. Picasso's early efforts to gain attention for his talent were aimed at promoting himself as a painter of the "School of Málaga." *The First Communion* (1896; Museu Picasso, Barcelona) was a typical subject and was probably selected by Picasso's father.

Academic Nude is one of the studies Picasso executed during these summer sessions or during the regular season in Barcelona in the studio of José Ramón Garnello, a colleague of Picasso's father who allowed the boy to paint from models in his quarters. The austere setting suggests an impromptu working space, although the figure's pose fits the traditional method of training specified by don José for his son. The model has been carefully arranged, and props support his limbs so that he can hold the pose for an extended period of time. A small, triangular block maintains the angle of his right foot, a large cubic one raises his left leg in the air, and a long pole helps the man keep his left arm elevated. Although it may seem surprising that the man's face is obscured, this painting is not a portrait, but rather a study of the body as a set of interrelated limbs revealed by the raking light of a high window.

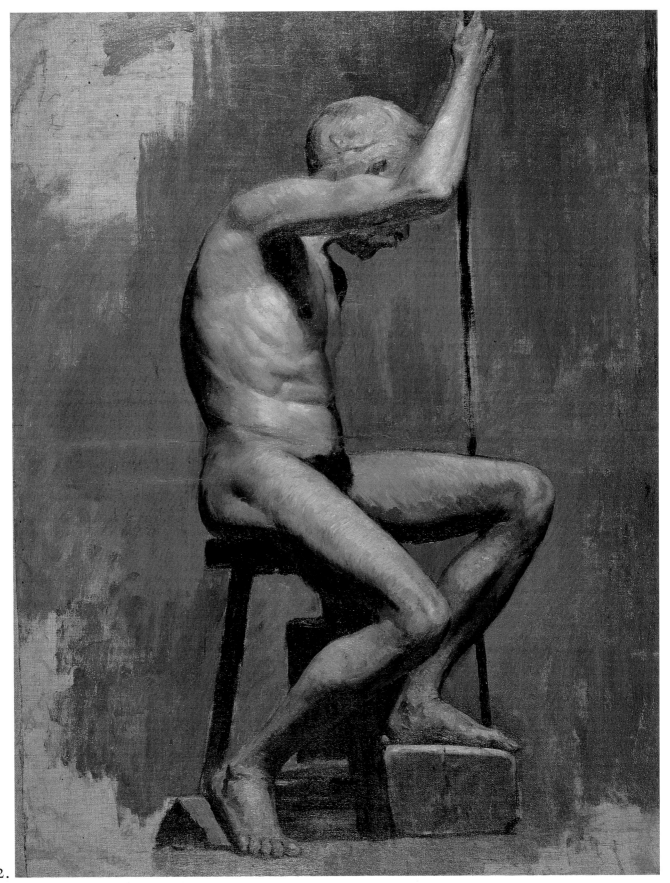

2.

3. The Artist Drawing and Studies of Hands

(Hartford only)
c. 1897–99
Charcoal on paper
13 × 9 ¼ in. (33.1 × 23.4 cm.)
Musée Picasso, Paris

This flamboyant self-portrait already manifests a rebellion from academic standards. Sporting a devilish beard and stripped to the waist, Picasso portrayed himself as a dashing figure of the modernist movement in Barcelona. His unconventional dress is matched by the simplified style of the drawing, which ignores details and uses thick, black lines to create a dramatic pattern of light and shadow across his figure

The emphasis on raw physical expression is a precedent for the self-portrait of 1906 (Cat. 9).

3.

4. Study for "Poor Geniuses"

(Cleveland only)
1899–1900
Pen and brown ink on paper
4 ⅝ × 7 in. (11.7 × 17.6 cm.)
Musée Picasso, Paris

John Richardson set the scene for this drawing: "On returning to Barcelona later in the summer [of 1899], Picasso concentrated more intently than ever on becoming a *modernista* [Catalonian modernist]. Ideas poured forth in such spate that his brush could not keep pace with his pencil, and only one of the more ambitious projects materialized. After failing to come up with a large version of the colorful *Andalusian Patio*, Picasso failed to come up with a large version of a composition provisionally named *Poor Geniuses*. Once again there is a deathbed, but for a change the victim is male, likewise the dejected bohemians – Verlaine's "poètes maudits" by the look of things. A likely concept since Casagemas [a close friend and supporter] identified with it. Apart from some powerful and moving sketches, nothing came of *Poor Geniuses*, at least for the time being. (The theme will surface again in the self-pitying self-portraits of the Blue Period.)"[1]

Since a large canvas appears to stand in front of the window in some versions of the interior, "the dejected bohemians" probably include painters as well as poets. The composition may be Picasso's first attempt to create an image of an avant-garde artist's studio and life within it, a theme he touched upon in *La Vie* (Cat. 5) and directly addressed in *The Tub* (1901; Fig 4)

4.

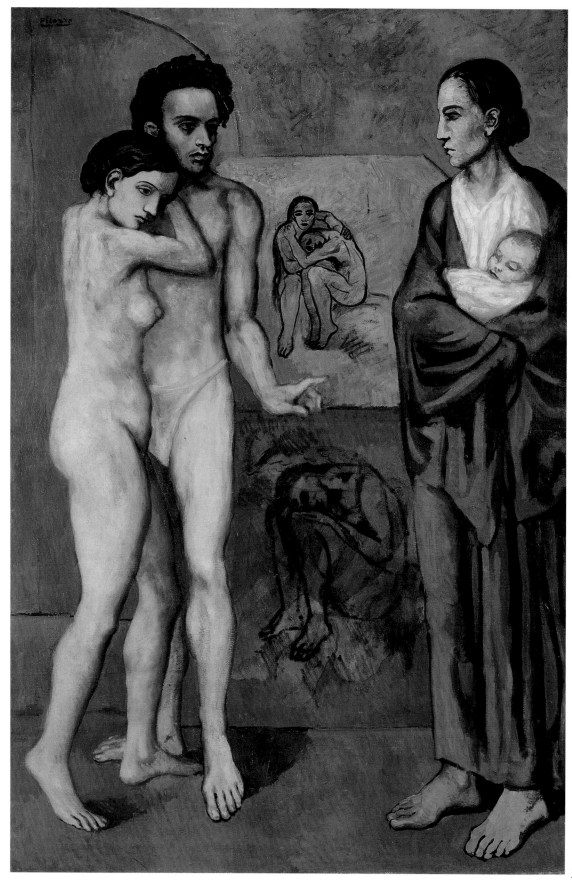

5.

5. La Vie

1903
Oil on canvas
77 ⅜ × 50 ⅞ in. (196.5 × 129.2 cm.)
The Cleveland Museum of Art.
Gift of the Hanna Fund 1945.24

6. Preparatory Drawing for "La Vie"

(Cleveland Only)
1903
Conté crayon on paper
6 × 4 in. (15 × 10 cm.)
Museu Picasso, Barcelona

7. Study for "La Vie"

(Hartford only)
1903
Pen and brown ink on paper
6 ¼ × 4 ⅜ in. (15.9 × 11 cm.)
Musée Picasso, Paris

See William H. Robinson's essay, pp.
63–87 in this catalogue

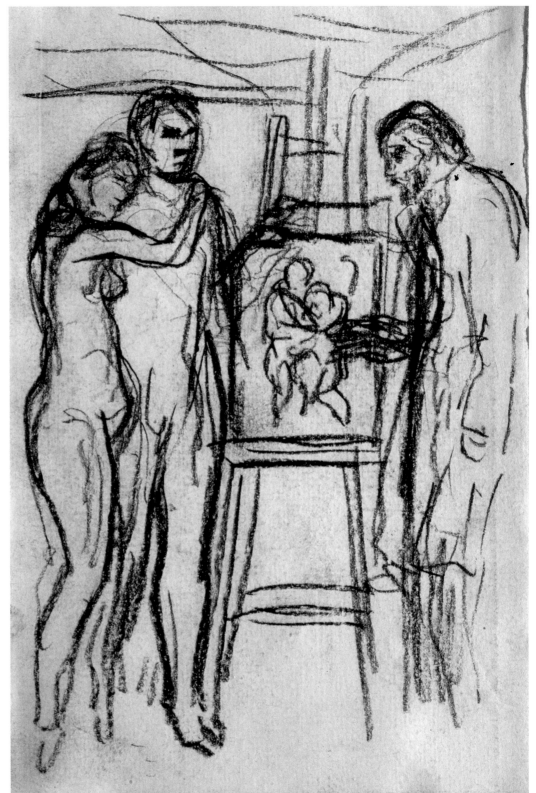

6.

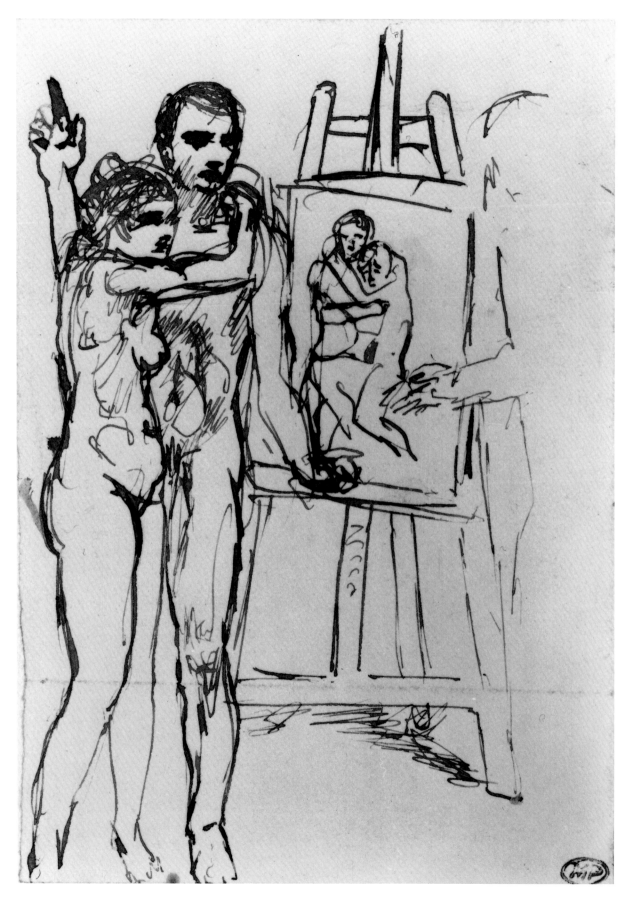

7.

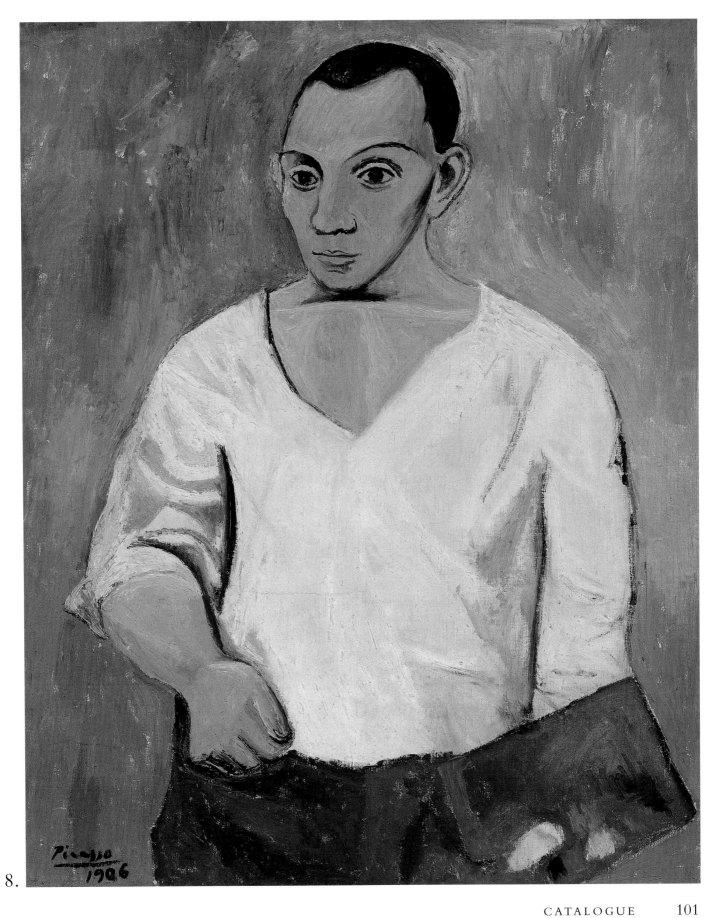

8.

8. Self-Portrait with Palette

1906
Oil on canvas
36 ½ × 28 ¾ in. (92.6 × 73 cm.)
Philadelphia Museum of Art.
A.E. Gallatin Collection

9. Studies for Self-Portraits

(Hartford only)
1906
Pencil on paper
12 ¾ × 18 ⅞ in. (32.5 × 48 cm.)
Musée Picasso, Paris

Picasso spent the early months of 1906 wrestling with a portrait of his most important collector, Gertrude Stein. By spring, they had had ninety sittings (Stein later reported), but Picasso was not satisfied and painted out her face, leaving the crucial commission unresolved. In April, his luck began to change when Ambroise Vollard, the art dealer who had given Picasso his first major exhibition in Paris in 1901 but not bought his work regularly thereafter, paid two thousand francs for almost all of the recent work Picasso had in his studio.

This substantial windfall enabled Picasso and his mistress, Fernande Olivier, to spend the summer in Gosol, a village in the Spanish Pyrenees. In this remote setting, Picasso settled many of the aesthetic issues that had hampered his work in the spring, particularly his growing interest in archaic Iberian figures he had been studying in the Louvre. Upon his return to Paris, Picasso returned to the portrait of Stein and gave her the Iberian-inspired mask that creates the forceful image of the painting.

Soon afterwards, he commenced *Self-Portrait with Palette*. Preliminary drawings, including the sketch in this exhibition, show that this composition also went through considerable transformation, although the early conceptions may have been confined to the sketchbook.[2] As the drawings record, Picasso considered portraying himself in the act of painting, with his gaze focused on touching brush to palette. In the final painting, however, Picasso showed himself staring outward and holding only a palette, his right hand clenched in a fist. Even more than the crude shirt he wears, it is the artist's broad, sharply chiseled face that conveys an impression of raw creativity. By appropriating for himself the mask he had first painted on

Stein, Picasso both celebrated his hard-won achievement and implied an equivalence between this wealthy and established patron and the recently arrived painter.

In 1934, the Wadsworth Atheneum organized the first exhibition of Picasso's work held in an American museum. Lent by its owner, the New York collector Albert Eugene Gallatin, *Self-Portrait with Palette* was the most important early work in the exhibition.[3]

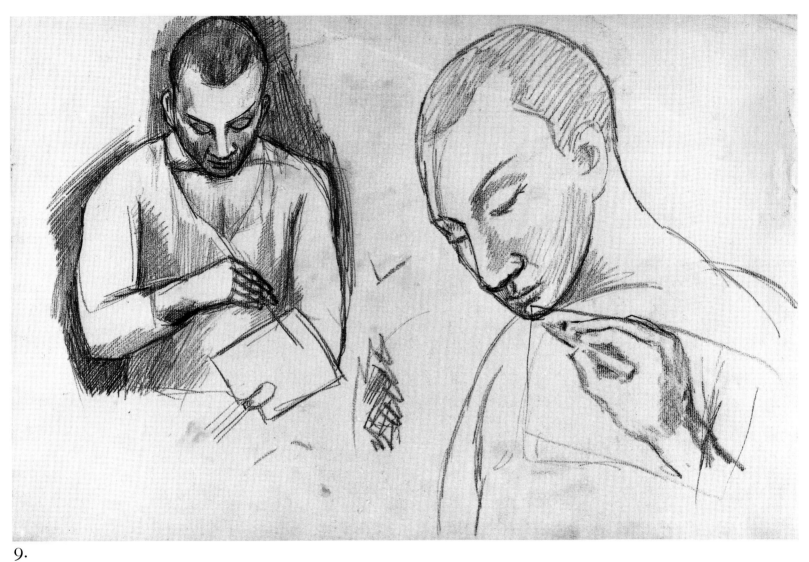

9.

10. Still-Life with Skull

(Cleveland only)
1908
Watercolor, gouache and pencil on
 paper
9 ½ × 12 ½ in. (24 × 32 cm.)
State Pushkin Museum of Fine Arts,
 St. Petersburg

This watercolor and a related oil (Fig. 8)[4] are generally thought to be commemorations of a German artist, Wieghels, who hung himself in the late spring of 1908. A resident of the tenement in which Picasso lived, Wieghels was a drug addict, whose proclivity for mixing toxic smokes (ether, hashish, and opium) drove him to madness and suicide in the Bateau Lavoir. Since Picasso and his friends occasionally indulged in opium, the death of a neighbor particularly struck them and apparently prompted Picasso to paint these garishly colored momentos of death set in his own studio.

The watercolor and the oil painting share the same foreground objects, a pipe, skull, and bowl, that presumably bear witness to Wieghels' death. This harsh subject matter is reflected in the sharply pointed facets that zigzag across the tabletop and are mirrored in the leaning rectangular palette and picture frame in the background. Both of these objects identify the space as an artist's studio, but only the oil painting specifies it as Picasso's own. The loose execution of the watercolor strongly suggests that it is a preliminary sketch and explains the rough blocking of the palette, without brushes, and the vague image within the frame. The oil, however, shows this painting-within-a-painting to depict a nude woman rendered in the style of *Three Women* (1908).[5]

In July 1912, when the Russian collector Sergei Shchukin bought both the oil and the watercolor from Picasso's dealer, Daniel-Henry Kahnweiler, dealer and artist exchanged letters discussing their reluctance to sell. Whether or not their hesitation was based on the link to Wieghels, there is no doubt that Kahnweiler held out for a very high price — 10,000 francs.[6]

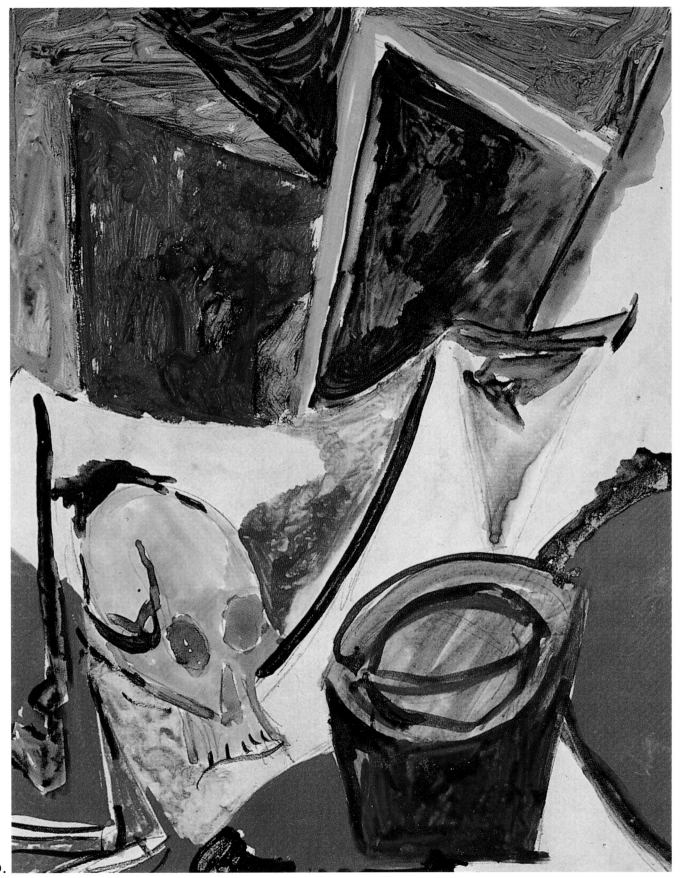

10.

11. The Architect's Table

Early 1912
Oil on canvas mounted on oval panel
28 ⅝ × 23 ½ in. (72.6 × 59.7 cm.)
The Museum of Modern Art, New
York. The William S. Paley
Collection, 1971

Although generally dated to the early months of 1912, this painting appears to have been begun in the spring of 1911 and put aside for a year before Picasso returned to it. He probably began the picture as a horizontal composition depicting one of his usual combinations of a mandolin and a glass resting on a tabletop. When he resumed work, he radically altered the painting's style, composition, and subject matter. He rotated the oval canvas to vertical and substantially repainted its surface in the highly ambiguous style of the winter of 1911–12, which reduced specific forms to what Picasso described as "like a perfume – in front of you, behind you, to the sides. The scent is everywhere, but you don't quite know where it comes from."[7] Among the objects that can be identified, Picasso transformed the mandolin into a violin and added the architect's ruler that gave the painting its title.

These two elements shift the picture from a café still-life, so typical of his contemporary work, to a still-life of the arts, a subject generally associated with the Old Masters. The ruler is an archaic choice to evoke the visual arts, since the traditional coherence of painting, sculpture, and architecture rarely persisted among Picasso's contemporaries. The violin's presence may help explain this selection. Besides recalling the classical music frequently played upon it, the violin may also stand here for artistic accomplishment across other media. Pepe Karmel has recently suggested that Picasso may have added it as a reference to Ingres' famous skill with the bow, which was recalled by the inclusion of his instrument in a retrospective of Ingres' work held in Paris at the Galerie Georges Petit in the spring of 1911.[8]

If Picasso seems to have cast a glance back to a nineteenth-century master he greatly admired as he created one of his most challenging works, he also slyly included references to his private life. The phrase "Ma Jolie" floating off a sheet of music was his nickname for Eva Gouel, a lover whose presence was still clandestine. The copy of Gertrude Stein's visiting card was a more evident (and ultimately successful) play for the resumption of purchases that had lapsed in 1910.

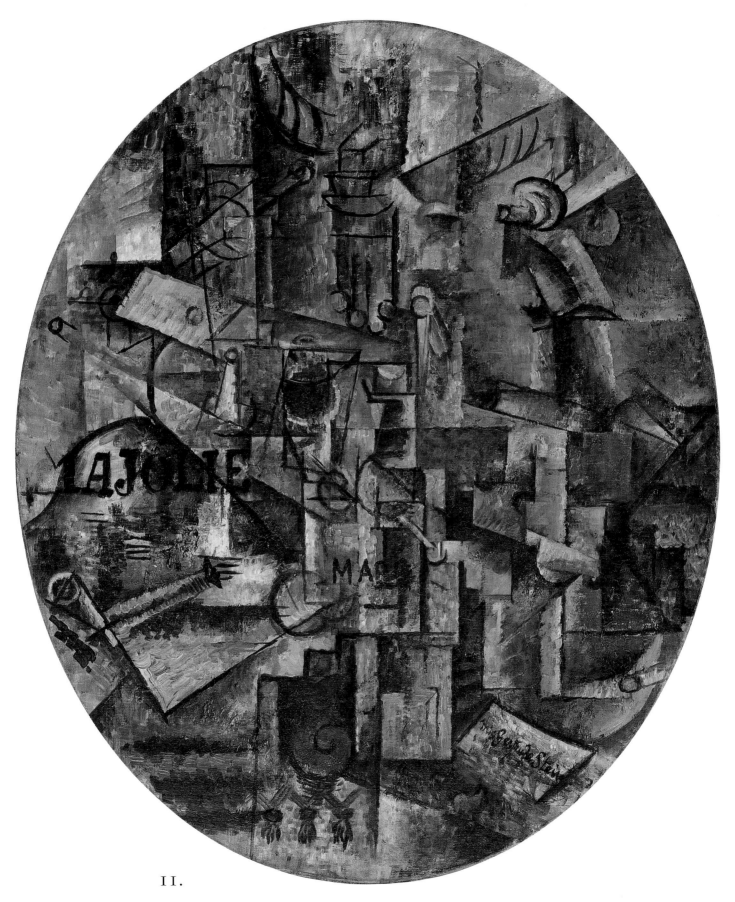

II.

12.

12. Four Studies of an Artist's Studio

(Cleveland only)
c.1914–17
Pencil on paper
2 ⅞ × 9 ¾ in. (7.2 × 24.7 cm.)
Musée Picasso, Paris

13. The Artist's Studio

(Hartford only)
c. 1914–17
Pencil on paper
10 × 9 ¾ in. (25.2 × 24.7 cm.)
Musée Picasso, Paris

Although the precise dates of these drawings are unclear, they can be situated among three other of Picasso's works – two paintings (*The Artist and His Model*, 1914, Musée Picasso, Paris, and *Harlequin*, 1915, The Museum of Modern Art, New York) and a group of photographs probably made in 1915–16. After rarely addressing the theme of the studio during the pioneering years of Cubism, Picasso returned to it in *The Artist and His Model* (Fig. 14), a crucial image of 1914 in which he explored his departure from the narrowly defined Cubism of his contemporaries by assimilating historical styles, particularly

Ingres' draftsmanship, into a broadened and reinvigorated Cubism. Picasso's decision to make the artist's studio the subject of his first painting in this revivalist, Neoclassical style evinces his self-consciousness of the change in aesthetic direction and its relationship to studio traditions. Nonetheless, his next studio picture was *Harlequin* (Fig. 12), an austere, strictly Cubist composition of the commedia dell'arte figure standing before an easel with a palette in hand. Picasso's long-standing resort to Harlequin for symbolic self-portraits portraying the artist as an itinerant performer is continued in this image made during the deprivations of the First World War, and it places the scene in Picasso's own studio. Given such role-playing, it is not surprising that Picasso took the series of photographs showing him in various guises – athlete, laborer, and dandy – at approximately this time.

The five drawings were probably made in rapid succession as Picasso roughed out a single composition. The four tiny sketches on a single strip of paper suggest this process, as does the shared imagery of palettes, canvases and sculptures placed in the same general location in each frame. The significantly larger drawing is very likely a more resolved and enlarged version of these

quick notations. On the left side of the left-hand little sketch, Picasso blocked out a man standing with a palette and brushes before an easel. Across the remaining three cells, this figure essentially disintegrates. In the larger, more finished drawing, only the curving outline of the man's back remains to mark his position, although the palette and brushes seem to float in the foreground (not unlike the palette in *Harlequin*), and a sculptural head rests on a shelf above, as if it had detached from the figure and metamorphosed into a classical bust. At the center, a painting remains on an easel, and to the right architectural moldings and picture frames fill the background.

Primarily a line drawing, this sketch probably anticipates a painting of the composition, which, unfortunately, Picasso never executed. The large, tilting planes of the drawing, however, clearly indicate that any painted version would have resembled the style of *Harlequin* or the slightly more intricate designs of 1916. One element would have distinguished this composition from its contemporaries: the explicit combination of classicism and Cubism. Instead, Picasso waited nearly ten years before he included in his paintings references such as the bust and the striding horse that stands at the peak of the composition.

13.

14. Rue La Boétie – Figure in the Studio

c. 1919
Oil on canvas
64 × 51 ½ in. (162.8 × 130.8 cm.)
Private Collection. Courtesy Art
 Focus Gallery, Zurich

In the fall of 1918, Picasso and his bride, Olga Khokhlova, moved into new quarters on the rue La Boétie, a fashionable street in the eighth arrondissement, on the right bank of the Seine. Picasso's building was next door to the Galerie Paul Rosenberg, and this location announced both the commercial alliance that artist and dealer had just concluded and the Picassos' entry into the *beau monde* of wealth and privilege that had once seemed inaccessible to Picasso and most other avant-garde artists.

As is discussed in the following entry, Picasso made drawings of the new accommodations soon after arriving. He rarely, however, devoted a painting to the subject. Far less than the drawings, which seem to catalogue the contents of the rooms, this painting structures a complex interplay between the interior and exterior view (in a later painting, *Studio Window*, July 3, 1945, Israel Museum, Jerusalem, Picasso used the interior of his Grands-Augustins studio as a frame for an exterior view).

In the summer and fall of 1919, Picasso frequently sketched and painted a subject he had rarely addressed, an open window. Since he was then staying in the Mediterranean village of Saint-Raphael, he probably took up the subject not only because of the spectacular scenery, but also in response to the contemporary artist most closely associated with it – Matisse – who lived a short distance away along the coast. While rendered in the brilliant hues of southern light, Picasso's images are relatively austere, avoiding the palm trees and boats common in Matisse's work and that both specify the location and supply a festive mood.

When he returned to Paris in October, Picasso continued the series, again without identifying the location. Like the previous works, these show a table set with various objects, standing before open French doors, through which a balcony and the open sky are visible. This painting is far more specific. The ribbed dome rising in the distance is the church of Saint-Augustin, which stands at the foot of the rue La Boétie, in the Place Saint-Augustin. Its presence immediately shifts the subject to an urban setting Matisse did not choose and into the context of Parisian scenes familiar among the work of his contemporaries, such as Maurice Utrillo.

Picasso's is not a tourist view. It is both specific to his home and rendered in a style that undercuts the simple pleasures of those pictures. His somber palette and use of the fractured planes of Synthetic Cubism create an image that surrounds the dome with an almost illegible set of signs. A rooftop and chimney pots stand to the left of the dome, and the curvilinear ironwork of the balcony are clear enough. In the darkened interior, a secretary table with letter slots below its flat top rests in front of the window. A large envelope lies on the table, and a woman, identified by her curvaceous figure and tiny waist, is at the right. While there is no precise indication, she is likely Olga – standing sentinel in Picasso's studio in the midst of Paris's most glamorous quarter. This scenario echoes in Picasso's late paintings of his second wife, Jacqueline, seated in the studio at La Californie (Cat. 41, 42); although, there, the luxuriant setting and her relaxed presence imply a far more sympathetic relationship between artist and muse, a mutuality suggested by the abundance of Picasso's art and materials that surround her but which are not present in the 1919 painting.

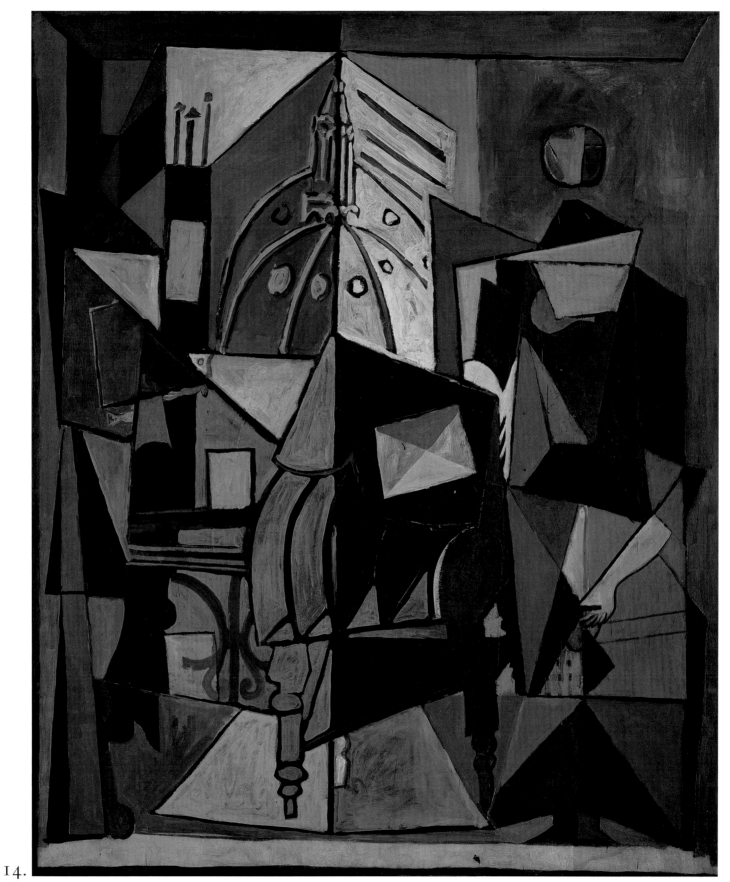

14.

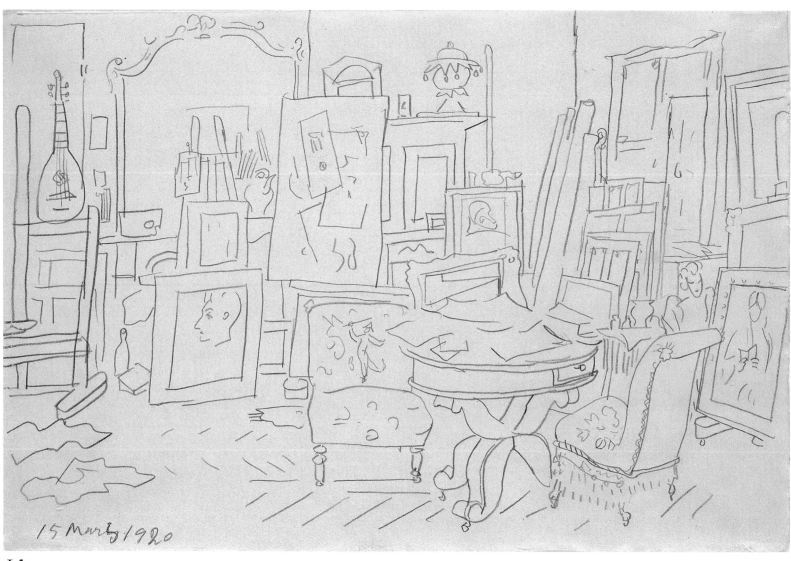

15 March/1920

15.

15. The Artist's Studio in the Rue La Boétie

(Hartford only)
March 15, 1920
Pencil on paper
9 ½ × 13 ½ in. (24 × 34.1 cm.)
Musée Picasso, Paris

16. The Artist's Studio in the Rue La Boétie

(Cleveland only)
June 12, 1920
Pencil and charcoal on gray paper
24 ½ × 18 ⅞ in. (62.5 × 48 cm.)
Musée Picasso, Paris

Soon after Picasso and his wife took up residence on the rue La Boétie in the fall of 1918, he began to draw their life in these commodious quarters. In a sense, the drawings presage his paintings of the villa La Californie, done in the 1950s, but the later works portray only his painting studio while the earlier sketches record a variety of domestic spaces and explore the high-bourgeois life he and Olga led. On November 21, 1919, he drew a group of friends gathered in the couple's sitting room.[9] Although the visitors were all men of culture, Jean Cocteau, Erik Satie, and

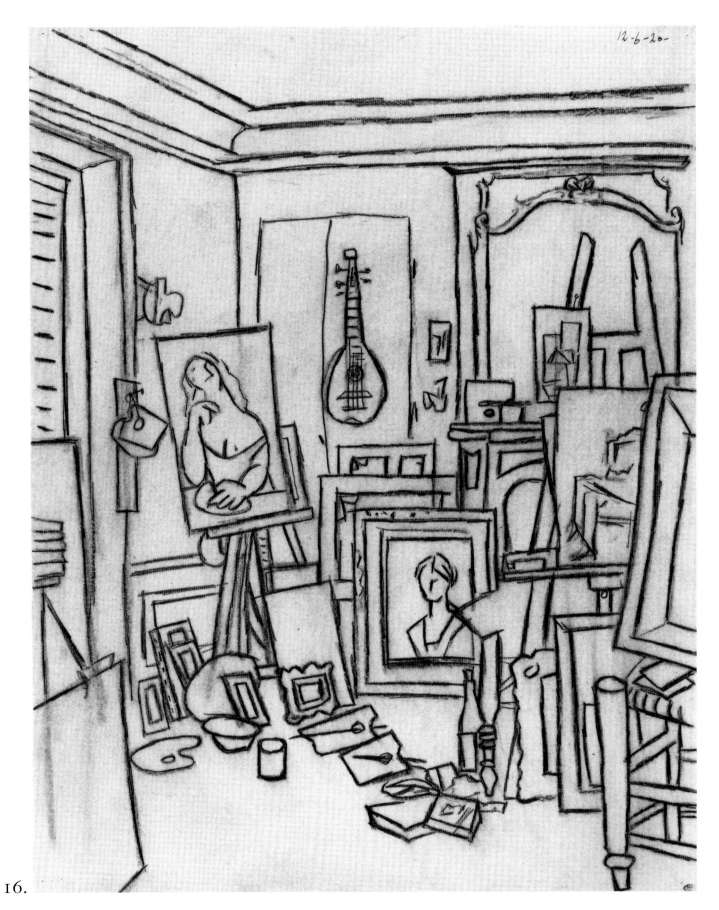

12-6-20-

16.

Clive Bell, their formal dress of suits and spats and the semi-circular seating suggest a proper tea party more than a meeting of intellectuals, especially seen against the herringbone floor, ornate fireplace and intricate wall moldings.

By March of 1920, Picasso had turned to his own studio. That drawing, like the one of June 12, shows an environment of a very different character. Instead of polite order, apparent chaos reigns, as paintings – finished and unfinished, framed and unframed – are squeezed between palettes, stringed instruments, chairs, and easels. The mullioned fireplace and walls are hung with ephemeral sculptures, probably cut from string and cardboard. The paintings in the June 12 sketch are recognizable portraits of Khokhlova, and the sheet does, presumably, record the room as it looked at that time. If so, the array of palettes in the foreground is unexpected, since Picasso is said to have rarely used this traditional tool, preferring instead to mix his paints on a board or paper laid on a table.

The scatter of Picasso's workplace could not be further from the strict order of the sitting room below, where Khokhlova held court. This series of drawings seems to capture the opposing sensibilities of husband and wife, who would soon split their domestic lives and separate formally in 1935.

17. Nude with Drapery

1922
Oil on panel
7 ½ × 5 ½ in. (19 × 14 cm.)
Wadsworth Atheneum Museum of Art. The Ella Gallup Sumner and Mary Catlin Sumner Collection Fund, 1931.198

When A. Everett Austin, Jr., purchased this painting for the Wadsworth Atheneum in 1931, he got a picture of far larger impact than the panel's tiny dimensions. In 1927, Austin became director of the museum. He immediately set out to make it "the art center of New England" by expanding its admirable collection of Old Masters and placing it at the cutting edge of contemporary art by sponsoring exhibitions and making a few ground-breaking acquisitions.[10] The purchase of *Nude with Drapery* for the modest sum of $2,500 was one of these adventurous moves. Very few American (or European) museums had yet acquired Picasso's work, but Austin already shared the opinion of his friend and colleague Alfred H. Barr, Jr., the founding director of the Museum of Modern Art, that Picasso was the greatest artist of the twentieth century.

If Austin could not marshal the funds to make more extensive purchases, he did bring off a spectacular temporary event: the first retrospective of Picasso's work held in America. It opened at the Atheneum in February 1934 and included seventy-seven paintings (as well as a group of prints and drawings) ranging from 1895 to 1932. *Nude with Drapery* was the only painting in the exhibition owned by the museum, yet this collaboration between Austin and Picasso's dealer, Paul Rosenberg, gathered many remarkable works from private collections, including *Self-Portrait with Palette* (1906; here Cat. 8).

Nude with Drapery is one of Picasso's most extreme explorations of the visual effects of disparities between size and scale. His so-called "Neoclassical" works of the late teens and twenties recall the proportional systems used by ancient Greek and Roman artists to depict the human figure, but exploit the reference to subvert those proportions radically

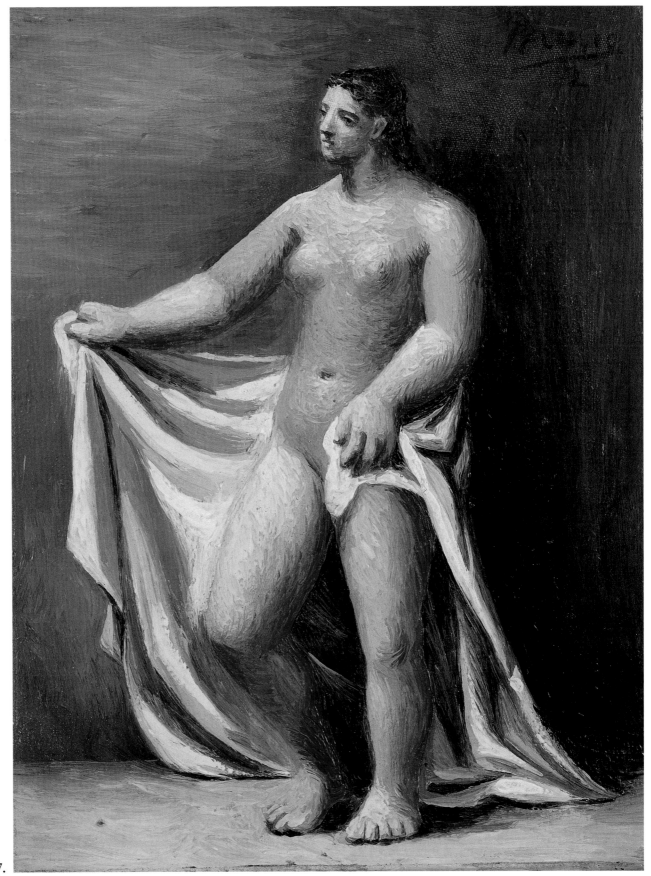

17.

(Fig. 15). The limbs of his Neoclassical nudes swell to amplitudes never sanctioned in classical harmonies and compose figures of such concentrated mass that they register as gigantic. They are his response to the posing models he had sketched in the academic courses of his student years.

Some of his paintings match the apparent mass of the figures with large format canvases, but others, such as *Nude with Drapery*, showcase the power of proportion alone to create the impression of great size by filling a tiny space with Lilliputian hulks. When seen on a wall, the paintings carry a visual weight far beyond their actual dimensions.

18. Bust and Palette

1925
Oil on canvas
21 ¼ × 25 ¾ in. (54 × 65.5 cm.)
Museo Nacional Centro de Arte
Reina Sofia

During his summer holiday at Juan-les-Pins in 1924, Picasso began a series of still-lifes that extended through his return to that Mediterranean village the following summer and his return to Paris for the final months of 1925. Although he had consistently painted still-lifes in the early 1920s, these present a vibrancy of local color and sun-drenched atmosphere missing from the previous ones. Set in intricately paneled interiors that open onto brilliant blue skies, they display menageries of objects from Picasso's accustomed repertoire of guitars, mandolins, liquor bottles, and bowls of fruit laid on luxuriously patterned cloths. Mixing Cubist patches of flat color with realistically detailed, perspectival projections of familiar objects, they suggest an almost Old Masterish opulence compared to the far more austere Cubist ones that preceded them.

The compositions from the summer of 1925 regularly expand this repertory to include works of art and artists' tools – fragments of sculpture, palettes and brushes, and sometimes a right-angle ruler. More than assemblages of symbolic attributes of artistic practice, as in still-lifes by Chardin, Picasso presented the objects in vivid juxtaposition. *Bust and Palette* is a prime example of this approach. Picasso gave the head, probably based on Roman portrait busts, visual drama by having it look directly out of the picture and playing strongly contrasting light and shadow across its features. Reading as a dark silhouette against a delicate blue of filtered sky, the palette stands erectly on edge, as if snapped to attention. The brushes also evoke artifice. Although their dark brown handles lie on the tablecloth and parallel its diagonal stripes, their thickly painted bristles seem more three-dimensional than the flat, black shadow falling across the sculpture they lean against. Rather than mere tools for an artist to

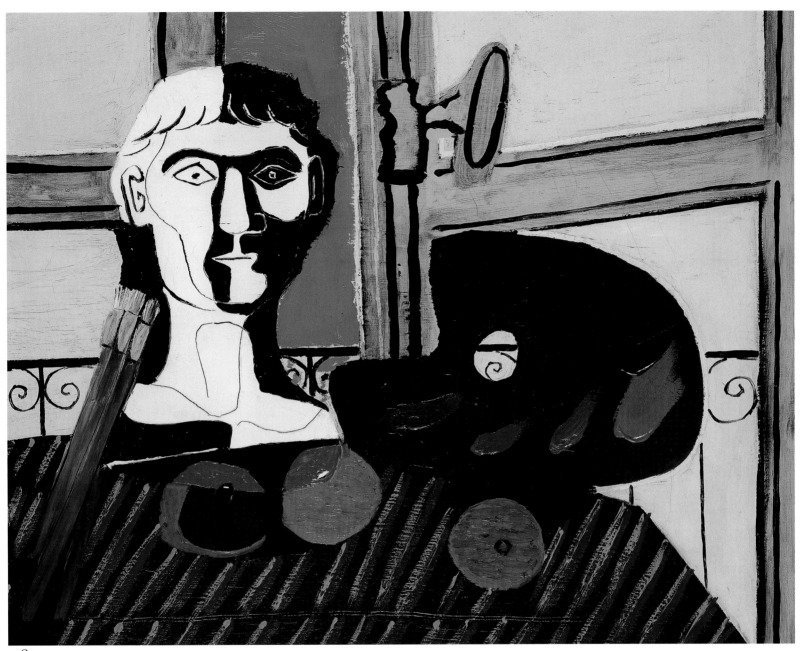

18.

wield or products of his imagination,
these traditional attributes seem to be
presented by Picasso as vital in their
own right, much as in the probably con‐
temporaneous *Studio with Plaster Head* in
the Museum of Modern Art, New York.

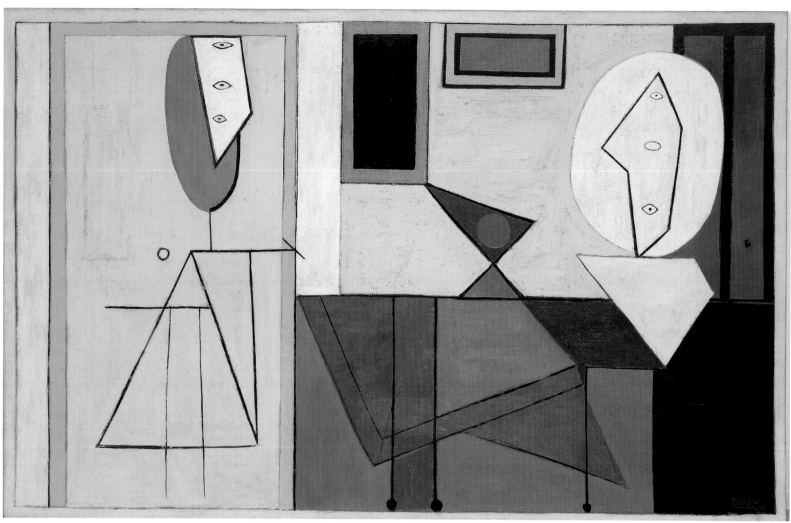

19.

19. The Studio

Winter 1927–28; dated 1928
Oil on canvas
59 × 91 in. (149.9 × 231.2 cm)
The Museum of Modern Art, New
 York, Gift of Walter P. Chrysler,
 1935

20. Painter in his Studio

1928
Oil on canvas
18 ⅛ × 21 ⅝ in. (46 × 55 cm.)
Private Collection

21. Painter with Palette and Easel

1928
Oil on canvas
51 ⅛ × 38 ⅛ in. (130 × 97 cm.)
Musée Picasso, Paris

22. The Studio

1928–29
Oil on canvas
63 ¾ × 51 ⅛ in. (162 × 130 cm).
From the Collection of the Musée
 Picasso on deposit at the Centre
 Pompidou, Paris

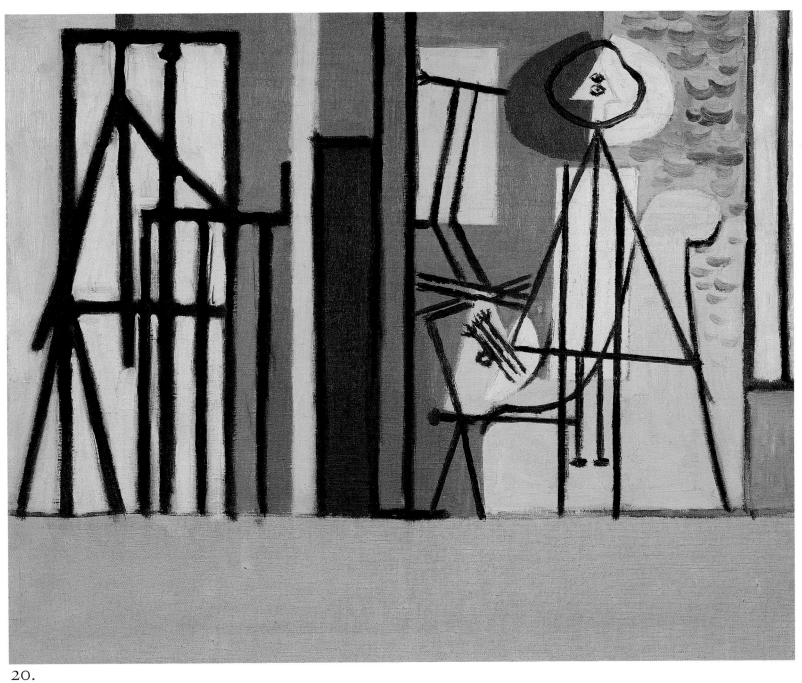

20.

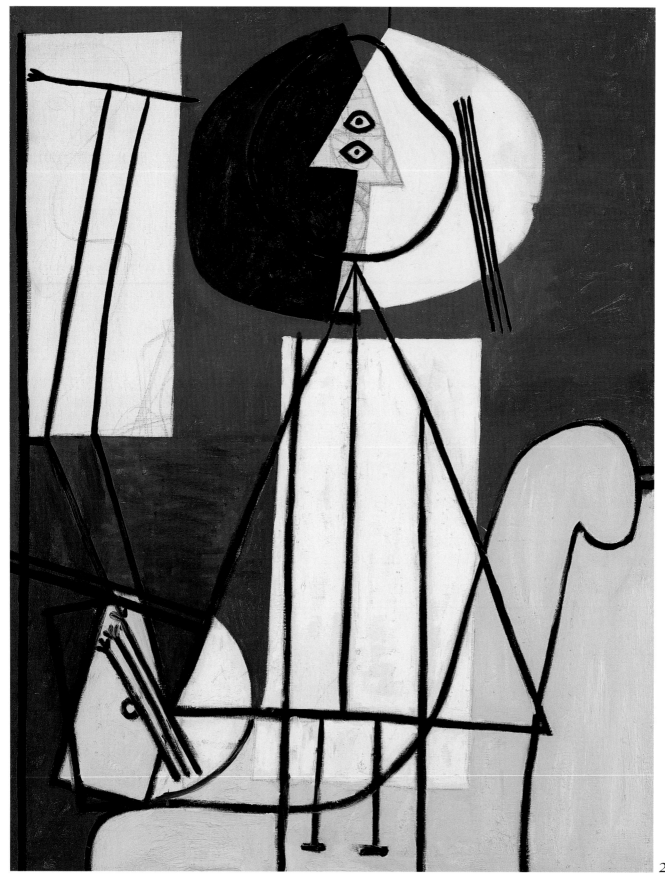

21.

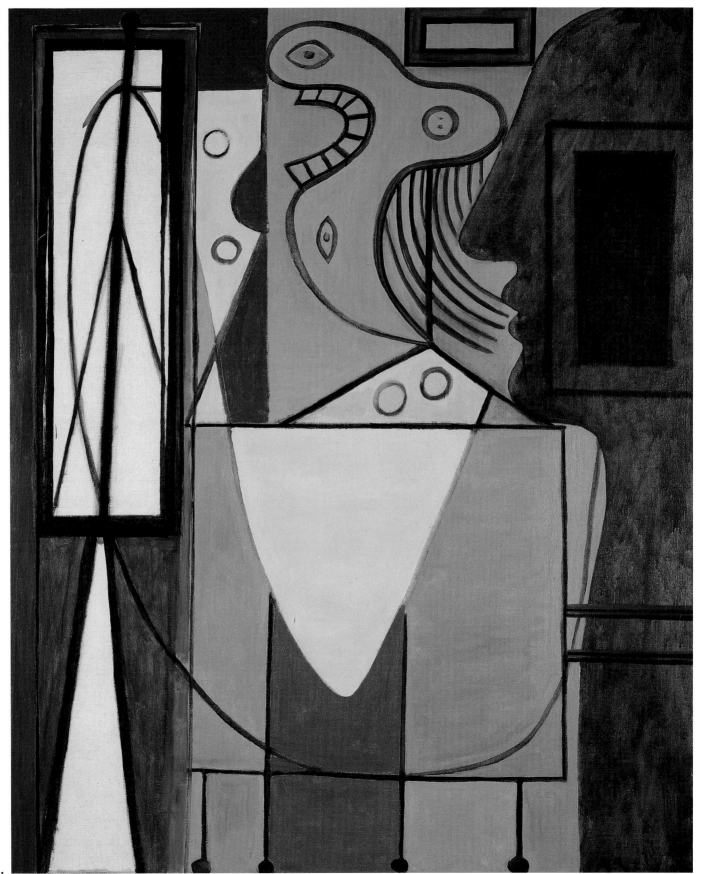

22.

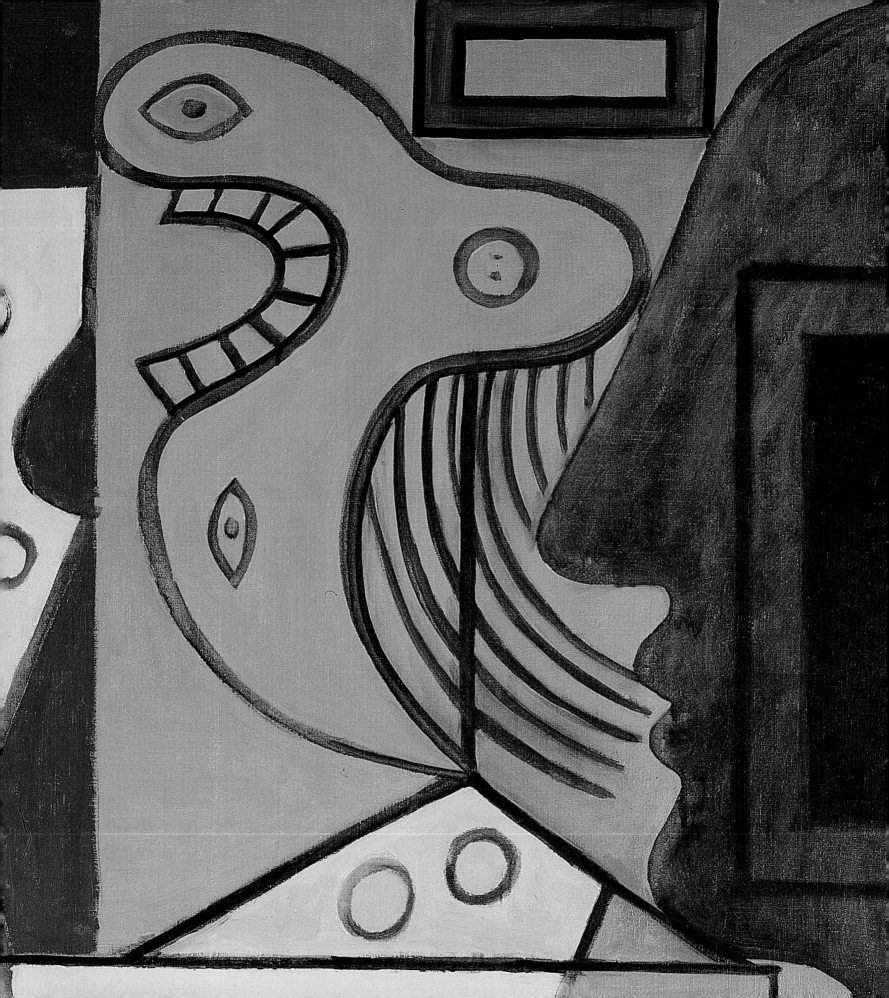

In the winter of 1927–28, Picasso made two large paintings of an artist at work in a studio that were immediately judged to be among his finest. The most innovative art magazine of the time, *Documents*, published both *The Studio* (Cat. 19) and *Painter and Model* (Fig. 21) in the first issue (April 1929) with commentary by the leading critic Carl Einstein and an unprecedented series of close-up photographs showing intricately worked passages of *Painter and Model*. Picasso presumably shared this high opinion of the two pictures since they appeared in the first retrospective of his work, which he played a large role in organizing, held in Paris at the Galerie Georges Petit in 1932.

Picasso's dealer, Paul Rosenberg, bought the paintings as soon as the artist would part with them and made them the centerpiece of his exhibitions on a number of occasions during 1929 and 1930. Despite their prominence, neither painting sold immediately. The collector (and, later, dealer) Sidney Janis left an account of how he acquired *Painter and Model* in 1933, shortly after another American collector, Walter P. Chrysler, Jr., had purchased *The Studio*: "in 1929 Paul Rosenberg…had this exhibition with new works by Picasso. And in that show was the *Painter and Model* [modern title] and also the stunning *Studio* picture… Well, the *Painter and Model* was in that show and I fell in love with it, and I came every day to look at it. And I finally got together with Paul Rosenberg on it, and he gave me a very handsome allowance on the Matisse *Interior at Nice* [which Janis had purchased in 1927–28], and I acquired this picture. After the deal was sealed, I asked Paul Rosenberg, 'Why did you part with this magnificent picture on a trade-in on the Matisse?' He said, 'Janis, I'll tell you. The Matisse I can sell immediately, the Picasso I wouldn't be able to sell for thirty years.'"[11]

There were very few collectors willing to buy such challenging pictures (particularly during the depths of the Depression), yet thanks to the discernment of Janis and Chrysler both of these came to America. And due to these two collectors' later generosity, both entered the collection of the Museum of Modern Art (*The Studio* in 1935 and *Painter and Model* in 1967). Janis lent *Painter and Model* to the Wadsworth Atheneum's first American retrospective in 1934, and both were included in Alfred Barr's landmark exhibition, *Picasso: Forty Years of His Art*, held at MoMA in 1939. In his subsequent monograph, *Picasso: Fifty Years of His Art* (1946), Barr offered the first historical analysis of the paintings, an approach that his successor, William Rubin, greatly enlarged along with other scholars.

Given this substantial attention to the paintings, it was surprising when three unknown versions emerged with the inventory undertaken after Picasso's death in 1973.[12] Suddenly this great set of paintings, which also included *The Studio* (1928, Peggy Guggenheim Collection, Fig. 22), doubled in number, and the relationships among the compositions offered an opportunity to follow in great detail Picasso's development of the theme. Two of these newly found paintings, *Painter with Palette and Easel* (Cat. 21) and *Painter in his Studio* (Cat. 20) are clearly transitional works but one, *The Studio* (Cat. 22), is a fully realized composition in the series. Yet, none appeared in the multi-volume catalogue of Picasso's work edited by Christian Zervos.[13] There is no evidence of why Picasso kept the three paintings or why he did not allow Zervos to photograph them for his catalogue.

Throughout his career, Picasso frequently worked in series, rejecting the academic goal of a single, consummate rendering for variations expressing multiple, sometimes contradictory, aspects of a composition. After the first decade, however, he rarely used canvases as preparatory works. Either he employed drawings or, more frequently, he worked through the problems of each variation on a single canvas, burying a rejected passage under a new solution. Any observer attuned to this process can see that Picasso substantially repainted both of MoMA's canvases, *The Studio* and *Painter and Model*. *The Studio*'s thin layers of paint only partially obscure an earlier stage of the composition in which the artist (standing at left) held a palette, and *Painter and Model*'s thickly built impasto often follows the contours of submerged outlines.

This evidence of revision might seem sufficient to explain the differences between *The Studio*, which Picasso painted in the winter of 1927–28, and *Painter and Model*, which probably dates from the early months of 1928, after the completion of *The Studio*. Yet the changes in both the overall proportions of the composition and its internal imagery are among the most divergent in any of Picasso's series, shifting from an austere, planar elegance to an ornate curvilinearity. And the few preparatory drawings for *Painter and Model* show the new version already largely resolved. The small canvas, *Painter in his Studio* (Cat. 20) fills the gap. While the design follows the format of the earlier painting, the greater verticality of the stretched canvas (with an unpainted lower strip) suggests that Picasso was in the process of altering the proportions toward those of the later *Painter and Model*. Moreover, the imagery of *Painter in his Studio* falls squarely between that of the two major paintings. Although the fundamental transformation is underway with *The Studio*'s artist becoming a model and its bust the

Painter's artist, many remnants remain. On the left side of the composition, in particular, the rectilinear framework of *The Studio* remains in the thick black bands that surround and construct the figure. On the right, the painter's body emulates *The Studio*'s triangular rendering, although its shield-like head and the palette and brushes grasped in its spindly hands are a major step towards the later version. The drawing, *The Painter and his Model*, marks a further step toward the final painting by showing the model as a female figure, largely reduced to an elongated head, and a classicizing profile inscribed on the painter's canvas. Dated by Picasso "11 February 1928," this sketch (together with one from the following day) provides the only specific documentation of the series' chronology.[14]

Painter with Palette and Easel (Cat. 21) is even more unusual in Picasso's work, because it extracts a section of the full composition as an independent work. Picasso almost always substantially varied a subject when he returned to it in a series, yet in this case the image of the painter is nearly a duplicate of the one in *Painter in his Studio*. The only substantial changes are the evenness of the larger painting's background and, more significantly, an elaboration of the painter's head. This conception, with a triple strip extending beyond the perimeter of the face, appears only in this version. It closely resembles, however, a small sculpture of a head standing on a tripod that is generally thought to have been made by Picasso in the fall of 1928. If so, the two-dimensional version probably preceded the three-dimensional one, and the sculpture marks a return to the subject some months after Picasso finished *Painter and Model*. The resort to sculpture is not especially surprising, since the model in both the large paintings is a bust, nor is Picasso's

choice to make a sculpture of the artist rather than of a subordinate figure. Indeed, the fundamental transformation from *The Studio* to *Painter and Model* is the intricately realized rendering of the artist and his creative process, evident in the figures on the canvas, which is now tilted for the viewer to see.

The final painting, *The Studio* (1928–29; Cat. 22), in many ways stands apart from the series. Unlike the others, it does not focus on the artist (alone or with a model); it does not even directly picture anyone. Its shadowy interior resembles the setting of the previous *Studio* (Cat. 19) with a female bust and a fruit bowl resting on a table (at center) and an easel on the right. Yet the mood is entirely different. Instead of the vivid primaries of the earlier pictures, this one is mainly shrouded in grays, brown and black, as if the lights had been extinguished. The woman's head is contorted by a gaping grimace and seems about to attack the easel, while behind her a dark silhouette fills the right side of the canvas. This juxtaposition of a monstrous female head with an impassive, classically featured profile, both cast in shadow, spills from another of Picasso's contemporaneous series – paintings such as *Figure and Profile* (1927–28, Private Collection). The profile is based on Picasso's own (at approximately this time, he photographed his silhouette cast on a wall) and the open-mouthed woman is generally believed to derive from Picasso's wife, Olga Khokhlova, whose unhappiness with her husband regularly resulted in fits of screaming. With this last work, the series completes a trajectory from the near abstract, to a fantastic tangibility, and, finally, autobiographical realism.

23. The Sculptor and his Model

(Hartford only)
August 4, 1931
Pen and India ink on paper
12 ¾ × 10 in. (32.4 × 25.5 cm.)
Musée Picasso, Paris

24. The Sculptor

December 7, 1931
Oil on plywood
50 ⅜ × 37 ¾ in. (128 × 96 cm.)
Musée Picasso, Paris

In May 1931, Picasso took possession of the chateau of Boisgeloup, an estate located about forty miles northwest of Paris, which he had purchased the previous June. The country house served as an escape from the city and his troubled relationship with his wife, Olga, where he and his mistress, Marie-Thérèse Walter, could be together without intrusions. It also provided the opportunity for Picasso to open a new direction in his art. Taking advantage of the property's ample accommodations, he immediately converted a stable into a sculpture studio. For most of the preceding decade, his work had reflected a concern with composition in mass that seemed to beg for realization in three-dimensions. Yet, Picasso produced very few sculptures in the twenties, and most of those explored the possibility of industrial metals to shape volumes rather than solids.

Once at Boisgeloup, however, he immersed himself in sculpture, creating a body of work that is among the high points of the medium in the twentieth century and rivals his painting during the early thirties. The core of this contribution is a series of heads, based on Walter's full features, in which Picasso ranged across the gamut of representation from near portrait-like realism to highly abstracted transformations.

This return to sculpture literally spilled into his contemporary painting and drawing through the subject of a sculptor at work in his studio or contemplating a finished piece. Drawn in the first months after arriving at Boisgeloup, *The Sculptor and his Model* seems to document the mimetic phase of this process, as the sculptor carves a small replica of a nude woman who poses on a raised platform. The exquisite delicacy of the rendering and the airy view of the window convey an impression of realism; yet the artist is not a

self-portrait, and Picasso rarely, if ever, worked directly from a model in these years. Moreover, the triad of artist, sculpture, and model is fractured by a foreground figure nearly lost in shadow. Seen only as a head of a woman, this may be a completed sculpture or a person who turns her back on the session. Once discerned, she redirects the viewer from the scene behind and leaves the activities in doubt.

Picasso painted *The Sculptor* four months later, in December 1931. While the artist resembles the man in the preceding drawing, the painting addresses a different stage of the process. Realism has almost completely receded, and no action takes place. The sculptor contemplates one of his creations, a bust of a woman (which reflects Walter's features and closely resembles actual sculptures Picasso made in 1931) in a room where another sculpture, depicting a seated woman, also rests on a pedestal. A wide range of sculptural form is presented, from partial figure to whole and from flat linearity to blocky mass, yet the focus is not on contrast but metamorphosis. Even the sculptor seems to glide from solid to ribbony outline as we slip down his body to his outstretched toes. This constant change in the illusionistic field suggests the artist's creative process as he imagines one variation growing out of another, but, reinforced by the brilliant colors, it also conveys the relative ease of capturing such transformations in paint.

23.

24.

25. Still-Life with Bust, Bowl, and Palette

March 3, 1932
Oil on canvas
51⅜ × 38⅜ in. (130.5 × 97.5 cm.)
Musée Picasso, Paris

Throughout his career, Picasso regularly contributed to the longstanding western tradition of still-lifes representing the arts. Best known through the work of Chardin, these compositions of objects grouped on a table generally include either a selection of implements for painting, drawing, sculpture and architecture, or examples of the art works themselves.

Still-Life with Bust, Bowl, and Palette fits comfortably within this history, while actively altering its terms. Emblems of two arts, the palette and bust, appear with a bowl of fruit, an element that often appears because fruit's beauty and sensuality are considered complementary, even though its ephemerality contrasts with art's relative permanence.

Unlike the traditional pictures, however, this one does not rely merely on the realistic rendering of these significant objects to convey the theme. Spatially, the composition is skewed so that the palette hanging on a back wall seems nearly parallel with the bust. Although the golden fruit and tablecloth of blues and lavender (together with the green wall) contribute strong notes of color, the primary relationships are linear. By rendering each of the objects loosely and bounding them with thick black outlines, Picasso created a family resemblance, particularly between the palette and the bust seen in strict profile. In this comparison, sculpture looms large; yet painting is ultimately dominant, since the objects only exist through the illusion of pigment on canvas. Manipulation of shapes enabled Picasso to turn a static tradition into a dynamic composition of competing arts.

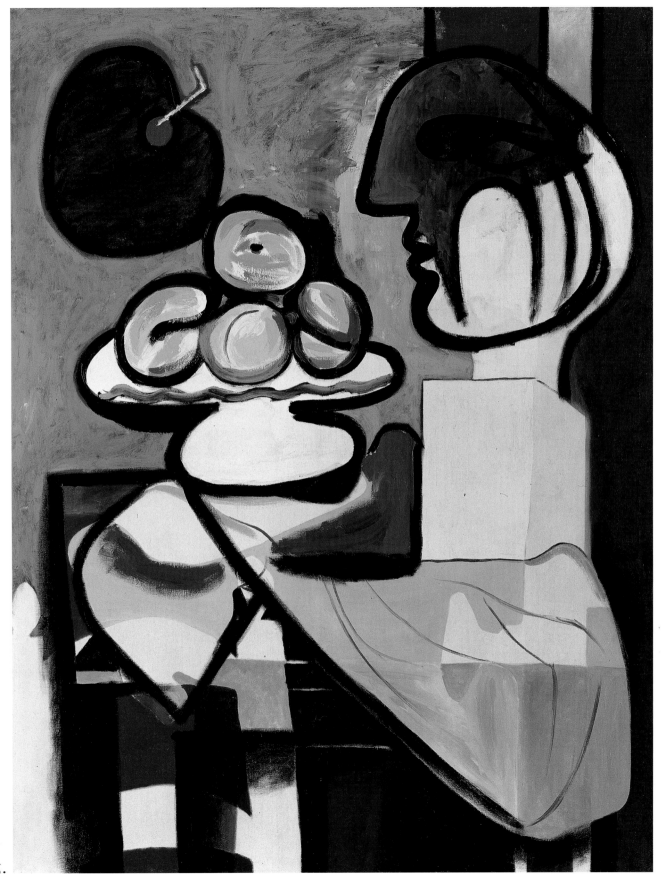

25.

26. The Studio

1934
Oil on canvas
50 ⅜ × 62 ⅜ in. (128 × 158.4 cm.)
Indiana University Art Museum. Gift of Mr. and Mrs. Henry R. Hope

Like *The Painter* (Cat. 27), this image of an artist working in a studio is largely devoted to the model, whose physical abandon is especially pronounced. Draped across the canvas in deep slumber, she is only marginally wrapped in a green dressing gown, whose s-patterned border repeats the extended curve of her body. This impression of languorous sensuality becomes explicit with the melon-shaped breasts that seem to have rolled to a halt by her pearl necklace.

Yet, the swell of her belly defines the image. As visible underpainting shows, Picasso had crossed the woman's stomach with heavy black lines, fragmenting it into separate facets as he did other parts of the composition. In the final version, however, he unified the volume and emphasized its rounded protrusion by placing thick lines along its contour. The effect is to make the woman appear pregnant. Since her full profile and bob of thick hair are features Picasso often derived from his mistress, Marie-Thérèse Walter, it is intriguing to speculate that he may be imagining or even anticipating her own pregnancy. On October 5, 1935, Walter did give birth to their daughter, Maia.

In contrast to this featured player, the painter and his canvas nearly blend into the woodwork. Not only do they occupy a small part of the canvas, but Picasso rendered them in the patchy manner he rejected for the model. Seated at the left, the artist holds a palette and sheaf of brushes as he works on a partially finished picture. Perhaps suggesting that this artist is completely identified with his materials, the scatter of vivid pigments across his palette suffuses his face, beard and hair in a brilliant camouflage that almost leaves him invisible.

The painting in progress is more legible and more surprising. It clearly depicts a flowering vine. Although the model holds a blossoming stem in her left hand, it is not visible to the artist, who looks toward the woman as he paints. Instead of portraying her imposing body, Picasso reduced it to a metaphor of natural fecundity, whose criss-crossing, curvilinear form and green sheath are mirrored in the vibrant plant. If the painter in *The Studio* is absorbed in his craft, his creative vision certainly transforms the subject.

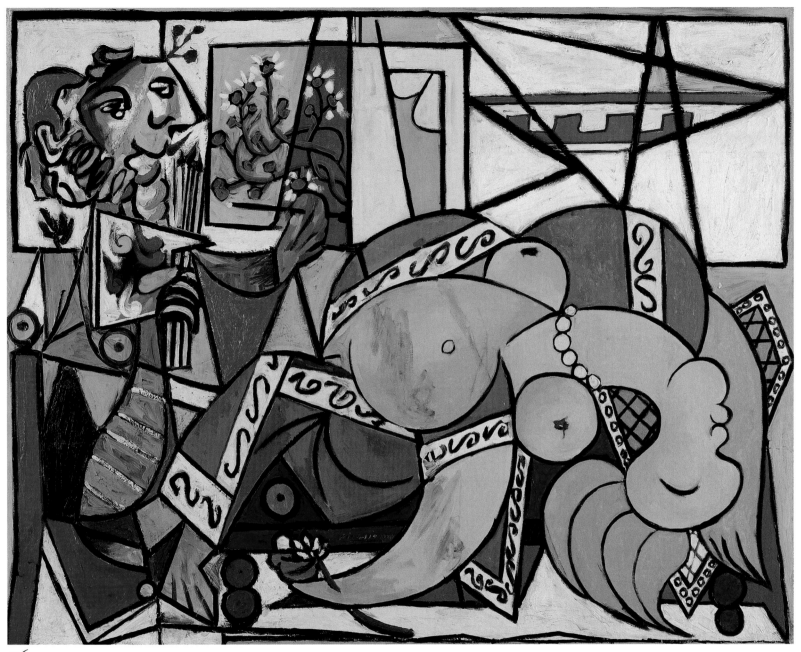

26.

27. The Painter

May 13, 1934
Oil on canvas
18 ⅛ × 21 ¼ in. (46 × 54 cm.)
Wadsworth Atheneum Museum of
 Art. The Ella Gallup Sumner and
 Mary Catlin Sumner Collection
 Fund, 1953.215

Like a child finger-painting, Picasso scribbled across a window at the upper right of *The Painter*, "Boisgeloup / 13 mai / xxxiv." The loosely drawn letters and numbers slip their lines and almost dissolve in a spiral of free strokes as they float on a brilliant green field, quite unlike the precision of Picasso's tiny signature. The fresh tones and air of spontaneity reflect the setting – a spring day at Picasso's country estate of Boisgeloup – and pervade the composition even as it inflects to represent radically different modes of behavior.

Picasso harnessed his full mastery of line and color to create a painting that juxtaposes seeming opposites only to join them in a harmonious union. The undulating lines of nature are duplicated in the model's sinuous languor. While the exterior light suggests daytime, the more somber lavender and turquoise hues of the female figure, as well as her deeply shut eyes, imply evening or night. Indeed, Picasso generally painted after dark, and a number of his pictures of his mistress, Marie-Thérèse Walter, are inscribed as having been made after midnight. The short, blond hair of this figure clearly associates her with Walter.

Beside this riot of natural abandon, the painter and his easel are strikingly removed. The strict rectangle of the canvas on which he works serves as a barrier between the artist and the spiraling forms of the model. Furthermore, the unmodulated primaries of the blue canvas and yellow painter stand in isolation from the secondary and tertiary tones across the majority of the painting. The visual impact of the yellow, in particular, gives the artist a prominence far greater than the proportion of the canvas he occupies and breaks the composition into two parts, suggesting a division between the naturalness of the model and the painter's discipline. If this dichotomy implies a hierarchy dominated by the artist, Picasso nonetheless includes both forces in the same composition and links them with the painter's gesturing arm, thereby insinuating the necessity of their union in a complete work of art.

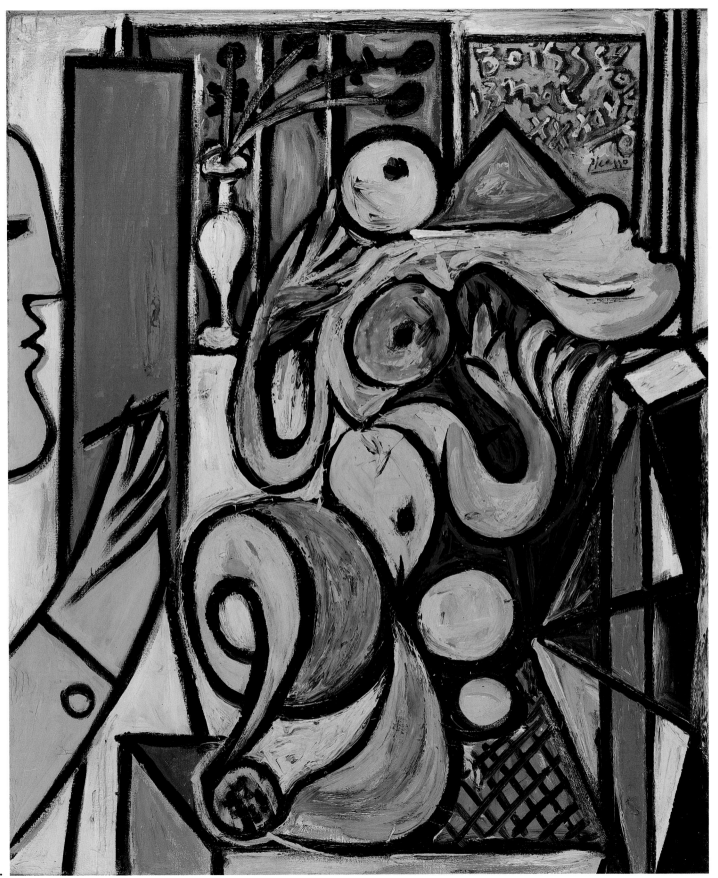

27.

28.

28. The Studio: Painter and his Model

(Cleveland only)
April 18, 1937 (I)
Pencil on blue paper
7 × 11 in. (18 × 28 cm.)
Musée Picasso, Paris

29. The Studio: Painter and his Model

(Cleveland only)
April 18, 1937 (IV)
Pencil on blue paper
7 × 11 in. (18 × 28 cm.)
Musée Picasso, Paris

30. The Studio: Painter and his Model

(Hartford only)
April 18, 1937 (VI)
Pencil on blue paper
7 × 11 in. (18 × 28 cm.)
Musée Picasso, Paris

31. The Studio: Painter and his Model

(Hartford only)
April 18, 1937 (XI)
Pencil on blue paper
7 × 11 in. (18 × 28 cm.)
Musée Picasso, Paris

29.

In January of 1937, Picasso accepted an invitation from the Spanish Republican government to paint a mural in support of their resistance to Francisco Franco's Nationalists, who were then battling to overthrow the legitimate government. The mural would be the primary artwork in the Spanish Pavilion at the Paris World's Fair, which was scheduled to open in June. In preparation, Picasso rented a large studio at 7, rue des Grands-Augustins, which would be his Paris residence for the rest of his life.

There is no evidence that Picasso set any ideas for the giant composition on paper or canvas until April 18. But on that day, he made a dozen sketches that reveal a highly resolved solution for the mural. It was to be a painting of an artist's studio. It would show a painter at work on a canvas, with a model reclining at the far left. The exceptional horizontality of the composition identifies it as a plan for the site in the Pavilion, and unusual features help clarify why Picasso considered it for the function of political address, before the bombing of Guernica, in northern Spain, wrenched him in another direction. Except for the bombing of that historic town, it seems likely that the mural would have depicted an artist's studio. Picasso's sketchbooks do not record alternatives, and the timing was too short for any-thing other than the jolt of inspiration Picasso received from reading the accounts of the attack on April 26.

Numbered I–XII, the dozen sketches map both the overall composition Picasso had in mind and its most significant details. He began with the layout, (Cats. 28 and 31): the artist, easel and model are grouped on the left side of the wide studio, with a large window occupying the right side. Turned away from the window and the outside view it presumably affords, the artist focuses on painting under the illumination of two electric lights, one standing on the floor and one hanging from the ceiling. As several sketches specify, both the

18-A.37.

(VI)

30.

painter and the model are women, and Picasso positioned them so that they overlap, causing an appearance of unity between them. Sheet VI (Cat. 30) shows in excruciating detail that the model's body is tortuously distorted, fingers dislocated, tongue out-thrust, and limbs radically stretched. Presumably, this anguished woman would have embodied Picasso's humanistic theme of resistance to brutality.

Despite the very different subject Picasso finally presented, certain aspects of the original composition persist. The electric lights may explain the glowing bulb in the mural, which has long caused critics to wonder whether the scene was set inside or out, and, among other details, the central triangular beam cast by one of the lights in the studies remains. Most importantly, the model's contorted features are transferred to the horrified women in *Guernica*.

31.

32. Palette, Candlestick, and Head of Minotaur

November 4, 1938
Oil on canvas
29 × 35 ½ in. (73.7 × 90.2 cm.)
The National Museum of Modern
 Art, Kyoto

33. Still-Life with Candle, Palette, and Red Head of Minotaur

November 27, 1938
Oil on canvas
28 ¾ × 36 ¼ in. (73 × 92 cm.)
Private Collection

34. Still-Life with Bull's Head, Palette, and Brush on a Table

(Hartford only)
December 10, 1938
Oil on canvas
28 ¾ × 36 ¼ in. (73 × 92 cm.)
Marina Picasso Collection (Inv.
 12844), Courtesy Galerie Jan
 Krugier, Ditesheim & Cie, Geneva

In November 1938, Picasso painted four versions of a still-life each featuring three sets of elements – a burning candlestick, a palette and brushes resting on an open book, and an ambiguous head, which oscillates between bull and minotaur, sculptural bust and severed body part, as the series unfolds. On December 10, he painted one final variation, a summary reprise, in which the composition is reduced to wash and outlines showing only the palette and brushes resting next to a bull's head (Cat. 34).

The canvas dated November 4 is the first (Cat. 32), and the one of November 27 is the last of the four (Cat. 33). The initial version is the most dramatic, reflecting an intensity of engagement that moderates through the series, until the December picture asserts a new rawness. Haloed with a red triangle, the bright green candle casts a blazing golden light toward the minotaur's bust. Nestled under the flame, the book's pages and the array of hues on the palette glow brightly. Symbolically, these two groups of objects represent the force of enlightenment against the bestiality of the minotaur (half man and half bull). Yet, the brilliance of the ensemble casts only a pallid, lunar tint over the creature, leaving its distant side in darkness. Its staring eye and pointed horns appear menacing, even though its attachment to a pedestal base indicates that it is a sculpture and confines the conflict within the arts.

An opposition between creativity and violence, particularly employing the bull or minotaur to symbolize the latter, is inseparable from the Guernica mural and the events that provoked its execution in the spring of 1937. As Picasso later explained about the imagery in the mural, "No, the Bull is not fascism, but it is brutality and darkness." Since Picasso avoided direct references to the Spanish Civil War in this huge picture,

which he made for public display in support of the Republican government against Franco's Nationalists, it is not surprising that his later considerations of the theme are even less explicit. Yet for Picasso, a Spaniard and an artist above all, the issue of greatest personal significance was art's potential to oppose the destruction and oppression that was enveloping Spain and threatened all of Europe.

As the sequence of five paintings implies, Picasso offered no single answer to this fundamental question. True to his constantly shifting and often contradictory sense of reality, he offered an array of possibilities, some hopeful and some bleak. The pyrotechnic display of the first picture gives the greatest impact to the forces of light, without overwhelming the beast (Cat. 32). The following three versions are relatively defused, both in their less densely packed compositions and more evenly lit environments. The middle two also moderate the conflict by presenting a bull's head rather than the more freakish hybrid.

The fourth painting (November 27; Cat. 33) revives the minotaur, quite literally. While planted on a stand like a sculpture, this head seems animated. Both eyes stare out, and both the orangish coloring and full-bodied flesh of its head evoke life rather than a corpse or stone effigy. Unlike the dark angularity of the first incarnation, this softened one, with an almost placid expression, is far less threatening. And the candle, book, and palette, are not accentuated. In this final of the four fully worked versions, calm prevails. The contrast that had first focused the series has nearly disappeared as the minotaur appears more man than beast.

The fifth and final painting, however, rejects this resolution by reducing the theme to its essential opposition. Without the candle and its light, a giant

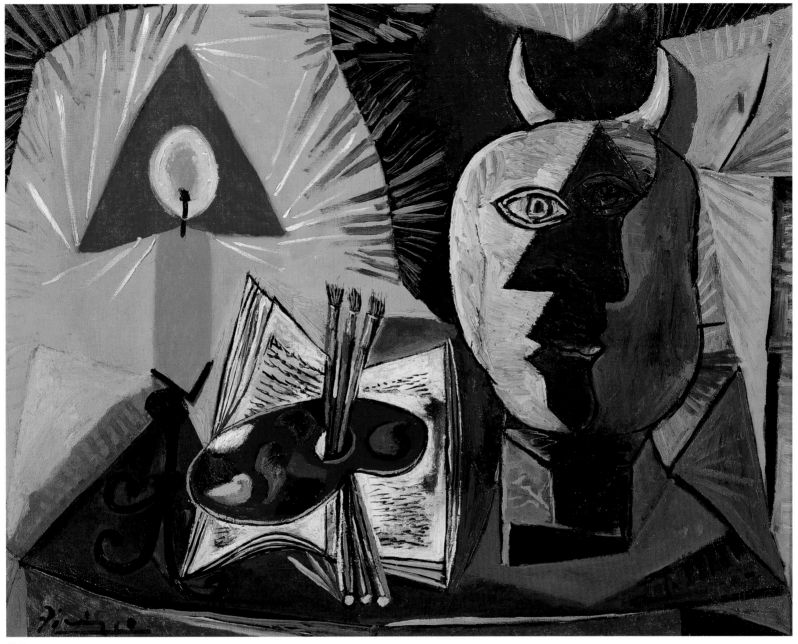

32.

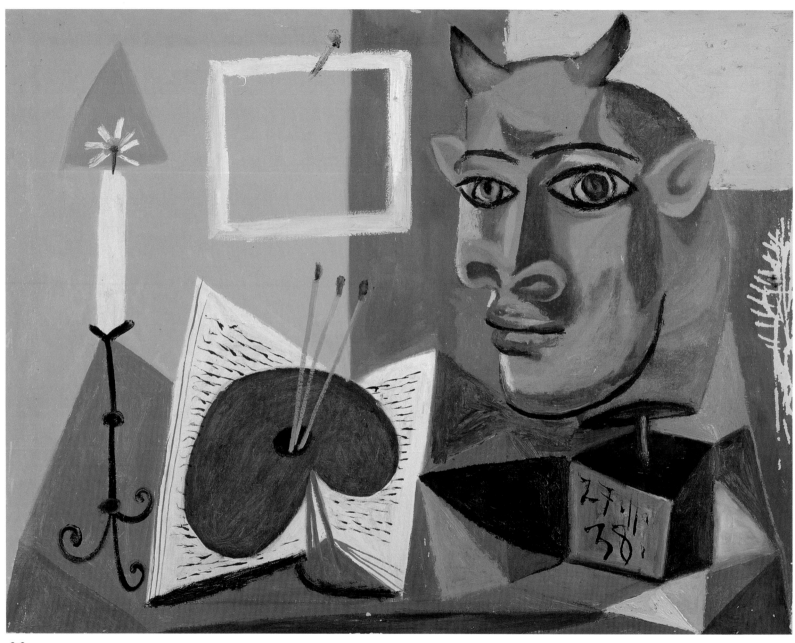

33.

bull's head looms over a diminutive
palette and brushes in a gray gloom. No
longer mounted on a base, the tilting
head seems about to devour the artist's
tools that lie just beyond its open
mouth. With barely enough space for
the two protagonists, the tabletop and
surrounding walls provide a tight arena
for a confrontation that recalls the ele-
mental battle of the bullfight.

34.

35. Portrait of a Painter, after El Greco

February 22, 1950
Oil on plywood
39 ½ × 31 ⅞ in. (100.5 × 81 cm.)
Collection A. Rosengart

Innovation is often considered to be the quality that separates avant-garde artists from academics, and innovation, itself, is frequently defined as the supplanting of previous artistic traditions with new approaches. As the artist most widely identified with the avant-garde in the twentieth century, Picasso would seem to be the standard bearer of this conception of modern art. Certainly his fundamental contribution, Cubism, was a radical departure from the art of the past; yet even during the pioneering years, Picasso's art reflected his continuing fascination with the achievements of artists in preceding centuries. Indeed, recent reconsiderations of Picasso's career have led to a realization that he maintained a constant dialogue with the history of art and have exposed the arbitrariness of reductivist theories of modern art.[15]

More than any other single painting, *Portrait of a Painter, after El Greco* demonstrates his devotion to the past, even as it marks a change in this longstanding preoccupation. Unlike previous works in which he had made reference to historical art, such as *The Lovers* (1920), which he playfully inscribed "Manet," this painting is a direct copy of a particular picture, the first Picasso had made since his student years when he regularly copied paintings by Spanish masters. Moreover, the subject is not a work by a modern, such as Manet or Cézanne, but a seventeenth-century painter – El Greco's portrait of his son, the painter Jorge Manuel Theotokopulus (c. 1600–1605, Museo de Bellas Artes, Seville; Fig. 29). In choosing this painting, Picasso not only broadcast his respect for a leader of the Baroque but also affirmed his identity as a Spanish artist, an awareness he would demonstrate more extensively a few years later in his variations after Velázquez's *Las Meninas*.

Picasso's version of the El Greco follows the original to a remarkable degree, maintaining its dark tonality and placing the young artist (palette and brushes in hand) in the same location on a canvas of similar dimensions. Yet this familial homage of a painter to another painter's picture of his son, breaks from reverence into open competition. The self-conscious artifice of El Greco's style is transformed into the equally unreal structure of Cubism, flattening the man's billowing lace collar into a ring of fractured planes and pancaking the dramatically lit, three-quarter image of his head into overlapping profile and frontal views. The result is such a substantial alteration of the original that most observers would not be able to identify the source without reference to the title.

A few touches suggest Picasso may have been thinking of his previous self-portraits as well: the white lines he added to join the ends of the palette to the painter's sleeve modify a device he had adapted from Cézanne for his 1906 self-portrait (Cat. 8). Moreover, in this head-to-head competition with a revered forebear, Picasso was not above a touch of ridicule for the image of an artist. El Greco pictured his son as a figure of consummate elegance, a quality that Picasso no doubt saw as mere effeteness and skewered by exaggerating the over-bred extension of his right pinky.

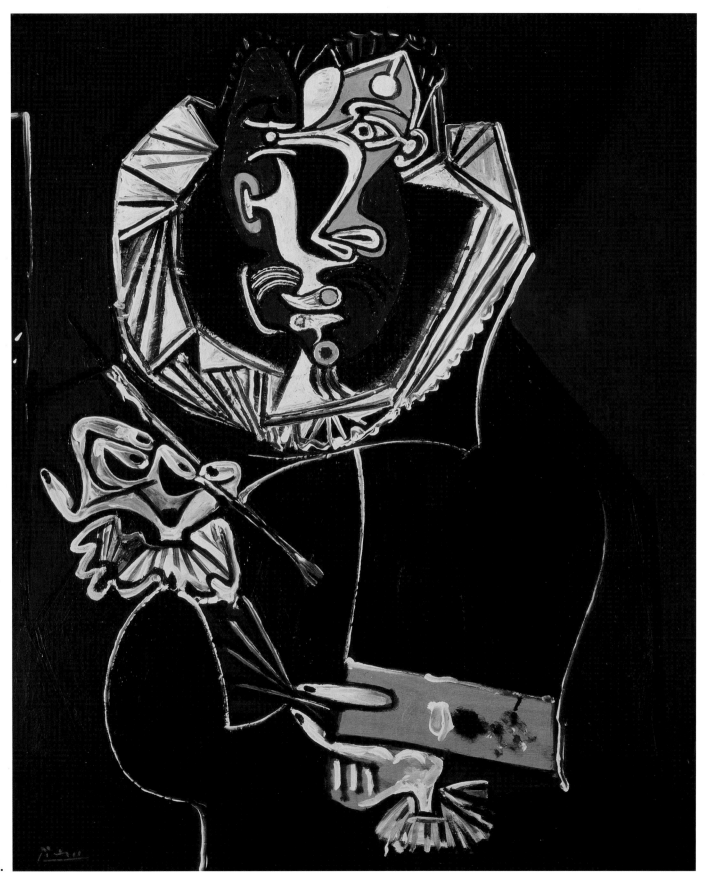

35.

36. Woman Drawing (Françoise Gilot)

(Hartford only)
March 13, 1951
Oil on plywood
45 ⅝ × 35 in. (116 × 89 cm.)
Private Collection

Françoise Gilot met Picasso in May 1943, when she was a twenty-one year-old student and he was still involved with Dora Maar.[15] The new friendship between a young, aspiring artist and master grew slowly until she moved in with him in the spring of 1946. In the early years of the relationship, Picasso created portraits of Gilot that emphasize her youth and full-breasted figure, most notably in *Woman-Flower* (1946). These characterizations frequently draw on conceptions of fecundity and sexual attraction that he had developed for a predecessor, Marie-Thérèse Walter.

By 1951, Picasso and Gilot had produced two children, Claude (born in 1947) and Paloma (born in 1949) but were drifting apart. Although their relationship would not end until late 1953 when Gilot moved to Paris with the children, during the previous three or four years the couple was increasingly estranged. As Gilot recorded in her memoir, *Life with Picasso* (1964), she had grown extremely thin following Paloma's birth, and he urged her to become pregnant with a third child as a means of restoring her looks and good humor. She quotes Picasso saying, "You were a Venus when I met you. Now you're a Christ – and a Romanesque Christ, at that, with all the ribs sticking out to be counted." Instead, Gilot chose to divide her time between caring for the children she already had and resuming her career as an artist, which would result in an exhibition at Picasso's dealer, Louise Leiris, the following year.

Gilot particularly admires this complex portrait. It reflects the strained circumstances of the relationship, while also bearing witness to her ambitions as an artist and their mutual appreciation of classic Spanish painting.

Unlike his portrayals of previous artist-companions, particularly Dora Maar (who was a well-respected pho-tographer), Picasso's portraits of Gilot in the early fifties regularly depict her in the act of drawing or painting. Most of these, however, show her surrounded by Claude and Paloma, whom she watches while attempting to work. In *Woman Drawing*, she appears in isolation, although the line that tethers her pencil to the drawing board signals a domestic situation. She rigged it to prevent the pencil falling to the floor and breaking the lead when she jumped up to help the children.

Picasso's portrayal of Gilot captures the transformation he described by showing her face creased with heavy lines, her hair gathered in a tight bun and her twenty-nine-year-old body swathed in a loose, green-striped robe. Her blanched skin and seemingly sight-less, white eye sockets create an almost skeletal effect until one realizes that she does not regard the viewer but looks down at her paper, completely absorbed in the process of drawing. Even though she is seated, the low viewpoint Picasso chose gives her the monumentality of a standing figure. The image combines frailty and vigor, Picasso's conception of a distant, haggard figure and a woman of dignity engaged in her work.

Unlike the bright palette of most contemporaneous portraits, this painting's dark hues and rough support enhance its austerity. Painted in white on tan plywood, Gilot emerges from the deep blacks and browns that frame her figure and outline her features. This somber but dramatic tonality evokes the achievements of seventeenth-century Spanish painting, particularly the works of El Greco and Velázquez that repeatedly occupied Picasso in the 1950s and that Gilot revered. As an image of an artist at work, it conveys a near abandonment of sensuality and social intercourse for the discipline of art.

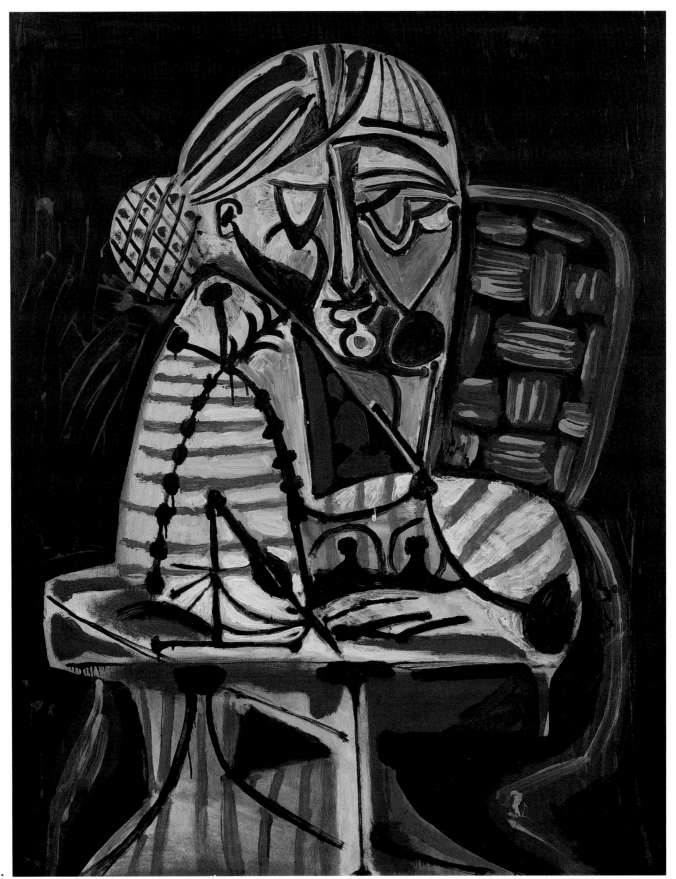

36.

37. The Model in the Studio

(Hartford only)
February 2, 1954
Colored crayons on paper
9 ½ × 12 ½ in. (24 × 32 cm.)
Musée Picasso, Paris

This playful drawing is a clever turn on the traditional notion of the artist's dominance over the model and the artistic process through his power to control a subject with his line.

In this case, the model is clearly overwhelmed. She cowers under an onslaught of dense strokes that pepper her with dots like the detonations of artillery shells. The male artist escapes this assault. He sits calmly in an empty space, yet his mere gesture of raising a brush seems to have unleashed the attack. The conceit, of course, is that this painter is himself an illusion, a figure drawn on the canvas that rests on an easel. The artist of this studio is not present. Perhaps he has fled after rendering the image, since art, rather than the artist, seems to wield the power.

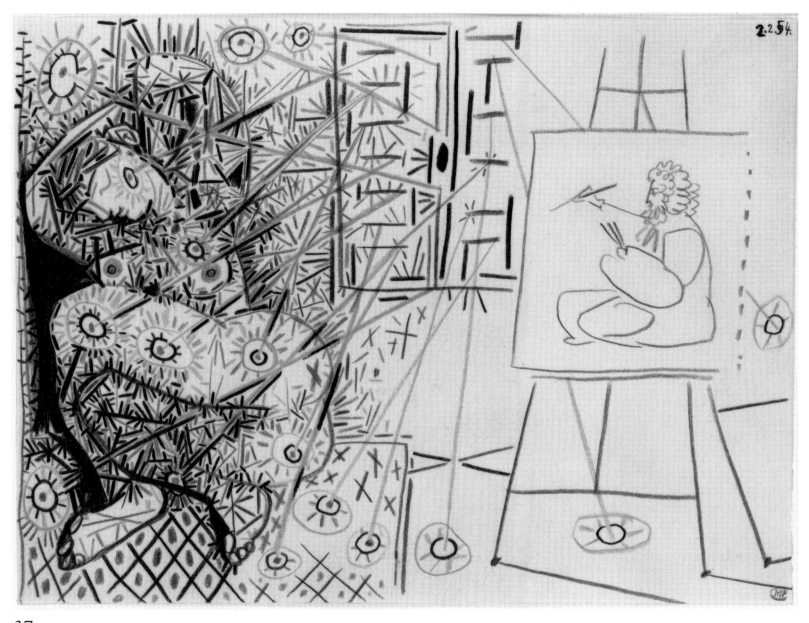

37.

38. The Studio

October 30 and 31, 1955
Oil on canvas
31 ⅞ × 25 ½ in. (80.9 × 64.9 cm.)
Tate Gallery, London. Presented by
 Gustav and Elly Kahnweiller 1974
 and accessioned 1994

In the summer of 1955, Picasso bought La Californie, a nineteenth-century villa overlooking the Mediterranean coast at Cannes. Since 1946, he had spent a great deal of time in the south but his accommodations had always seemed temporary, the houses rented or not sufficient for long-term occupancy. This large building surrounded by a garden with eucalyptus and palm trees afforded both the space and the privacy of a permanent home. Its acquisition signaled Picasso's decision to make his base of operations far from Paris. As his burgeoning celebrity in the years after the Second World War made Picasso by far the most famous living artist, he sought a more secluded environment, one in which he could prevent the swarms of admirers who descended upon him from disrupting the intense working schedule he maintained until the end of his life.

Since he bought the villa as a work place, rather than for entertainment and leisure, Picasso took the grand salon as his primary studio. This large, high-ceilinged room offered extensive views over the property through French doors and glazed overdoors of curvilinear, Art Nouveau patterns. By fall, he had taken possession of the space, filling it with his tools and examples of his work, both finished and still in progress.

On October 23, he began a series of paintings focused on the room itself. Over the following eight days, he completed eleven canvases, with a final, double-width one on November 12. Throughout his career, Picasso had frequently salted his work with reference to his current studio, but he rarely made it the primary subject, a "paysage intérieur," as he described the 1955 pictures to Pierre Daix.[16] Only *The Tub (The Blue Room)* (1901; Fig. 4) is so specifically a portrait of a particular atelier, a cramped apartment filled with works of art and domestic furniture of everyday life.

The Studio is the last in the series of October 23–31, and the only one that Picasso dated to a two-day span, instead of a single session. It corresponds to the vertical orientation of these pictures and depicts the consistent view centered on one of the vast windows. The painting's densely worked surface bears witness to the time Picasso spent completing it and creates a contrast between the thinly washed view of the garden and the thickly encrusted interior of the studio. This opposition between interior and exterior is a driving force of the series, articulated most prominently by the shift of colors and textures Picasso scraped into the impasto.

Although Picasso had rarely portrayed his studio, Matisse had made it one of his most frequent subjects. Picasso's choice to adopt it at this time seems a direct response to his old friend and rival, who had died the previous year and many decades earlier had led the exodus to the south by taking up residence there at the end of the First World War.[17] This series of La Californie paintings is steeped in Matisse's approach – the central window that establishes the contrast between a brilliant natural exterior and a somber interior, and even the profusion of linear patterns scratched into the walls and floors with the butt of a brush, making the room as visually dynamic as the blazing yellows and greens outside. While they evoke Matisse's interiors, particularly those painted in 1947–48 (such as *The Egyptian Curtain*, Phillips Collection), Picasso's are both coloristically more restrained and more articulated by line, either drawn or incised. Populated with his paints, brushes, paintings, and sculpture, Picasso's studio is both more removed from the seductive world outside and more highly energized.

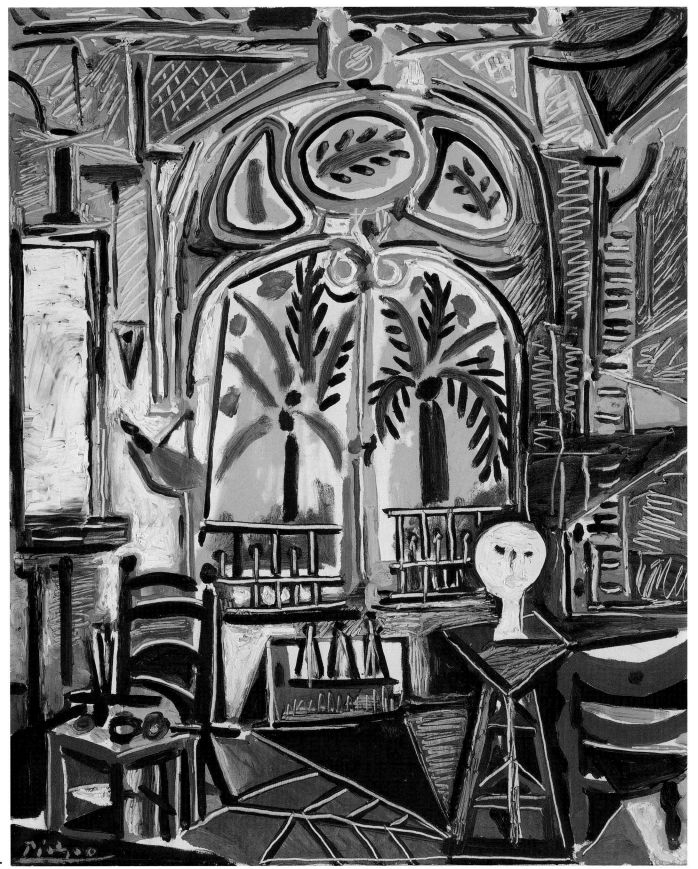

38.

39. The Studio (II)

April 1, 1956
Oil on canvas
35 × 45 ⅝ in. (89 × 116 cm.)
Private Collection

40. Studio in a Painted Frame

April 2, 1956
Oil on canvas
35 × 45 ½ in. (88.8 × 115.5 cm.)
Private Collection

After a hiatus of nearly five months, Picasso renewed his examination of the La Californie studio on March 30, 1956, when he began the first of four paintings he would complete over the following three days. For these, he followed the final painting in the previous series (November 12, 1955) by selecting a wide horizontal format that allows the inclusion of a greater slice of the room. Moreover, he substantially changed the scene and the interpretation of the subject it presents.

Unlike the previous pictures, these are not primarily structured on an opposition between interior and exterior. The large, ornate windows are present, and they still reveal verdant palm trees, but they are now reduced or relegated to the periphery. The axis of the compositions has shifted from outside and inside to a largely interior address – the past of an artist's accumulated materials and works versus the present challenge of an untouched canvas. In the first series, Picasso used the constant to suggest a physical and psychological difference between nature and art, even when they join harmoniously. In the second, he bore down on art itself.

The painting of April 1 (Cat. 39) is the second of this group. In it, the window still serves as a visual attraction because of its size, view of green palms, and, most striking, its new feature of blue borders around the tracery. Nonetheless, it is located at the far right. The blank canvas stands on an easel near the center, and the two windows behind are nearly occluded with gray wash. The result is a dramatic contrast between the gleaming white canvas (a rectangle of unpainted cloth) and the surrounding darkness of gray, black and brown. Along with at least one sculpture, many canvases (presumably finished) are scattered across the room. But each is turned to the wall, so as not to detract attention

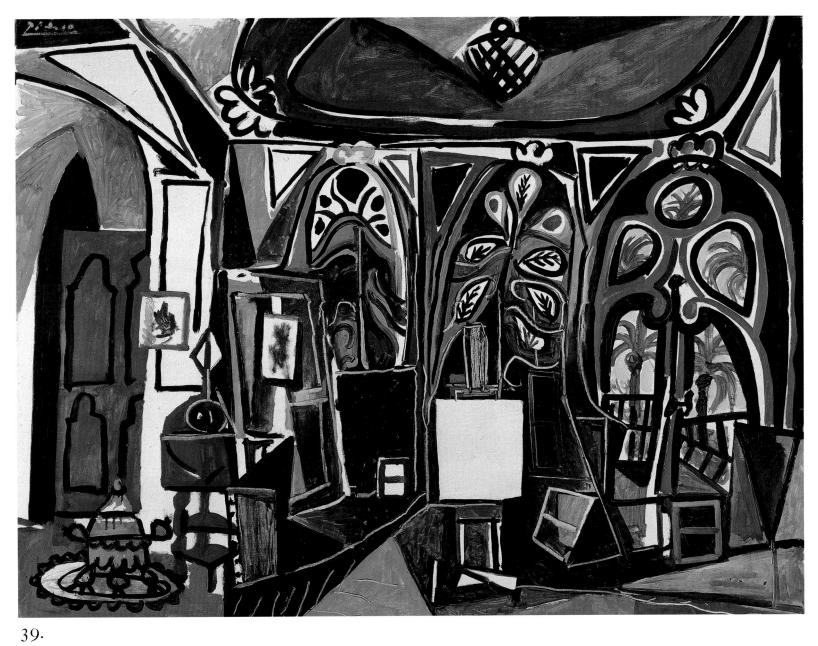

39.

40.

from the challenge that awaits. This version of the studio not only indicates art's isolation from nature, it registers both the anxiety and elation that accompany the beginning of every work of art.

On the next day, April 2, Picasso painted the last two variations in this series. The painting in this exhibition (Cat. 40) is the larger of the two and is unique among the four in its addition of a new layer of interpretation. The scene closely resembles the composition of the day before: a blank canvas on an easel near the center, surrounded by materials and works of art, and a palm tree seen through a large window at the right. Yet, the visual agitation of the previous picture is missing. Instead, Picasso simplified the composition to a few salient objects, forms, and colors. The reduced number of things scattered around the room complements Picasso's rendering in flat, largely uninflected planes of color in an austere harmony of tan, black, and brown, as well as the white of the unpainted canvas. When Alfred Barr mentioned this distinctly Spanish tonality to Picasso, the artist commented, half in self-mockery, "Velázquez."[18]

As the series developed, Picasso shifted from engagement with a particular place and his contemporary, Matisse, to more general issues of creativity that ranged back through the history of art to his greatest Spanish predecessor. In the coming year, Picasso would devote an extensive series to Velázquez's masterpiece, *Las Meninas*, but at this point he remained focused on art as its own reality, separate from specific incarnations. To emphasize that this painting is fundamentally a work of art about the process of making art, he added an element not present in any other painting in the series and one that he had rarely, if ever, used since his invention of collage with Georges Braque: a painted frame around the image. Drawn as if it were the molding surrounding an Old Master picture, the frame is an explicit indication of Picasso's self-awareness. In the process of portraying the room in which he worked, Picasso created an image that shifted from documentation to interpretation, one that can hold its own in a long history of representation. To make it obvious, Picasso painted his name on the fictive frame, like a label used by museums.

41. Jacqueline in the Studio

(Cleveland only)
April 2–8, 1956
Oil on canvas
44 ⅞ × 57 ½ in. (114 × 146 cm.)
Picasso Collection of the City of
 Lucerne. Rosengart Donation

42. Woman in the Studio (Jacqueline Roque)

April 3–7, 1956
Oil on canvas
7 × 8 ⅝ in. (18 × 22 cm.)
Collection of The Speed Art
 Museum, Louisville KY

The day he finished the *Studio in a Painted Frame* (Cat. 40), Picasso began a new variation on the subject of his La Californie series. This group turns away from austere confrontation with the artistic process to involve Picasso's everyday life, particularly his relationship with Jacqueline Roque. They had met in 1952 and were living together by the fall of 1954. Their marriage seven years later, in 1961, endured until his death in 1973, after which she devoted herself to his memory. Without question, this was the most steady of Picasso's many relationships with women.

These paintings show Roque in the strict profile pose he frequently chose for her in the early years. Although the composition is too tightly framed to include the features of the room, the painting positioned on an easel next to her provides the location. It clearly depicts the La Californie studio. The particular image resembles the April paintings, but altered to a vertical format so that the artist's materials are featured and the windows nearly excluded. The painting from the Rosengart collection (Cat. 41) began the series, while the Louisville picture is the second of three Picasso made between April 3 and 7. All show basically the same composition and convey a quality of selflessness generally associated with Roque. As William Rubin characterized their relationship, "Her understated, gentle, and loving personality combined with her unconditional commitment to him provided an emotionally stable life and a dependable *foyer* over a longer period of time than he had ever before enjoyed."[19] This image of Roque seated passively in the studio opposite one of his images of the place pairs her with the art – the dual poles of his life in their shared seclusion.

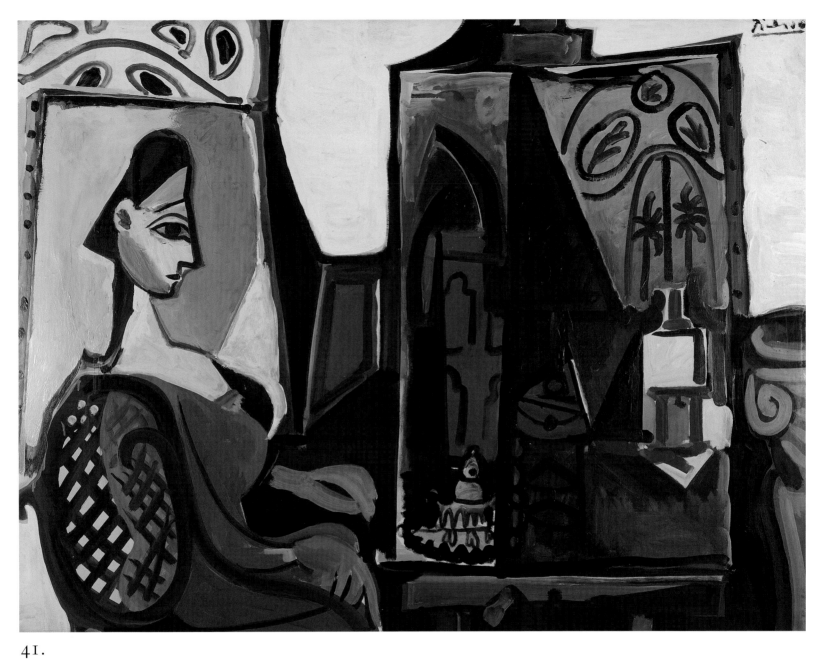

41.

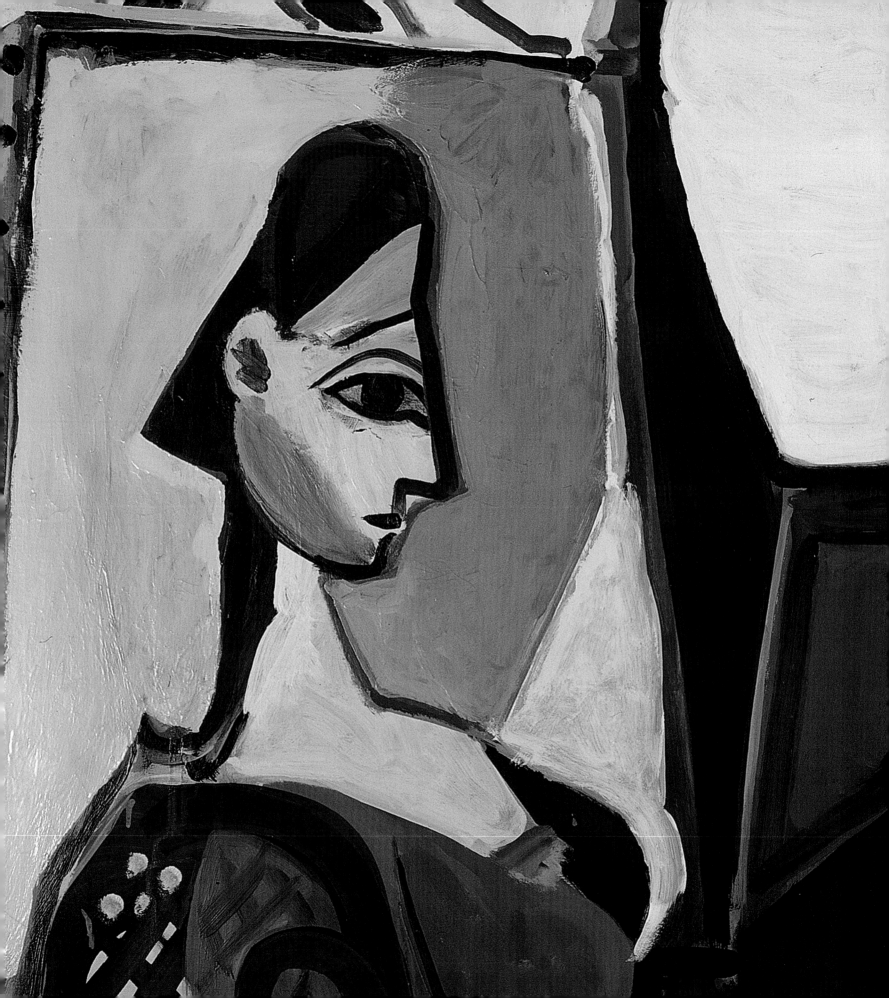

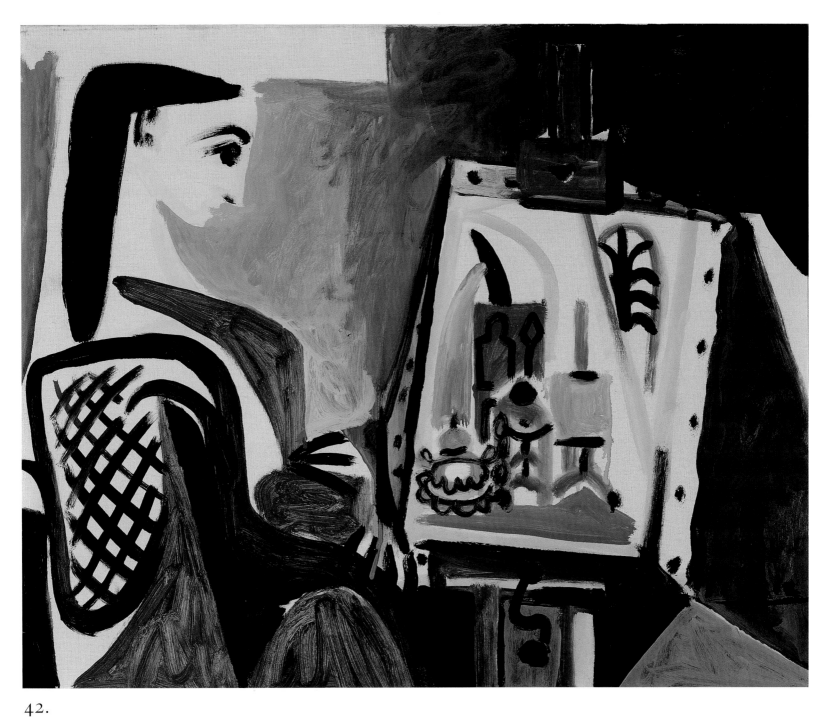

42.

43. Las Meninas, after Velázquez

October 3, 1957
Oil on canvas
50 ¾ × 63 ⅜ in. (129 × 161 cm.)
Museu Picasso, Barcelona

In August 1957, Picasso took the unusual step of temporarily vacating the grand salon of his villa La Californie, which he had utilized as a painting studio and portrayed frequently over the previous two years, to move to the attic. In this much more cramped and isolated space under the eaves of the house where pigeons roosted, he pursued his most concentrated dialogue with a single work by another artist, *Las Meninas*, Velázquez's masterpiece of 1656 (Fig. 30). From August 17 through December 30, he produced forty-five paintings based directly on Velázquez's picture, as well as an additional thirteen related works.

Among these fifty-eight pictures, only four reproduce the full composition showing Velázquez standing at his easel beside the Spanish Infanta and her attendants in a room of the Escorial palace outside Madrid – the first (August 17), the thirty-first (September 18), the thirty-third (October 2), and the thirty-fourth (October 3). The painting in this exhibition is the last of these.

Susan Grace Galassi, who has presented the most thorough and illuminating study of this series, wrote, "No painting in the history of art was more imbued with personal and historical meaning for Picasso than Velázquez's masterpiece, *Las Meninas*, which first imprinted itself on him in adolescence, before his own notion of tradition was formed and began to intervene."[20] His choice to address it in 1957, at the age of seventy-five, signaled unequivocally his sense of detachment from the contemporary world and his profound imaginative commitment to measuring his artistic stature against the great achievements of the past.

Galassi's analysis of the painting of October 3 follows: "Picasso returns to a more stable horizontal format, and banishes his vibrating colors and converging lines and shapes. In a reprise of no. 32, he turns back to somber tones of brown and black for the background, which set off the figures of the Infanta and her retinue in bright, primary colors. A relative sense of stability and depth returns, which parodies the old master's own spatial play. The figure of Velázquez reemerges . . . now shrouded in a black costume resembling a monk's habit or a domino. The spare geometric style and coloration of the painting again evoke *Three Musicians* [Picasso's 1921 painting in the Museum of Modern Art] though here Picasso may also draw on some of its darker meaning. As in his 1921 masterpiece, intimations of death can be felt in this painting too. With the reinstatement of Velázquez, in the studio, the door at the back guarded by the shadowy figure of the *aposentador* [queen's chamberlain] opens up into a vortex-like tunnel, and the diminutive guard/painter disappears through the passageway.

This painting marks the end of the most intensive part of Picasso's dialogue with Velázquez."[21]

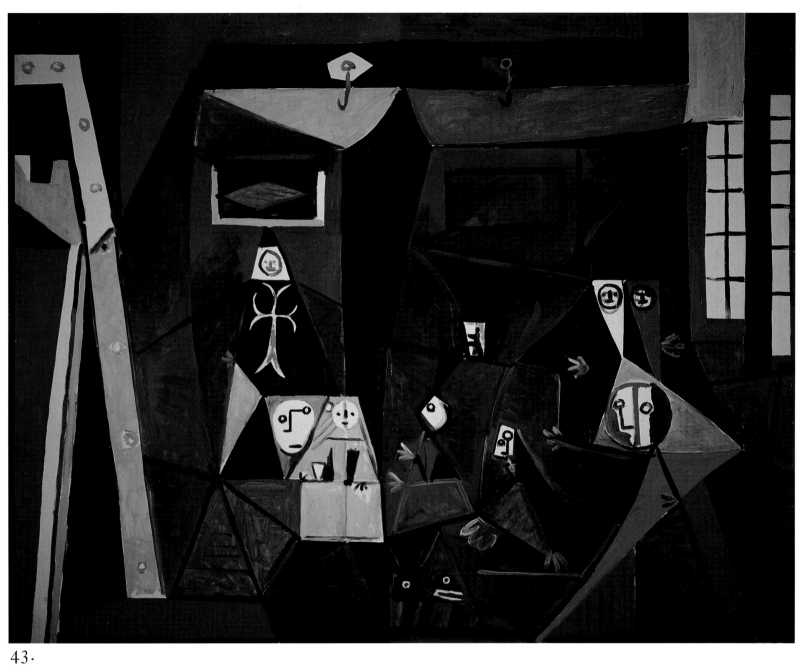

43.

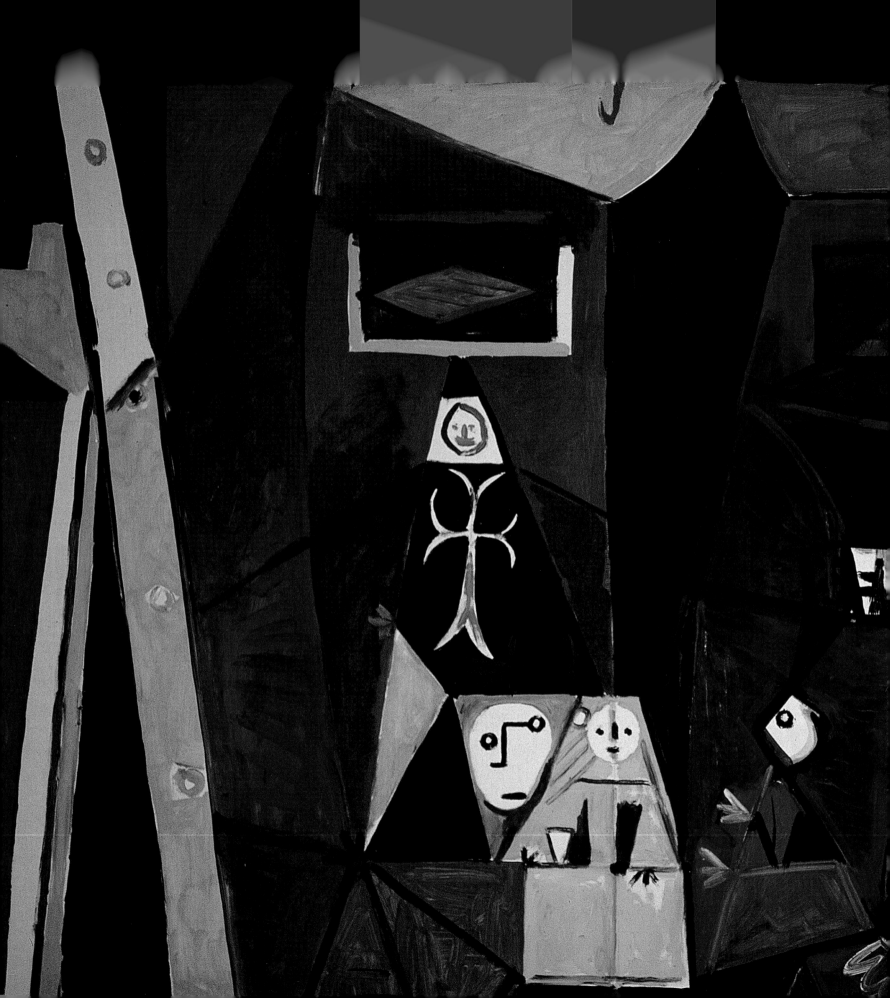

44. The Studio: Reclining Woman and the Picture

(Cleveland only)
December 1957
India ink on blue crayon and pencil
 outlines on paper
19 ⅞ × 26 in. (50.5 × 66 cm.)
Musée Picasso, Paris

45. The Studio: Reclining Woman, the Picture, and the Painter

January 4, 1958
Pencil on paper
19 ⅞ × 25 ¾ in. (50.5 × 65.5 cm.)
Musée Picasso, Paris

In the fall of 1957, Picasso received a commission from UNESCO (United Nations Educational, Scientific, and Cultural Organization) to design a mural for the delegates' lounge of its Paris headquarters. Since he had been affiliated with the Communist Party since 1944 and the Cold War was still raging, the project offered Picasso a significant public venue to express his views about contemporary politics and culture.[22]

In a sequence that mirrors his development of the *Guernica* mural twenty years earlier, Picasso began with the theme of the artist's studio, even though he finally turned to the Fall of Icarus for the UNESCO project. On December 6, he painted a gouache showing a studio in which a large canvas stands on an easel. The canvas depicts wooden sculptures of bathers he had made the previous year.[23]

On December 15, he began to fill a sketchbook with variations on the composition. These images contrast the apparently finished painting of the bathers with the raw materials of art – a reclining female model, a smaller canvas on an easel, and a chair piled with painting rags. The viewpoint emphasizes this transformation by containing most of the woman's body within the perimeter of the canvas, thereby suggesting that she may be a painted image, rather than an actual person. The folded planes of her arm that extend beyond the canvas continue this ambiguity by resembling the flat elements of the wooden sculptures depicted in the painting on the right. The result is an impression of the studio as an animated space separate from the artist.

The drawing of January 4 (Cat. 45) clarifies identities but also introduces a new character. An array of background facets replaces the smaller canvas, and the model is clearly a woman. On the

44.

far right, the full-length shadow of a painter appears, identified by the palette and brushes he holds at the center of his angular form. This presence recalls *The Studio* (1928–29; Cat. 22). Like that earlier painting, the artist stands outside the pictured studio, yet his shadow calls attention to his creative role, while still letting the art and materials inhabit the room independent of his direct control.

The story of Icarus' collapse into the sea includes warnings against excessive ambition that might carry political implications at UNESCO, and Picasso's original conception contains a kernel of the same idea: the artist's uncertain control of his means.

45.

46. The Studio

November 27, December 24 (II) and
25, 1961; January 24–25 and 31,
1962
Oil on canvas
29 × 36 inches (73.7 × 91.4 cm.)
The Patsy R. and Raymond D.
Nasher Collection, Dallas, Texas

When Picasso's widow, Jacqueline Roque, visited the owners of this painting in 1985, she commented that she still had the blue canopy seen in its background.[24] This touch of realism may seem surprising given the painting's lack of obvious reference to Picasso's everyday life, but it is characteristic of his creative method. His environment, whether people or things, was frequently drawn into his imaginative process, even though its use in an artwork might be fundamentally transformed as he worked and ultimately bears only the slightest relationship to the source.

In this painting, the composition not only floats free of Picasso's immediate circumstances but nearly escapes the studio theme itself. As usual, a nude woman rests in an interior (in this case, two nudes – one reclining and one sitting). But the large easel Picasso frequently included to anchor the scene is not present. Instead, the artist holds a small rectangle (probably a sketch pad) in his hands. His position at an edge of the composition is a strategy Picasso had used frequently to upset an assumption of the artist's dominance. As a result, the picture is devoted to the women, whose disposition recalls Picasso's 1954–55 variations on Delacroix's *Women of Algiers*. As Steven Nash analyzed the painting, "Here the artist in silhouette is separated by a surrounding band of color from the secluded, harem-like realm of seated and reclining nudes in proffering poses, which he observes almost as a voyeur."[25]

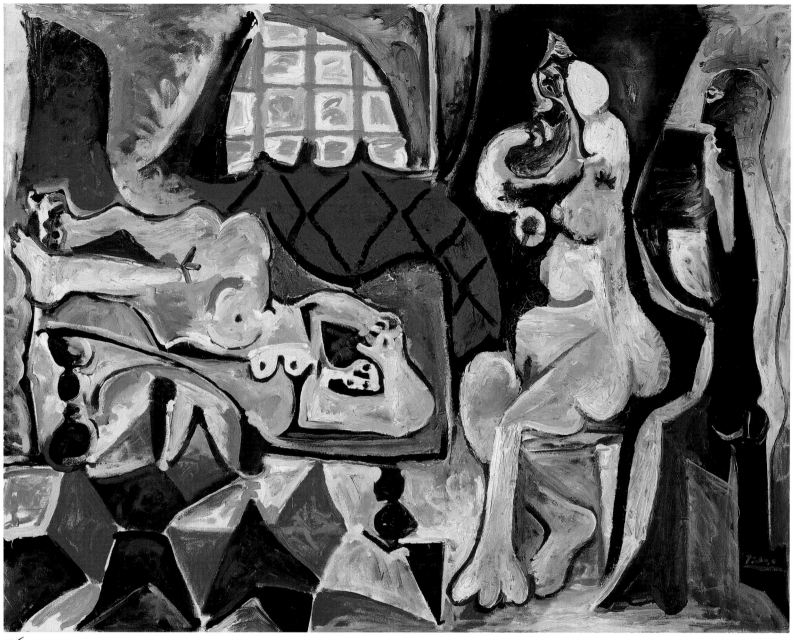

46.

47. The Artist

March 10 (III) and 12, 1963
Oil on canvas
39 ⅜ × 28 ¾ in. (100 × 73 cm.)
Wadsworth Atheneum Museum of
 Art. Gift of the Carey Walker
 Foundation, 1994.2.1

The early months of 1963 were among Picasso's most intense periods of concentration on the theme of the studio. In March alone, he painted dozens of pictures, often finishing three or more in a single day. *The Artist* falls in the middle of this focused time and stands out as unusual for its extension over two days – March 10, when it was the third painting of the day, and March 12, when Picasso returned to it after a day of consideration.

When he began the picture on March 10, Picasso clearly intended it to be a major work, because he chose a canvas nearly twice the size of the two preceding versions (100 × 61, versus 61 × 50 cm.). These paintings are quite similar in showing an artist (bust-length, in profile) touching a brush to a fictive canvas that meets the right edge of the actual canvas. The monochrome backgrounds of both suggest an interior setting, although their different hues (blue for the first, and red for the second) are basic distinguishing factors. This hotter tonality is only one of the ways Picasso intensified the image as he moved from the first to the second. In the initial image, the artist sits erectly, raises a delicate hand and brush, and touches the canvas so gingerly that the surface shows no inflection. In the second, a more massively proportioned artist strikes the canvas with a stroke that ripples its surface, a physical impact that matches the picture's high-keyed coloring.

The third version extends this development and presents a new interpretive context. On the larger canvas, Picasso filled out the periphery of his previous composition, showing the man's torso and boot, the complete easel, and a fuller background. The additional size enabled him to realize fully his conception of the artist's address. His painting arm thrusts in a straight line and hits the canvas with a force that seems to bend

the stretchers. The act of painting becomes a matter of physical aggression, an almost projectile-like attack.

In contemporary terms, it vaguely evokes the term Action Painting, which Harold Rosenberg had selected to characterize the methods of the Abstract Expressionists. While there is no doubt that Picasso knew the painting of Jackson Pollock and Willem de Kooning by the mid 1960s, the reference here is more likely to a nineteenth-century predecessor, Vincent van Gogh. Picasso emulated van Gogh's short, thick strokes of alternating colors, particularly in the artist's hair, and seems to capture the Dutch artist's presumed passion in his figure's lunge. Moreover, Picasso's shift of background to a green field scattered with what could easily be flowers implies a change of venue to a *plein air* setting preferred by the Impressionists and Post-Impressionists. (The artist's heavy boot also fits both the outdoor location and historical reference.)

The rapid evolution of this composition over such a brief time demonstrates the remarkable variety of Picasso's approaches to the theme of the studio and his continuing dialogue with the history of art to which the theme provided him access.

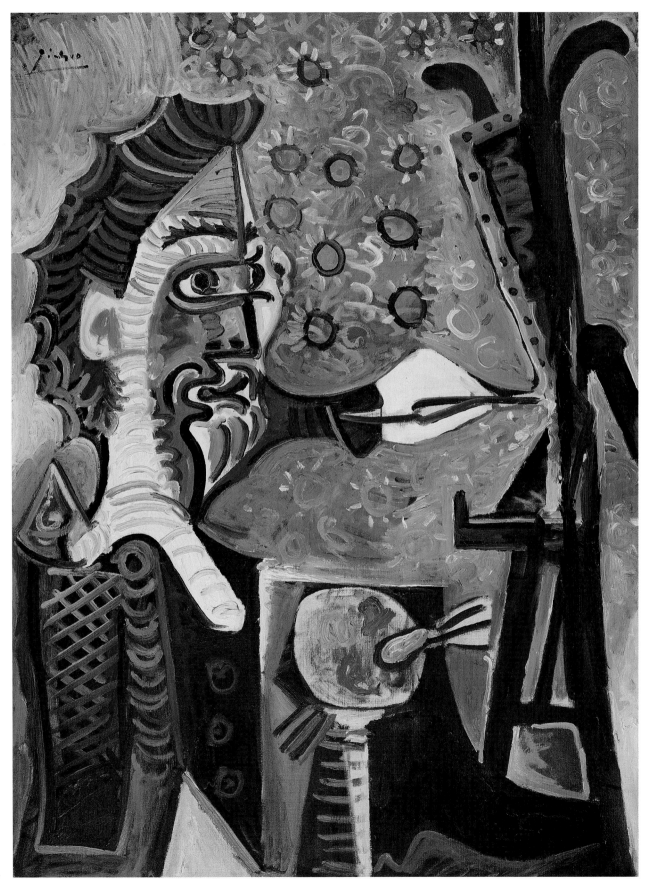

47.

48. Painter and his Model

April 3 and 8, 1963
Oil on canvas
51 ⅛ × 76 ¾ in. (130 × 195 cm.)
Museo Nacional Centro de Arte
 Reina Sofia

49. Painter and his Model

December 21, 1963
Encaustic on plywood
20 × 26 in. (51 × 66 cm.)
Musée National d'Art Moderne,
 Paris. Donation of Louise and
 Michel Leiris, 1984

These compositions follow a format Picasso used extensively in 1963. On a horizontal canvas, both paintings present an artist on the left and a nude female model on the right, with a painting on an easel in between them. While this arrangement may seem merely generic, Picasso created his own distinctive variation by placing the figures so close that they both brush the easel and by viewing the group from a perspective that denies the traditional hierarchy of relationship between them. Particularly in the late twenties and early thirties, he had played with the visual balance of a male artist and a female model, giving her greater physical presence in paintings such as *The Painter* (1934; Cat. 27).

In these two pictures, the shift is more subtle. By placing the viewpoint in the center of the picture, Picasso showed no preference for one figure or the other. In each rendering, however, he depicted the artist in colors that cause the figure to blend with the background, while the accentuated whiteness of the model's flesh gives her greater prominence. Moreover, each woman's eyes, the locus of visual perception, are more articulated than the male artist's. In the spring picture, the artist shows an unarticulated pupil. The model stares back at him with larger eyes of a distinctly oval shape, from which lines (derived from folds of the background curtain) seem to emanate and, thereby, shift the roles of observer and subject.

Beyond these interpretive nuances, the pair of paintings evinces the remarkable stylistic diversity Picasso brought to the theme. The first picture is a bravura demonstration of oil on canvas, the technique of the Old Masters that he had seemed to sweep aside with the invention of collage but adopted with renewed vigor in his later years, as he increasingly drew inspiration from historical art. The December painting,

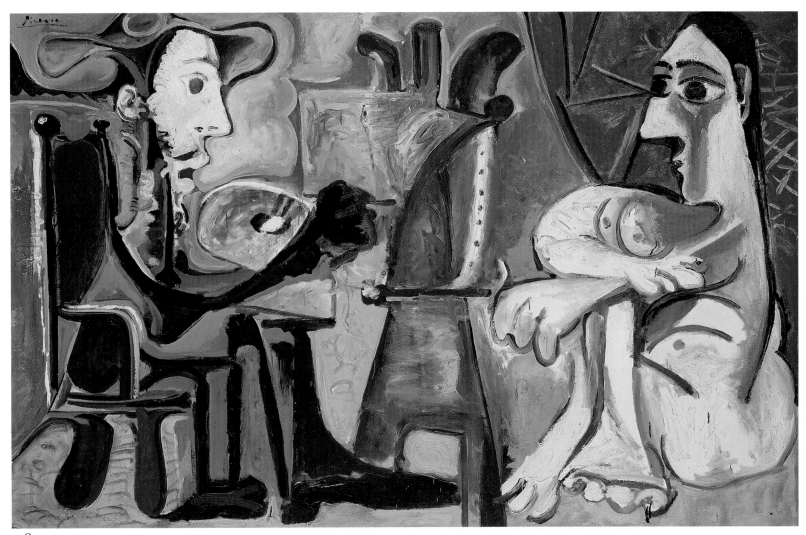

48.

however, explores a quite different set of materials. The support is plywood, a modern alternative to the panels used by medieval artists. The pigments are carried in a base of wax, a variation on the ancient technique of encaustic that Jasper Johns had brought back to prominence in the late 1950s. Exploiting the characteristics of the two techniques, Picasso achieved very different effects in the similar compositions. Instead of the flow of oil and its ability to mix with applications brushed on over hours or days, encaustic lays on stroke by stroke in a thick body that dries rapidly. The result is not only a contrast of materials but of styles – the painterly sweep and scumble of oil versus a graphic precision resembling crayon or chalk.

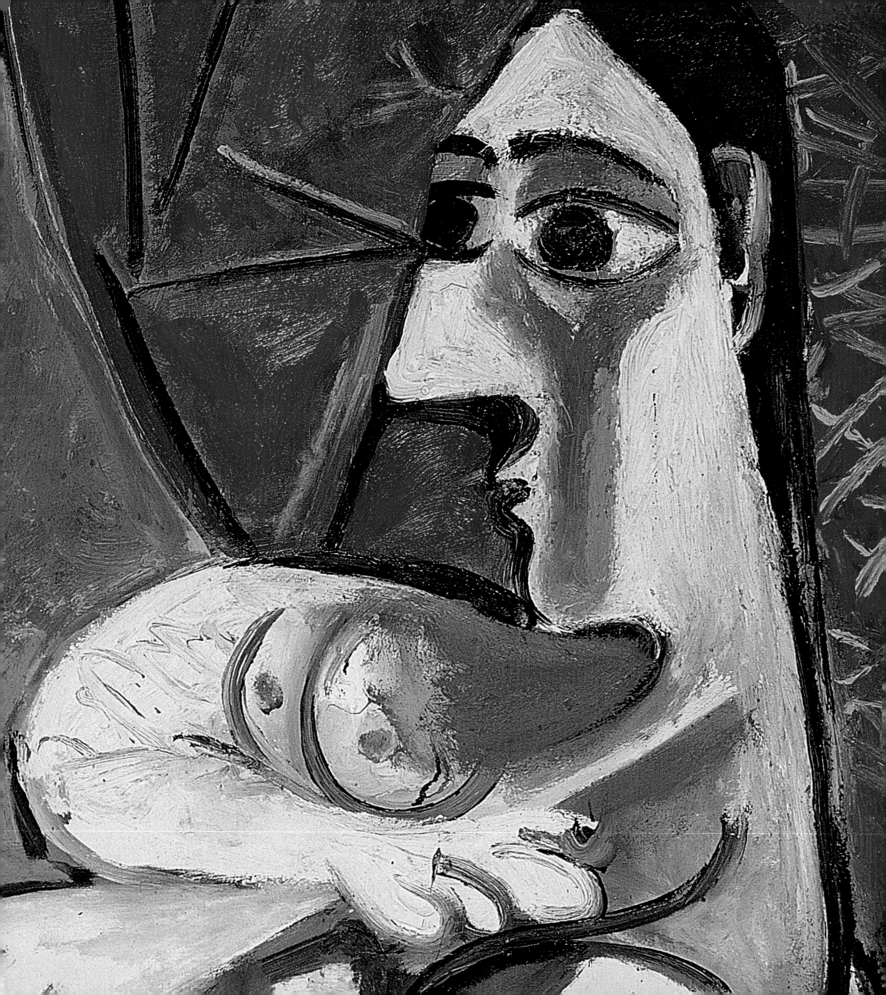

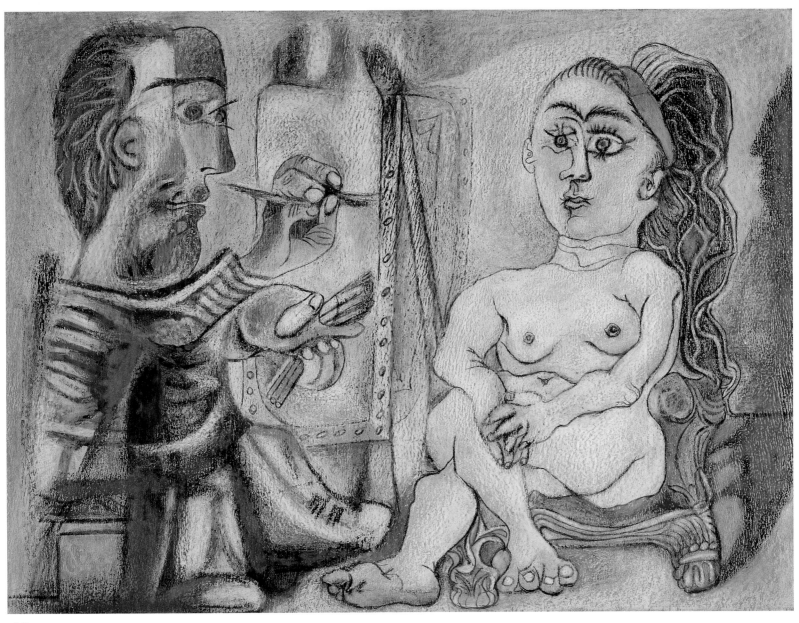

49.

50. Artist and his Model

November 7, 1964 (III)
Oil on canvas
35 ⅛ × 51 ¼ in. (89.2 × 130.2 cm.)
Private Collection

The extreme freedom of this composition is a product of Picasso's decades-long devotion to the theme of the artist's studio and the multiplicity of forms it can take. Without knowledge of his previous pictures, one would be hard pressed to identify this as a studio image. Even among his many contemporary pictures on the theme, this is among the most reductive.

The two figures immediately recall the common situation of a studio: a reclining nude woman across from an upright, clothed man. The woman's anatomy is the most fully rendered portion of the image, and presumably it is the subject of the artist's work. The gender of the man is registered only by the stubble on his face, while four vertically aligned dots mark the buttons of his shirt or coat, and an "X" of pink paint marks his flesh. This minimalism extends to the rectangular object (probably a canvas) that is partially visible to his left. Yet, these few clues are sufficient to establish the theme. As Picasso said, "A dot for the breast, a spot for the painter, five colored spots for a foot, some spots of rose and green, that suffices, doesn't it? What can I add to that? Everything is said."[26]

This severe restriction of representation not only enabled Picasso to telegraph his subject, it also freed him to explore an aspect of the theme that he had previously held in check – the sheer physical activity of wielding paint with a brush. It may seem paradoxical that Picasso did not address this most basic element of pictorial form until the last decade of his career. Yet the course of his involvement with the theme of the studio can be seen as a gradual liberating of his practice from the strictures of the academy that were drilled into him under his father's guidance and he escaped into more progressive approaches, until he arrived at a raw directness: the act of painting itself, as a statement of the studio theme and the creative expression that always underlies it, moored by only the most tentative lines to traditional ground.

In charting this trajectory, it should be recognized that the Abstract Expressionists, particularly Willem de Kooning, had arrived at a similar resolution in the previous decade. Picasso's late style is probably a product of both his accumulated history and his continuing, if now distant, attention to contemporary art.

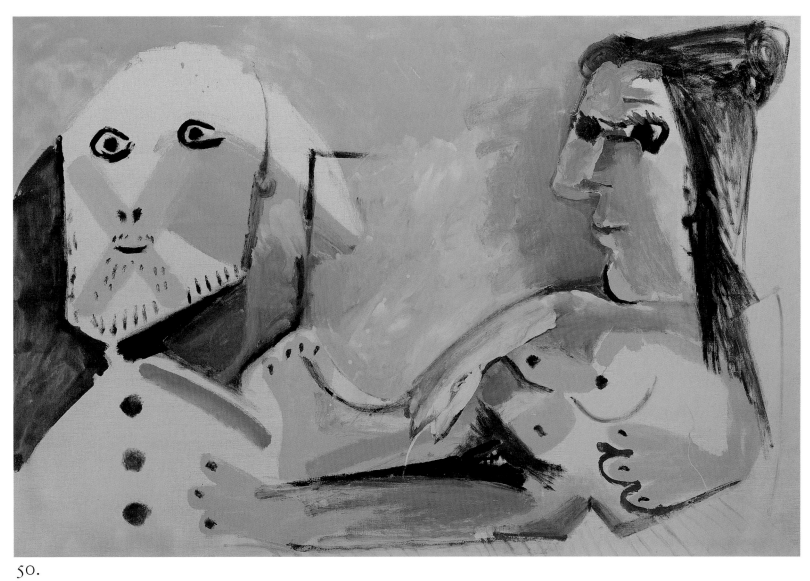

50.

51. The Painter and his Model

March 26, 1965 (III)
Oil on canvas
19 ⅝ × 24 in. (50 × 61 cm.)
Private Collection

This broadly executed painting revisits a dichotomy between artist and model that Picasso had first explored decades earlier in paintings such as the Atheneum's *Painter* (1934; Cat. 27). Like that picture, Picasso devoted the majority of the canvas to the model and banished the artist to the left edge. He differentiated between them by rendering the nude model in a profusion of purples, greens, and blues, while the artist and his easel stand entirely in black. Only the blue canvas adds a note of color to the left side. The greatest distinction, however, is not through color but line or stroke, since the image is clearly composed of broad sweeps with a brush. The model's body dissolves into a pattern of curvilinear segments that play hide and seek with her full-frontal nudity, while the artist and his easel present a parallel bulkhead of verticals.

The unifying elements are the unpainted, white canvas that surrounds the painter and flows across to signify the model's flesh, and the character of the brushstrokes, which in their breadth and fluidity move consistently across the canvas no matter what their representational role. Ultimately, Picasso's physical execution, rather than traditional symbolism or composition, is the primary agent of expression.

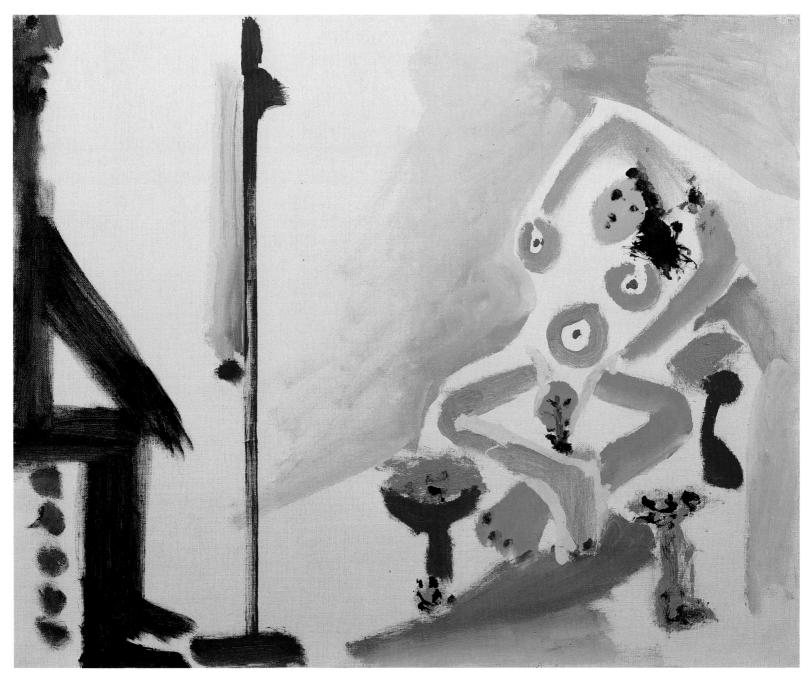

51.

52. Painter at his Easel

March 30, 1965
Oil on canvas
35 ⅞ × 28 ⅞ in. (91 × 73.4 cm.)
Private Collection

53. The Painter

March 31, 1965
Oil on canvas
39 ⅜ × 32 in. (100 × 81.5 cm.)
Private Collection

In these two paintings, made during the final two days of March 1965, Picasso explored the range of interpretation he could instill in a single, simplified subject. Both compositions are confined to the painter and his easel and place them in approximately the same location on the canvas. Within Picasso's conventional treatment of the studio theme, a model should be present at the right, even though, in reality, Picasso did not normally paint with a model before him. By truncating the scene, Picasso made explicit his primary concern with the artist and the picture he is creating.

The earlier painting (March 30) is by far the most vivacious. The image is suffused with bright hues, and the painter's rendition of a reclining nude (turned toward the viewer) scintillates with touches of pink, blue, and green. The figure of the artist is equally emphatic – his eyes, profile, and beard boldly drawn, and his sweater emblazoned with the horizontal stripes that Picasso often used to refer to the youthful spirit of a sailor in his jersey.

The version Picasso painted on the next day represents a very different mood. The tonality is a subdued range of black and grays, and the painter and easel are subtly shifted to defuse the previous image's energy. The painter no longer stretches beyond the edge of the canvas. His figure is diminutive, his features so weakly sketched and nearly hairless that he seems quite feeble, an impression that is reinforced by our inability to see what he is painting.

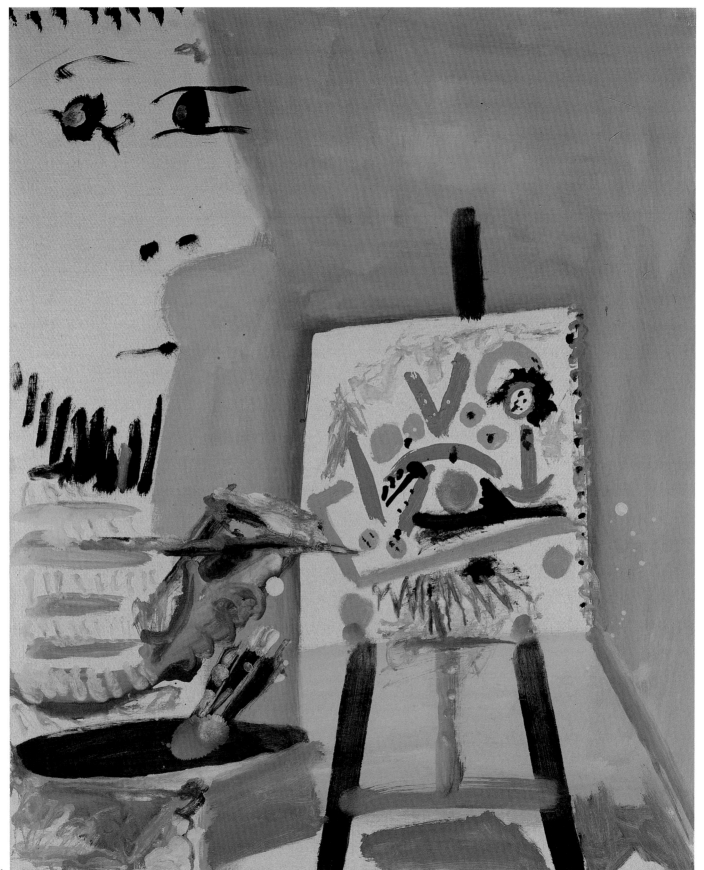

52.

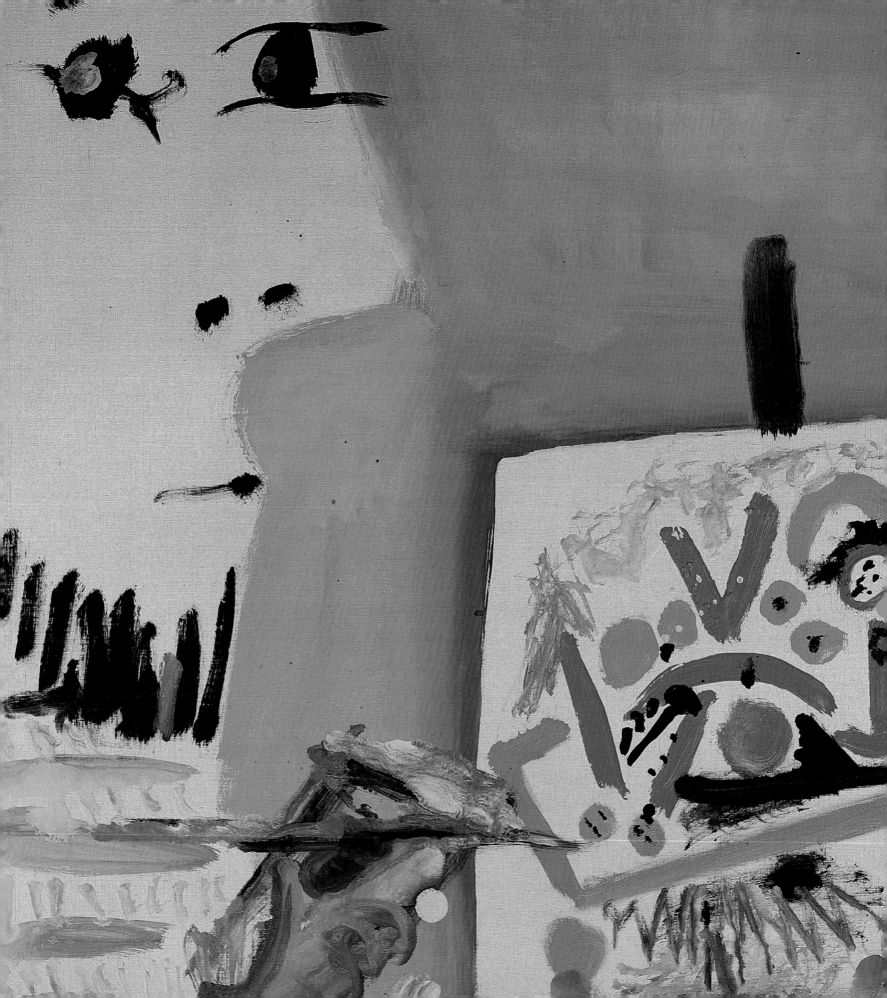

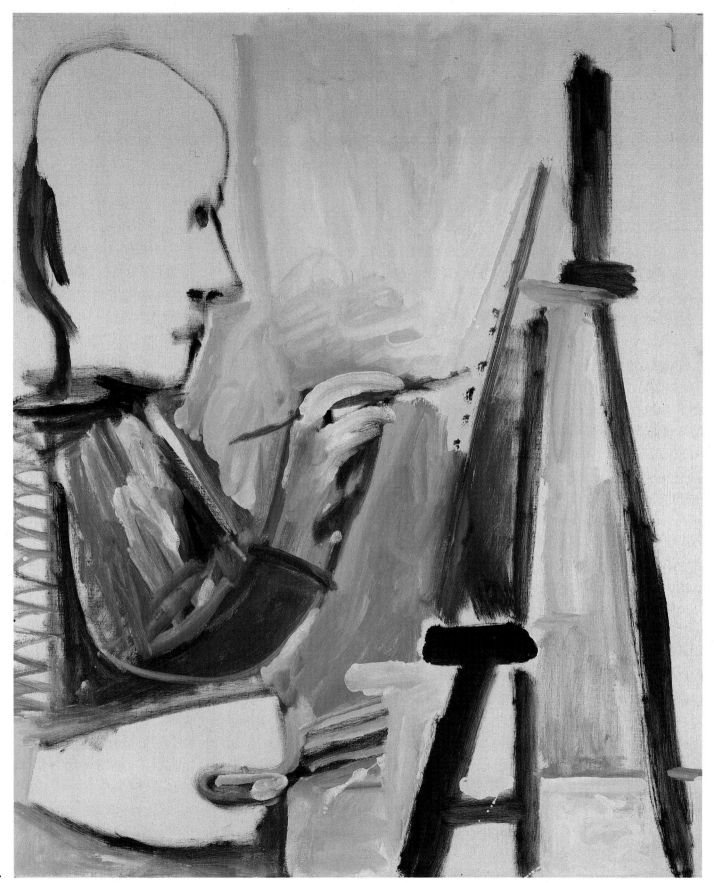

53.

54. Painter and his Model

February 21, 1967 (II)
Oil on canvas
15 × 18 ⅛ in. (38 × 46 cm).
Private Collection

The apparent simplicity of this image masks its sophisticated treatment of the studio theme. The split-screen composition juxtaposes a seated female nude and a man's bearded face. Within the conventions of Picasso's treatment, they are model and artist, while the vertical division between them may be the edge of a canvas. Yet, the ambiguity of the image offers the possibility that its right half may represent the artist's painting, so that we are seeing not the model but the artwork derived from her. Picasso created a similar polyvalence in the man, since the radical reduction of his figure to only a profile precludes the presence of any attributes identifying him as an artist. He may be another model, although his larger scale gives him prominence over the woman.

By painting an inner frame around the entire canvas, Picasso signaled his desire to engage shifting levels of illusion and a self-consciousness about the conventions of image making that underlie the subject of the artist's studio.

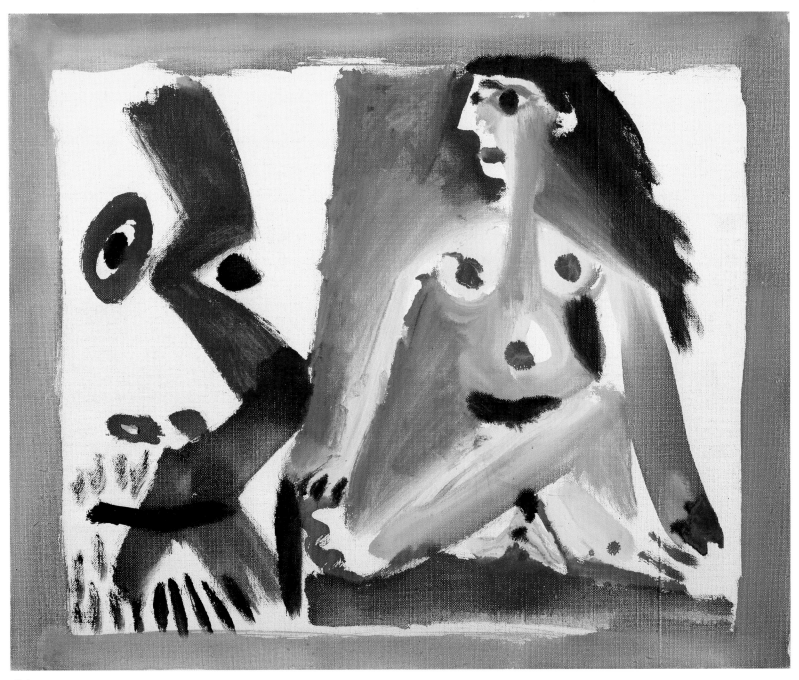

54.

55. Painter and Infant

October 21, 1969
Oil on canvas
51 ⅛ × 76 ¾ in. (130 × 195 cm.)
Musée Picasso, Paris

Four days before his eightieth birthday, Picasso painted this allegory of an artist's old age – the issue that haunted him in his final years. Following the birth of his first child, Paulo, in 1921, Picasso had portrayed the boy in the process of drawing, capturing the spontaneity of a young imagination that he and many other modern artists (particularly the Surrealists) prized for its freedom from academic structure and social inhibition. He returned to the theme in his images of Claude and Paloma, his children with Françoise Gilot.

In *Painter and Infant*, the unspoiled "genius" returns as a partner of an aged artist. The elderly, bearded man almost lies on the floor with his legs extended as a seat for the infant, who crouches and throws up an arm as if about to spring. The man holds the palette and brushes that signify his profession and raises a brush in the air. This instrument is the point of exchange between infant and adult. Its stem changes color from brown to black as it rises from the man's hand and is grasped by the child. Rather than a competition, this dual grip brings them in tandem to wield the brush as a joint effort, a collaboration that is reflected in their mutual address to the viewer instead of a potentially confrontational exchange between them.

This partnership of the relatively passive man and the dynamic infant suggests rejuvenation, but such a hopeful outcome is not certain. Besides changing color, the brush's stem fractures as it passes from elder to youth, opening up the possibility that the aged artist will be left on the ground as the infant ascends.

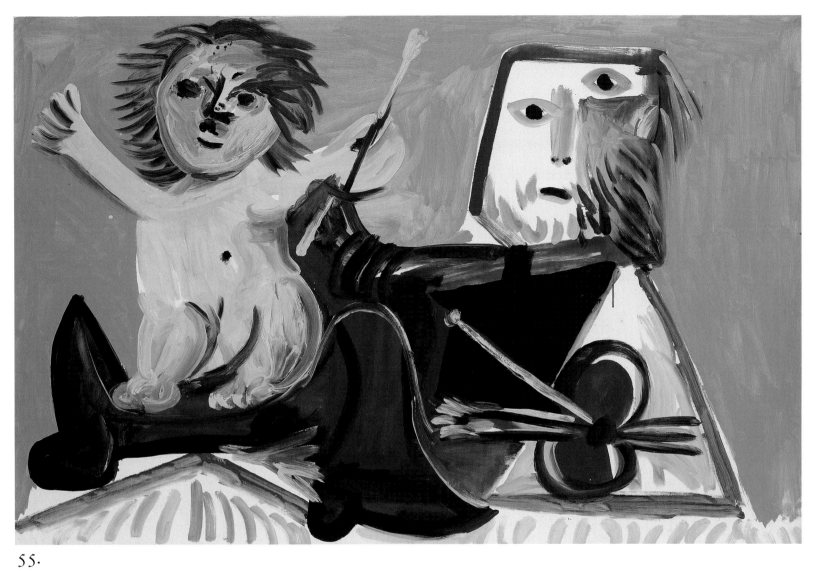

55.

56. At Work

August 1971
Oil on canvas
63 ¾ × 51 ¼ in. (161.9 × 130.2 cm)
The Museum of Modern Art, New
 York. Gift of Jacqueline Picasso in
 honor of the Museum's continuous
 commitment to Pablo Picasso's art,
 1985

Pepe Karmel has offered particular insight into this self-portrait: "In *At Work*, painted less than two years before his death (on April 8, 1973), Picasso endowed himself with the long hair and square-cornered tunic of his 1960s musketeers, but these dashing attributes were contradicted by the figure's squat proportions and oversized feet, which recall the sculpted baboon of 1951 or the leering dwarves who often appear in his late drawings and prints, grotesque symbols of sexual frustration. The visual rhyme between Picasso's almond-shaped eyes, boldly confronting his own mortality, and the figure eight of his nostrils recall numerous portraits of the late 1930s. What is new is the violence and expressiveness of the brushwork, boiling over in loops and slashes of green, pink, blue, and gray, beating against the thick black outlines of the figure, and exploding into a fan of black-and-white strokes at upper left."[27]

As a self-portrait and an image of a working artist, the figure retains the sense of physical force and intellectual intensity that Picasso had first achieved in his self-portrait of 1906, sixty-five years earlier.

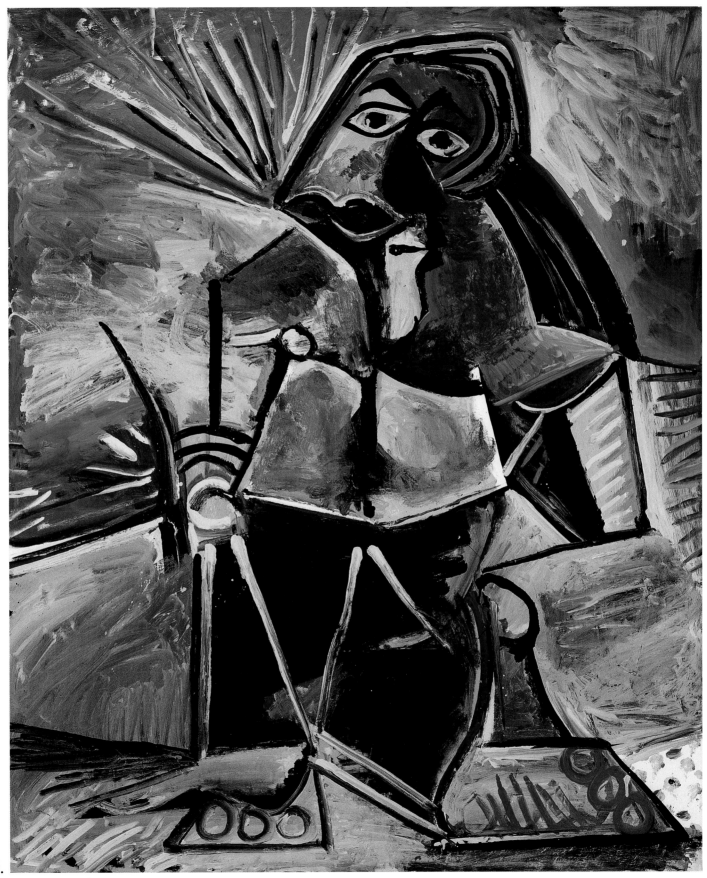

56.

NOTES TO THE CATALOGUE ENTRIES

1. John Richardson with Marilyn McCully, *A Life of Picasso*, vol. I, New York 1991, 126.
2. Musée Picasso, Paris, M.P. 524 and 526.
3. The painting was number 20 in the exhibition, *Pablo Picasso*, February 6 – March 1, 1934.
4. *Composition with Skull* (1908), Hermitage Museum, St Petersburg.
5. Hermitage Museum, St Petersburg.
6. See Judith Cousins, "Documentary Chronology," in William Rubin, ed., *Picasso and Braque: Pioneering Cubism*, New York 1989, 353 and 400.
7. Picasso made this remark to William Rubin, see Rubin, *Picasso in the Collection of The Museum of Modern Art*, New York 1972, 72.
8. Varnedoe and Karmel, *Picasso: Masterpieces from The Museum of Modern Art*, New York 1997, 60.
9. Musée Picasso, Paris, M.P. 869.
10. For a full biography of Austin that offers considerable insight into his work at the Atheneum, see Eugene R. Gaddis, *Magician of the Modern: Chick Austin and the Transformation of the Arts in America*, New York 2000.
11. "Interview with Sidney Janis conducted by Helen M. Franc," June 1967, 1–2 (The Museum of Modern Art Archives).
12. Another painting in this series, *The Studio* (1928) is in the Peggy Guggenheim Collection in Venice.
13. Christian Zervos, *Pablo Picasso*, Paris 1923–76.
14. Musée Picasso, Paris, M.P. 1026 and 1027 (respectively).
15. For the general issue, see Elizabeth Cowling and Jennifer Mundy, *On Classic Ground: Picasso, Léger, de Chirico and the New Classicism 1910–1930*, London 1990.
16. Quoted in *Picasso: Life and Art*, 327.
17. For the most recent study of the relationship between the work of Picasso and Matisse, see Yve-Alain Bois, *Matisse and Picasso*, Paris and Fort Worth 1998.
18. Quoted in "Museum of Modern Art Acquires Recent Painting by Picasso," press release, August 11, 1957.
19. "The Jacqueline Portraits in the Pattern of Picasso's Art," in Rubin, ed., *Picasso and Portraiture*, 458.
20. *Picasso's Variations on the Masters*, 148.
21. Ibid., 176–77.
22. For Picasso's political involvement after the Second World War, see Gertje R. Utley, *Picasso: The Communist Years*, New Haven and London 2000.
23. Musée Picasso, Paris, M.P. 394–99.
24. Steven Nash, *A Century of Modern Sculpture: The Patsy and Raymond Nasher Collection*, Dallas and Washington, D.C. 1987, 205.
25. Ibid.
26. Quoted in Hélène Parmelin, *Picasso dit*, Paris 1966, 19.
27. Varnedoe and Karmel, *Picasso: Masterpieces from The Museum of Modern Art*, 140.

INDEX

Page numbers in italics indicate artwork and photographs. Those in bold italics indicate Exhibit pieces.

PHOTOGRAPHIC CREDITS

The organizers are grateful to all those museum, galleries, and private individuals who have supplied photographs of works in their collection. Others who have kindly helped to provide photography are listed below

Fig. 15 Walter Klein, Düsseldorf, photographer

Fig. 18 David Allison, New York

Fig. 22 © 2000 The Solomon R. Guggenheim Foundation

Fig. 30, Cat. 1, 2, 6, 43 Photo Arxiu Fotográfic de Museus. Ajuntament de Barcelona

Cat. 3, 4, 7, 9, 12, 13, 14, 15, 16, 20, 23, 24, 25, 28, 29, 30, 31, 37, 44, 45, 55 Réunion des Musées Nationaux / Art Resources, NY

Cat. 17, 27, 49 Sean McEntee Photography

Cat. 18 Museo Nacional Centro de Arte Reina Sofia Photographic Archive, Madrid

Cat. 22, 47 Photothéque des Collections du Mnam/Cci

Cat. 26 Photography by Michael Cavanaugh, Kevin Montague

Cat. 33 Images Modernes – Photo: E. Baudouin

Cat. 39 Christie's Images New York

Cat. 42 Bequest of the Nancy Baston Rash and Dillman A. Rash Collection. 1998.19.5

Cat. 48 Museo Nacional Centro de Arte Reina Sofia Photographic Archive, Madrid